Whitechapel Gallery

A GALLERY IN WHITE CHAPEL

Rises in the East

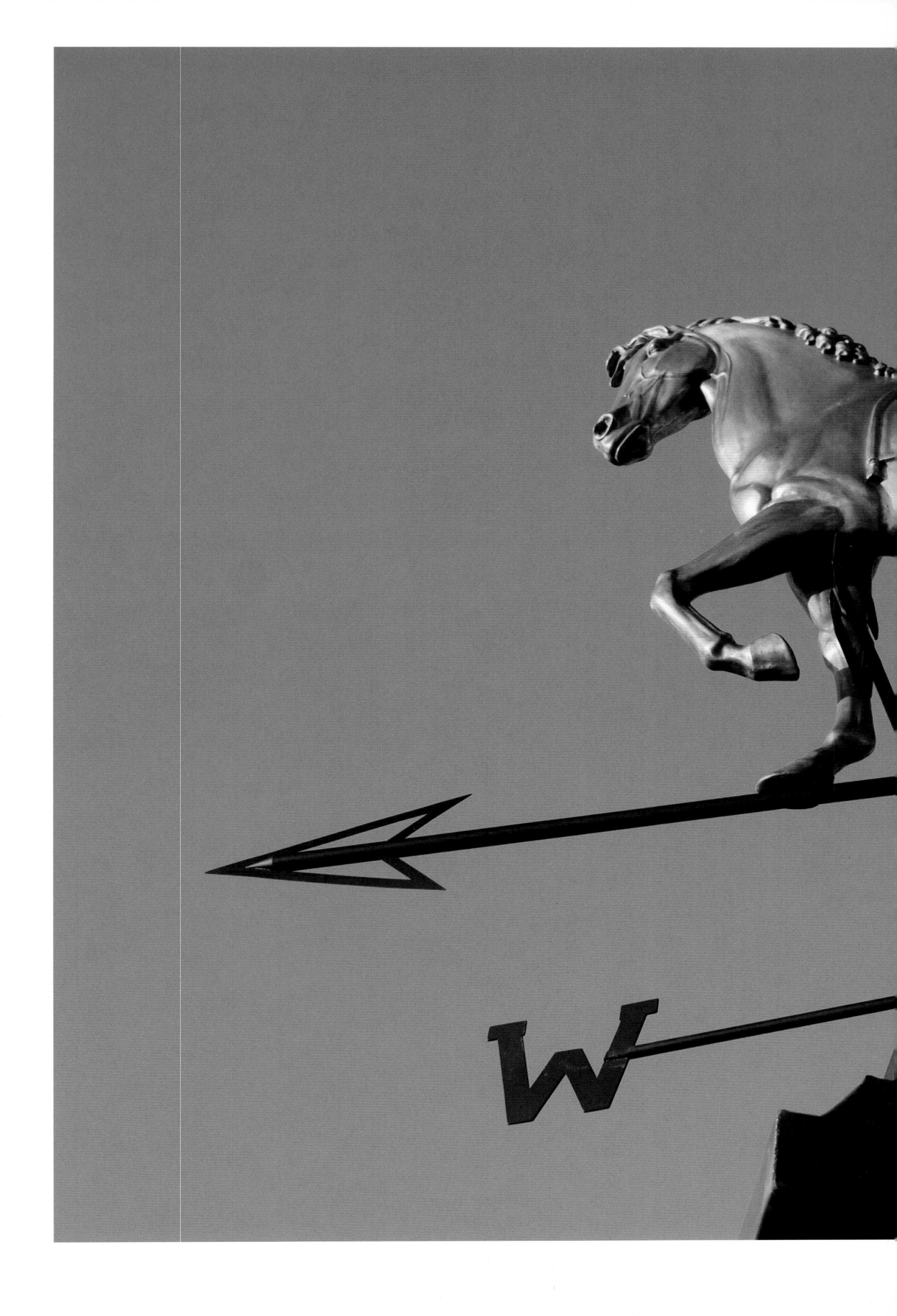

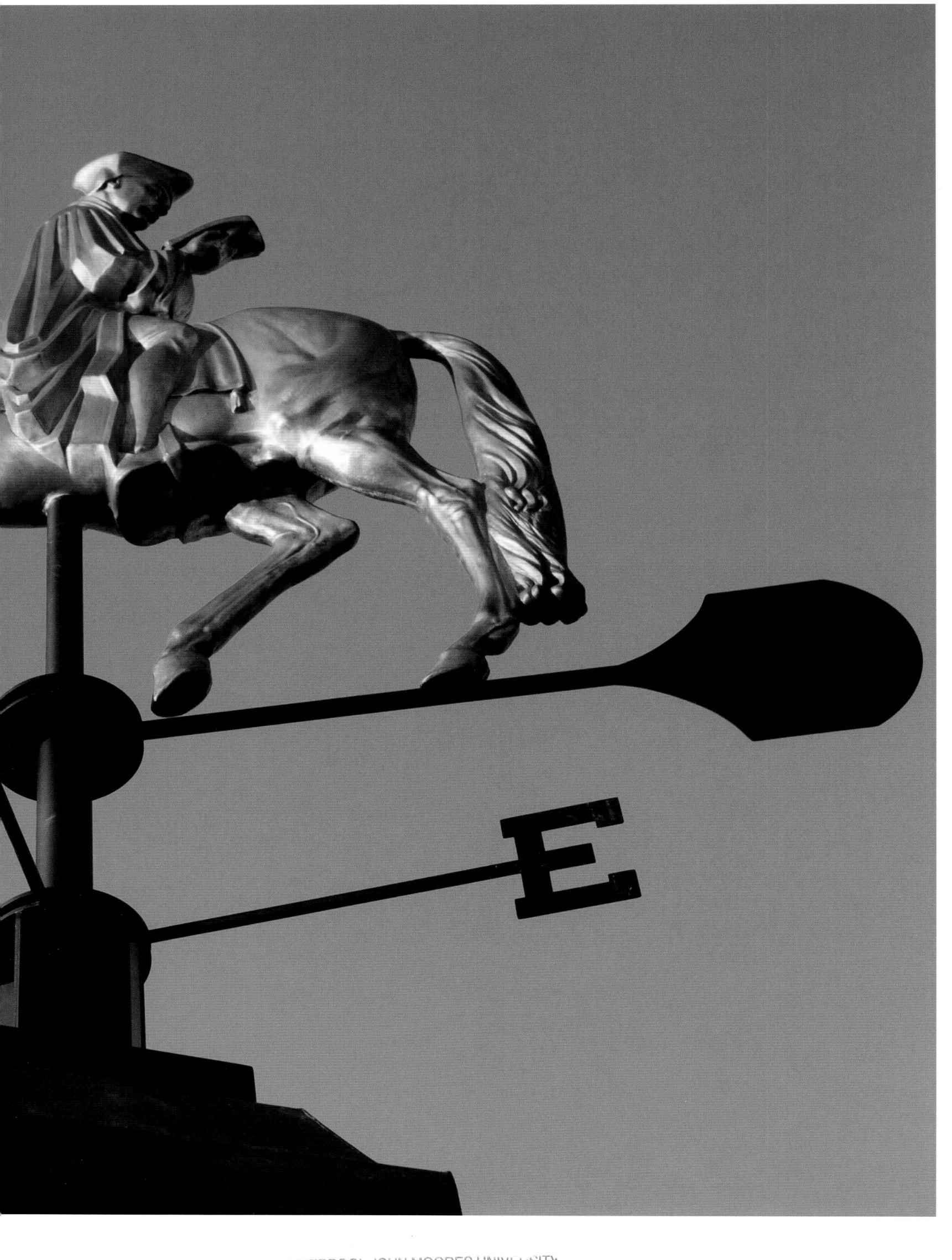

contents

It has been more than 1oo years since the original
Whitechapel Gallery opened its doors
in a beautifully designed Arts and Crafts
building, which today still looks and
feels as modern as it did at its inception.
Next door stands a Victorian library and
with the Gallery's acquisition of this space
in 2oo1, we are today proudly set up in
two magnificent examples of architecture
that span a century of historic events.
I believe this is what makes the Whitechapel Gallery
important — since 19o1 our space has been
used to exhibit some of the most important
pieces of, and movements in, modern art.
Many of the artists we have shown arrived
in Britain as immigrants and have lived in
the area near the Gallery; many collectors
who came as war refugees also made their
home in the surrounding neighbourhood.
Today the East End of London offers a
living and working environment to some
of the world's most creative individuals.
The Whitechapel Gallery has always
been an important part of that history.
We are now set to continue our role in a much larger
space that allows us to exhibit great
artists in different contexts. The expanded
building — with all its peculiarities — will
play a major part in telling these stories.
I look forward to hearing of your experiences
at the Whitechapel Gallery and
believe you will see a particularly
unique environment for the continued
development of contemporary art history.

ROBERT TAYLOR

Chairman of the Board of Trustees
Whitechapel Gallery, April 2oo9

This book is published to mark the expansion of a gallery that has played a central role in the way that the art of a century found its public. Purpose-built in 1901, London's Whitechapel Gallery reopened in expanded premises in 2009, incorporating the former Passmore Edwards Library, an adjacent Victorian structure, once known as the 'University of the Ghetto'.

The expansion was made possible by grants and donations from over 400 public funders, statutory bodies, artists, trusts, foundations, companies and individuals who together contributed 14 million pounds to create a new building and an endowment.

The twenty-first century Whitechapel Gallery includes two restored terracotta facades, eight galleries, two restaurants, an auditorium, an archive and library, a dedicated education and research tower and a weathervane created by Canadian artist Rodney Graham.

The Ghent-based architects, Robbrecht en Daem Architecten, working in partnership with London-based Witherford, Watson, Mann, were given the brief to expand the programming potential of the Gallery. In addition to continuing to present solo shows and thematic exhibitions, the spaces they created offer the possibility of commissioning new site-specific works of art; and the display of important collections and archives.

The architects also made a beautiful creative studio looking over the rooftops of the city where whole classrooms of children and young people can make art; and a study studio where artists can discuss their work — and where anyone interested in art can take courses on making it, understanding it, even acquiring it. There is also an art library open to all.

Between the galleries, a project called *Social Sculpture* presents permanent works by artists, whose art is also functional. Their sculptures may double as couch, lamp, drinking fountain, chair, pin board, weathervane or guided tour. They offer visitors points of conversation, revival and exploration in and around the exhibitions.

The Whitechapel Gallery is a special place with a special purpose. By choosing to locate it in the East End, amidst the poverty of late-Victorian London, our founders made a deliberate statement. It's a statement that echoes down the decades and still motivates us today.

Great art can and must belong to everyone. Wherever you come from, however difficult your circumstances, art has the power to nourish, inspire and transcend.

This gallery has been a catalyst for personal and political transformation. This is the place where generations of immigrants have come to seek knowledge and understanding. This is the place where, crucially, artists know they can realize their vision.

Our mission, reinforced by our location, allows us to form a bridge between the great financial engine of the City and the aspirational energy of one of the most cosmopolitan communities in the world. Diversity, entrepreneurship, intellectual experimentation — the Whitechapel Gallery is at the heart of what defines twenty-first century London.

This book is published at a time of great economic uncertainty. All those who have contributed to our expansion share a belief that it is at such times that we need the aesthetic, philosophical and inspirational power of art more than ever.

We are grateful for the dedication of our staff who have worked so hard to realize the full ambitions of this project. The Gallery is also indebted to our predecessors who lay the intellectual, artistic and social foundations that have enabled this art institution to flourish. It was the passion and commitment of generations of librarians who made the former Passmore Edwards Library central to the community and whose legacy also informs the ethos of the Whitechapel Gallery.

Rises in the East also pays tribute to the vision of the architects and the expertise and craftsmanship of builders, engineers, designers, planners, surveyors and conservation experts, all of whom made their vital contribution.

I would like to thank the editors of this book — Katrina Schwarz and Hannah Vaughan — and the contributing authors for sharing their knowledge and critical perspectives. Photographs by Patrick Lears and Richard Bryant combine with the beautiful design of Niall Sweeney and Nigel Truswell at Pony to make this a great commemoration of a great moment in our history.

IWONA BLAZWICK
Director

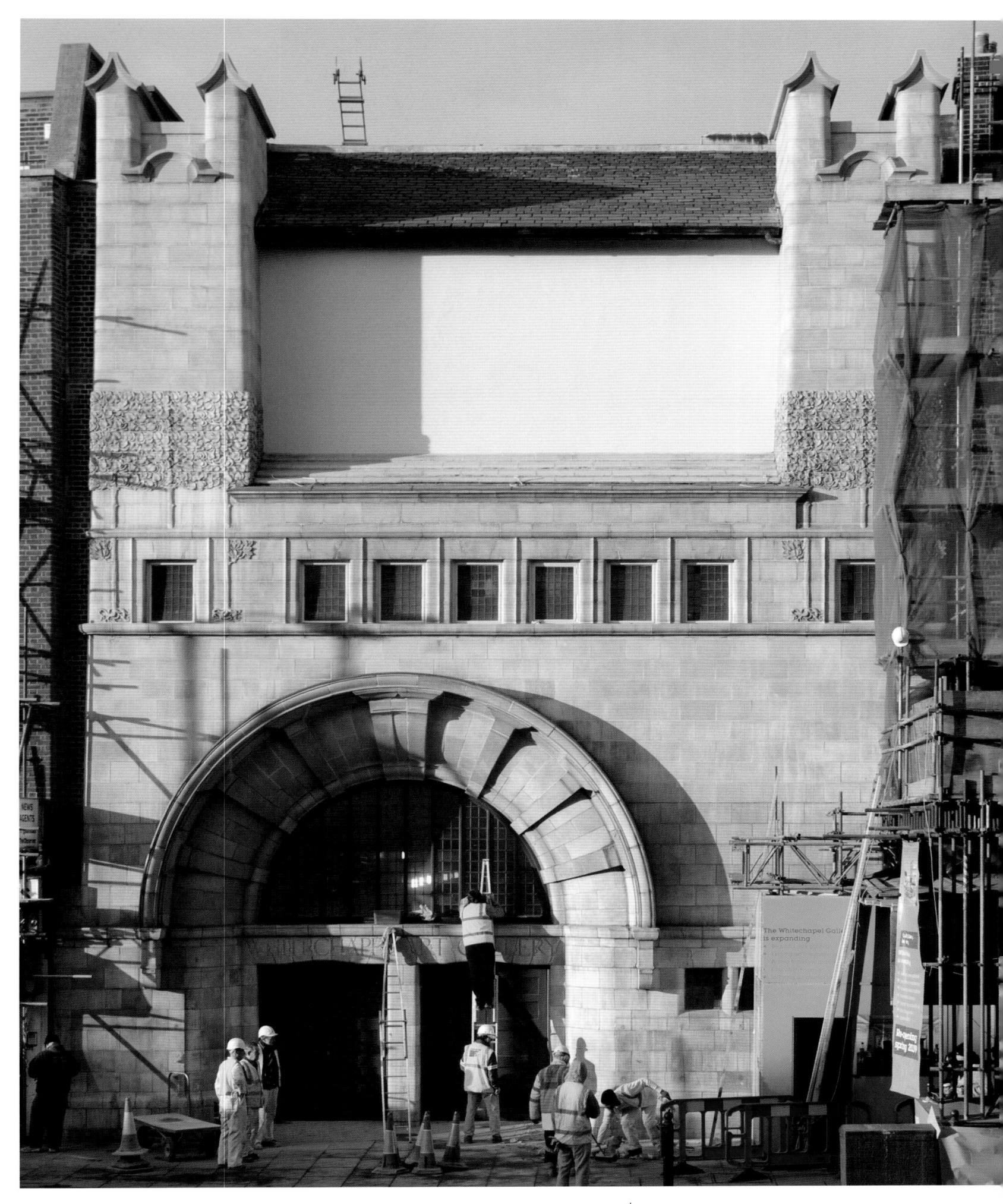

HIGH RISING: AN AERIAL VIEW

Spinning on his axis on the domed gallery roof, Rodney Graham's Erasmus as weathervane overlooks an East London skyline dominated by building cranes, rising towers and a glittering gherkin. There is something to be said for Erasmus' peculiar and particular vision — looking backwards and forwards, spinning at altitude — but it is not necessary to hoist ourselves skyward to appreciate that the expansion of the Whitechapel Gallery occurs not in isolation, but within the context of a transforming cityscape and an architectural vernacular increasingly allied to spectacle and wonder.

The Whitechapel Gallery, described by Nikolaus Pevsner at its half-century point as an 'epoch-making building',[1] is in its expanded form now illustrative of another epochal moment; one defined by an unparalleled growth in the number and diversity of art museums, by the augmentation of existing sites, a global increase in museum visitors and a new prominence within cultural discourse. As the sensibility and activities of the museum penetrate everyday culture and experience — from the veneration of flea markets and retro fashions to the memoir boom ('self-musealization' now transmitted via blog, Facebook update and Twitter), the museum has become, in the formulation of Andreas Huyssen, the 'key paradigm of contemporary cultural activities'.[2]

As if to emphasize this new authority, in the dozen years since the unveiling of the great Gehry Guggenheim, the art museum has also given rise to a condition — oft diagnosed, much discussed — known as 'The Bilbao Effect'.

> *The Bilbao effect is what local politicians and those in the regeneration business hope to gain for their towns when investing in an exciting new arts building. It all began more than a decade ago when Frank Gehry's stunning, titanium-clad Guggenheim museum was declared open by King Juan Carlos even as ETA tried to blow him, and Jeff Koons' Puppy (the museum's mascot), off the face of the Basque city.[3]*

Of course the Wow-factor[4] intrinsic to these architectural icons predates Gehry's 'titanium artichoke' but, in combination with the global franchising of the Guggenheim brand, Bilbao has become a byword for financial and cultural regeneration by means of a flagship building project. The dictum 'Expand or Perish', attributed to Thomas Krens in his former role as Director of the Solomon R. Guggenheim Foundation,[5] has been adopted with gusto, if mixed results. While the closure of the two Rem Koolhaas-designed Guggenheim outposts in Las Vegas leaves the Sin City strip with only one art musuem;[6] on an island named Happiness off the Arabian Gulf — Saadiyat Island, Abu Dhabi — the museum makers are breaking ground. In a stunning instance of Bilbao-Effect-gone-bonkers, the world's biggest Guggenheim, courtesy again of Gehry, will share marina space with an outpost of the Louvre, designed by Jean Nouvel, a performing arts centre by Zaha Hadid, Tadao Ando's Maritime Museum and the Sheikh Zayed National Museum, by Foster + Partners.

The Whitechapel Gallery might be located on an island — but it is neither *ex novo*, nor particularly cheery. Thank goodness for that. Looking, like Erasmus, both backwards and forwards, we will remember that a belief in the ameliorative potential of the art museum is not, like so many Guggenheim franchises, bulbous extrusions and globetrotting starchitects, a phenomenon that can be ascribed to 'The Bilbao Effect', but was rather present at the very foundation of the Whitechapel Art Palace in 1901. In the dark heart of 'outcast London', the Whitechapel was founded upon Ruskinian ideals, which identified the gallery as a catalyst for urban and social transformation. Just as Bilbao has become an, albeit contested, icon of what architecture and art can achieve for a post-industrial ruin, the Whitechapel Gallery arose as an act of Late-Victorian social reform. Its target: the newly enfranchised working class of East London, who might be spiritually and socially elevated by their exposure to the transcendent beauty of art.

Transformation is, moreover, inscribed at the very core of a gallery whose awesome reputation stems not from a collection of permanent works, but rather from a shifting series of exhibitions and a remarkable role call of historic firsts. Thus liberated from the art museum's characteristically platonic emphasis on the eternal, the atemporal and the fixed, Whitechapel Gallery finds true echo in the frenetic, fantastic East End, and its ever-mobile, vivid, shifting populace.

Rises in the East is the first publication to chart the history of the Whitechapel Gallery through its phases of construction and expansion. In essays by Stephen Escritt and William Mann, the Gallery is examined as both an outstanding example of Arts and Crafts architecture and as the site of an innovative extension, executed by leading architectural firm Robbrecht en Daem Architecten. The practical and ideological considerations of the expansion are further teased out in a conversation between architect Paul Robbrecht, artist advisor Rachel Whiteread and design critic Alice Rawsthorn. Presented alongside a visual record of the construction process, archival material and a new programme of *Social Sculpture*, *Rises in the East* reveals the Gallery's numerous stages of transformation.

Surveying a century of museum design shaped, at one extremity, by the whiplash curves of Art Nouveau and, at its opposite, by Gehry's titanium extrusions, is to foreground the centrality of ornamentation and of spectacle. By contrast, the expanded Whitechapel Gallery, in its refusal of sculptural iconicity, in its subtle efficacy, might just represent, in Hal Foster's phrase, 'a new moment in the art-architecture rapport'.[7] Spectacular, show-pony architecture has been eschewed in favour of democratic design — the original façades of the now conjoined Gallery and Library buildings are maintained, as is the Gallery's direct relationship to Whitechapel High Street, over which Erasmus — a beacon of learning, a symbol of enlightenment humanism — spins and spins.

KATRINA SCHWARZ

notes

1. Nikolaus Pevsner, *The Buildings of England: London*, Harmondsworth : Penguin, 1952, 421
2. Andreas Huyssen, *Twilight Memories: Marking Time in a Culture of Amnesia*, Routledge, 1995, 14
3. Jonathan Glancey, 'Margate should resist the Bilbao Effect', *Guardian*, 25 July 2008
4. Gehry, as reported in *Time*, tells a story about a German client who came to him after seeing an earlier building in Switzerland: 'He said to me, 'That one was Wow! Now give us Wow! Wow! Wow!'', Richard Lacayo, 'The Frank Gehry Experience', *Time*, 18 June 2000
5. Anna Maria Guasch and Joseba Zulaika, 'Learning from the Bilbao Guggenheim: The Museum as a Cultural Tool', *Learning from the Bilbao Guggenheim*, Center for Basque Studies, University of Nevada, Reno, 2005, 16
6. The closure of the Guggenheim Hermitage Museum in 2008 was preceded by the suspension, in 2003, of the 63,700 square-foot Guggenheim Las Vegas
7. Hal Foster, 'Architecture-Eye', *Artforum*, vol. 45, February 2007, 249

photographs Patrick Lears

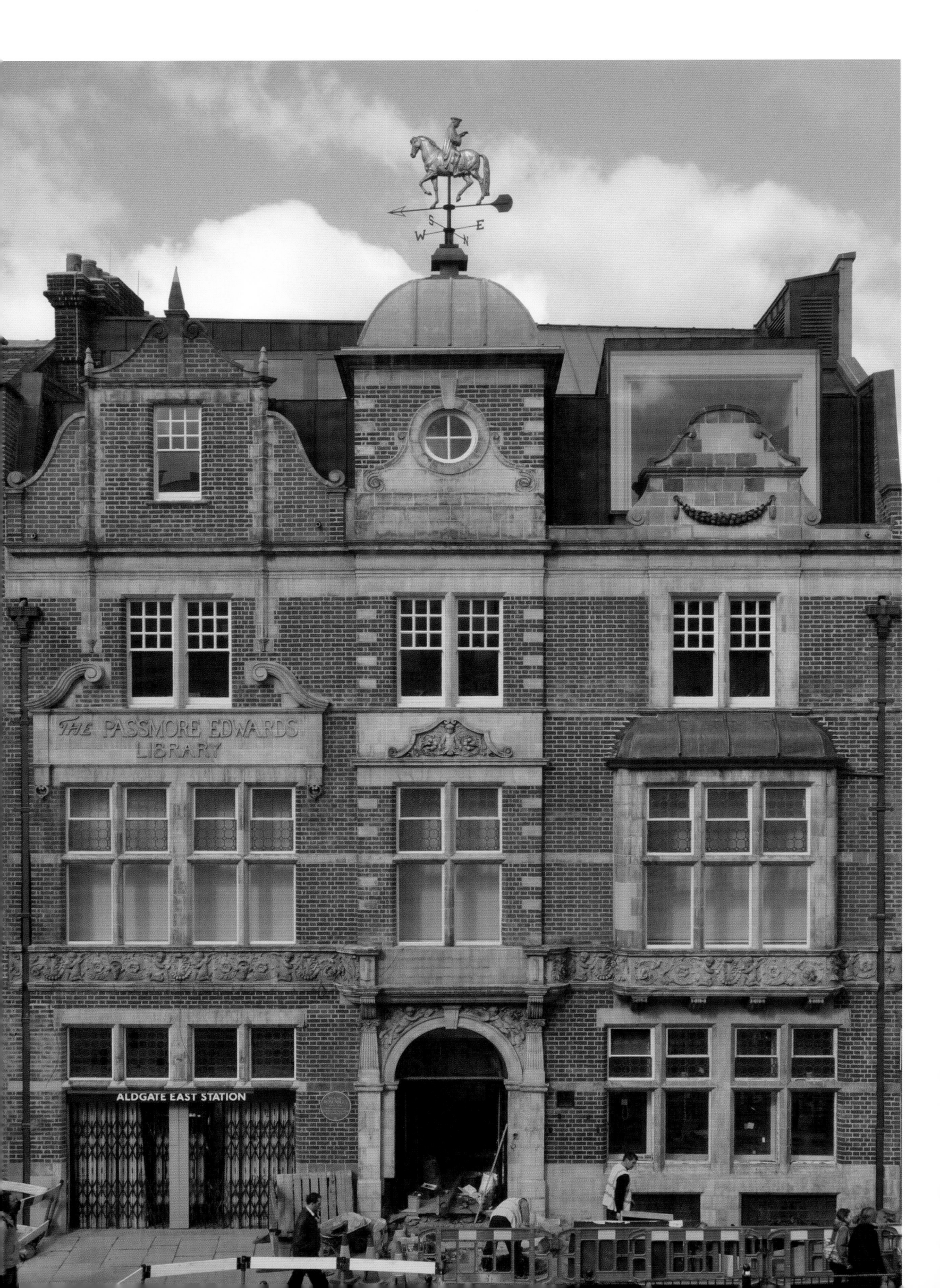

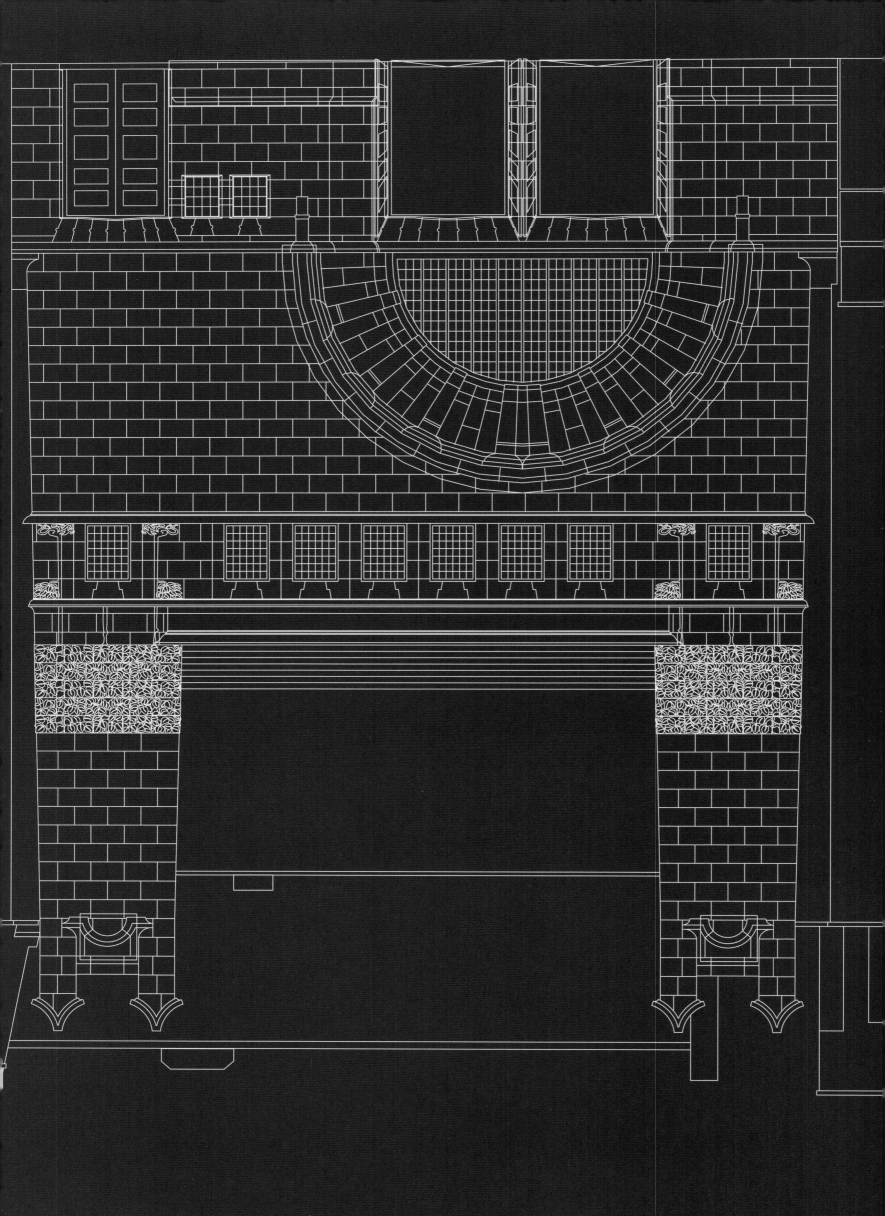

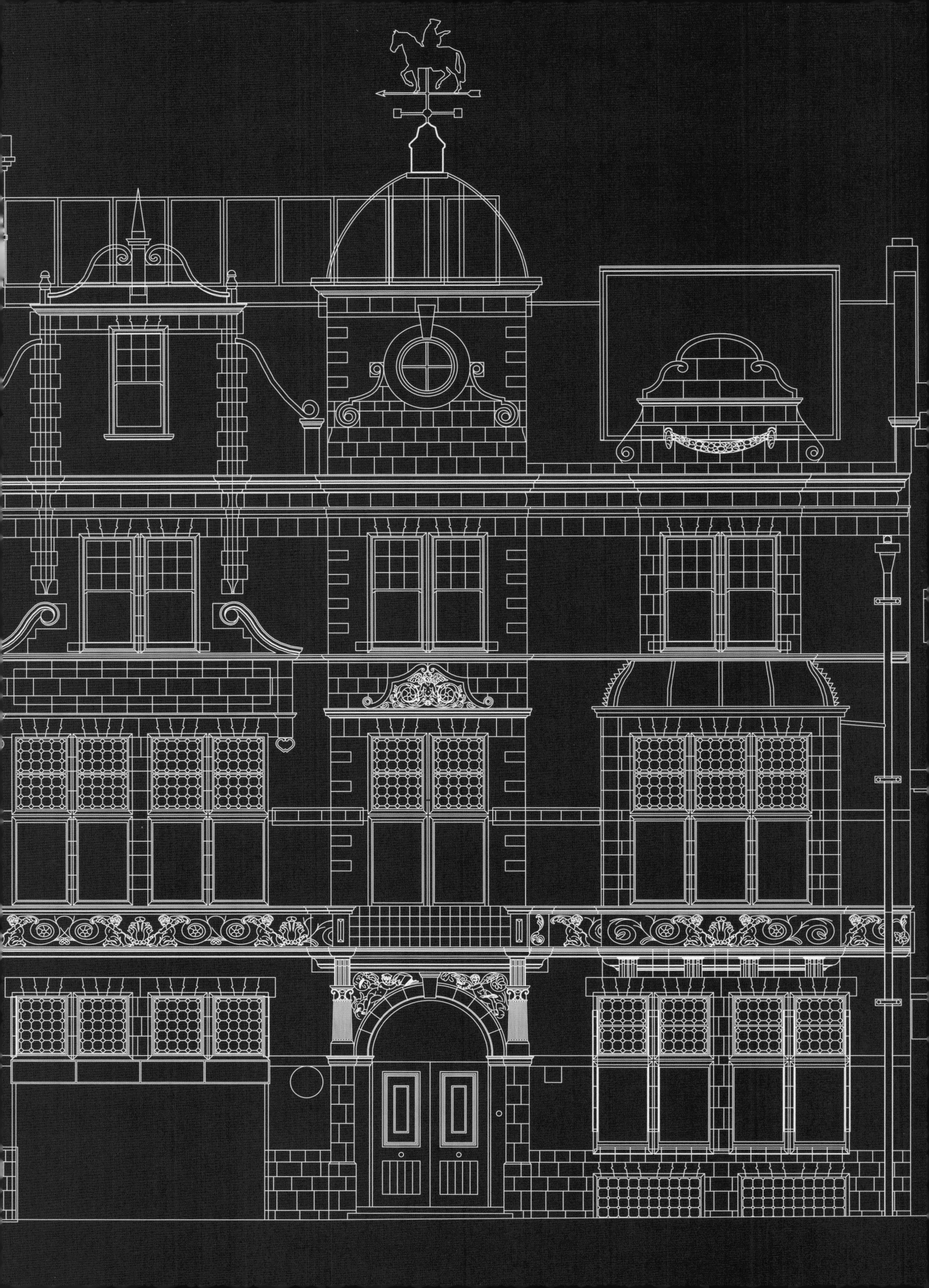

Charles Harrison Townsend, c. 19o3
RIBA Library Photographs Collection

Charles Harrison Townsend, the Whitechapel Gallery and the Enigma of English Art Nouveau

STEPHEN ESCRITT

I HAVE PERSONALLY
NEVER SEEN
ARCHITECTURAL WORK
MORE STRIKINGLY
ORIGINAL THAN
HIS [TOWNSEND'S]
BUILDINGS;
AND PERHAPS HIS
WHITECHAPEL ART
GALLERY IS ONE OF
THE FINEST BUILDINGS
OF DECIDEDLY MODERN
CHARACTER ONE COULD
SEE ANYWHERE

Hermann Muthesius (1861–1927)
19o2[1]

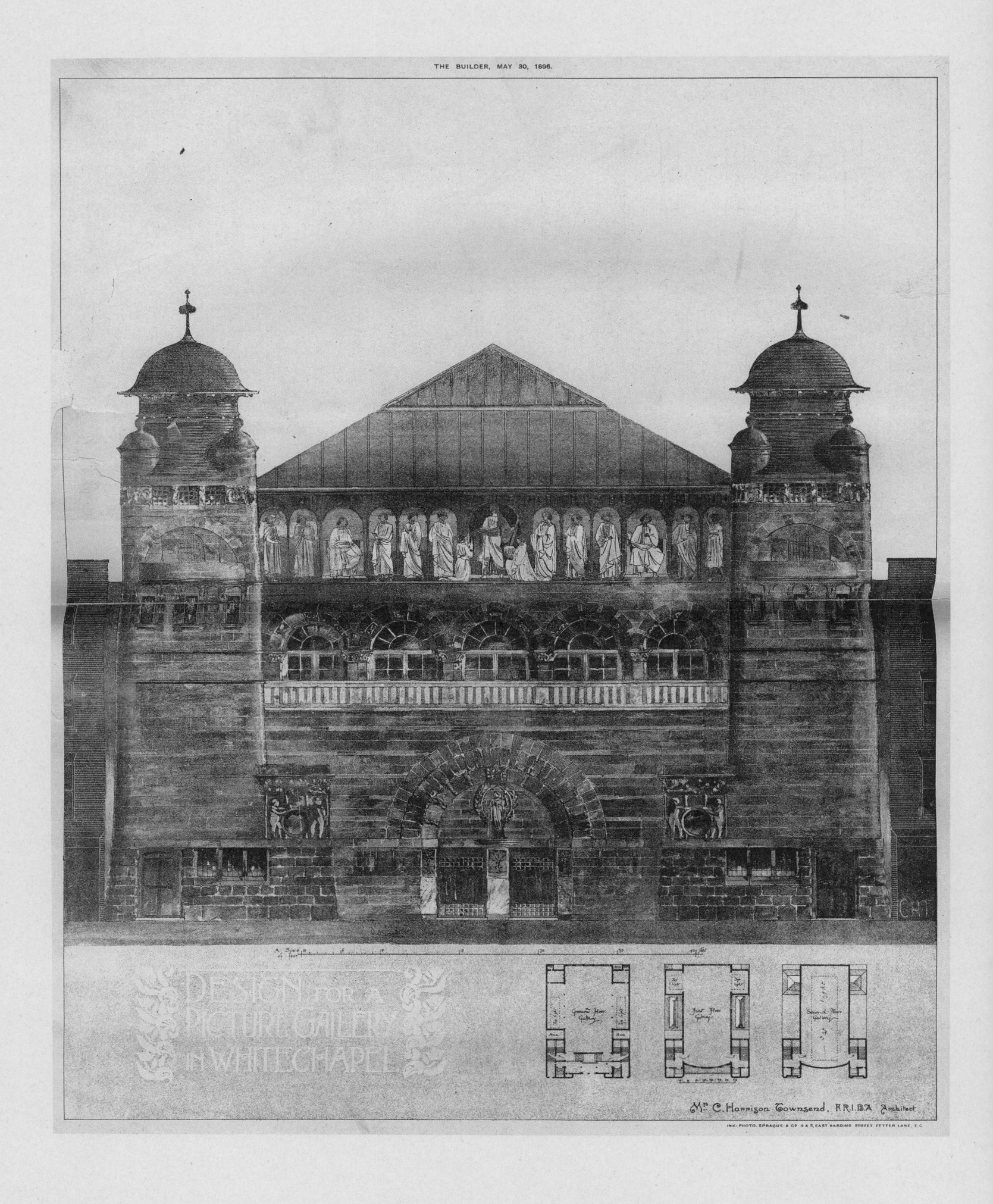

**Charles Harrison Townsend, first design for
Whitechapel Gallery,** *The Builder,* **30 May 1896**
RIBA Library Photographs Collection

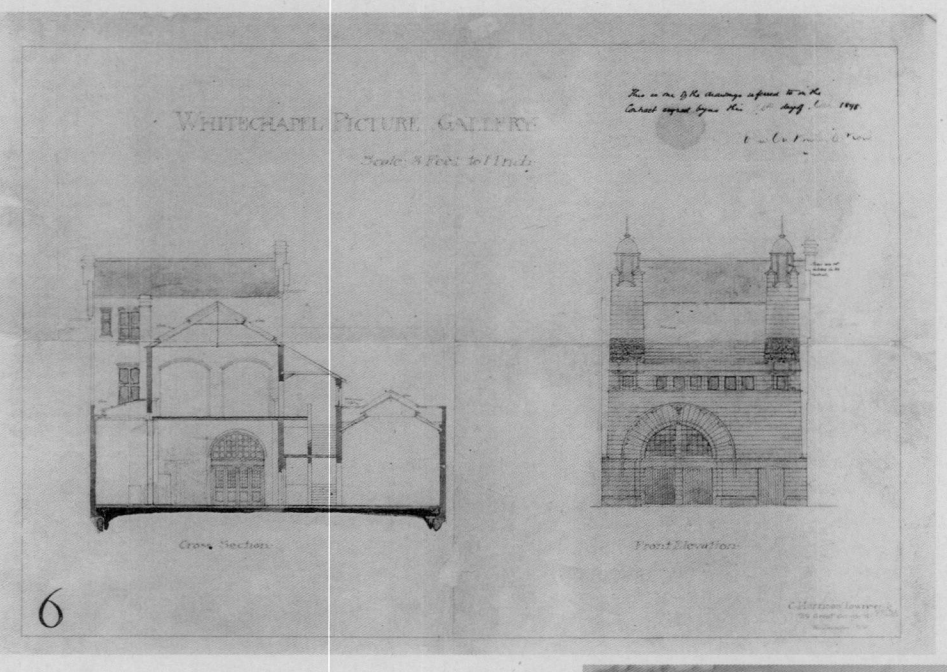

6

Charles Harrison Townsend, Contract drawings for
'Whitechapel Picture Gallery', ground and first floor,
cross-section and front elevation, 1898
Whitechapel Gallery Archive

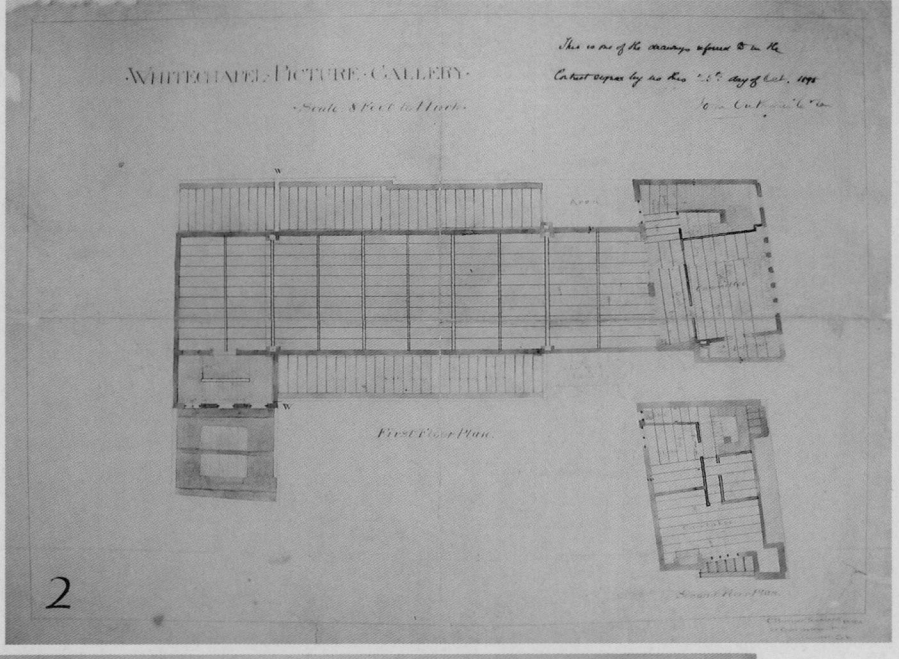

2

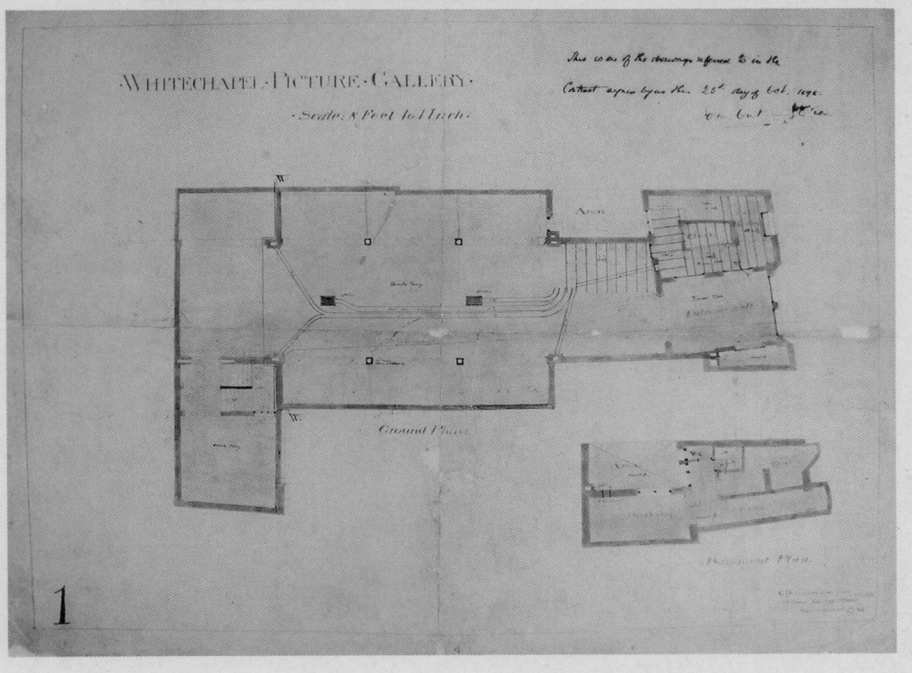

1

The twentieth century had a tumultuous first year. Queen Victoria died, ending a long reign synonymous with British imperial power and industrial prowess; the Boxer Uprising was suppressed in China; and William McKinley, the newly elected president of America, was shot dead by an anarchist assassin.

These seismic international events were matched by broader social and cultural changes. Across Europe the 189os were characterized by nationalist, democratic and sometimes socialist agitation for suffrage and social reform. In the arts the classical and historicist orthodoxy, which had been under threat for some time from design reformers and avant-garde artists, was finally eclipsed by a heady combination of Art Nouveau, Symbolism, Post-Impressionism and romantic nationalism. In architecture the most progressive work across Europe was dominated by variants of a new idiom, which combined simplicity and geometry, decoration drawn from Symbolism and nature, and romantic folk and craft influences. Depending on where it was found and how it combined these ingredients, the new style was variously known as *Art Nouveau, Le Style Moderne, Jugendstil*, Secessionism or simply the New Style. For all its eclecticism, one thing was clear — it was considered to be modern.

In London — a city not renowned as a centre of Art Nouveau — these contemporary social and artistic developments were exemplified in two new public buildings that opened within four months of each other in 19o1. On March 12th, the patrician former Liberal Prime Minister Lord Rosebery made the short journey to the city's poverty-stricken East End to open the new Whitechapel Art Gallery. South of the river on June 3oth a new public museum, the Horniman, was opened in Forest Hill.

Both projects were born of a reforming philanthropic desire to bring art and learning to the ordinary people of London. They also shared the same visionary architect — and one of the few proponents of the New Style in architecture in England — Charles Harrison Townsend (1851–1928). The Whitechapel Gallery and the Horniman Museum are two of a trio of public buildings in London for which Townsend is best remembered — the other being the Bishopsgate Institute, five minutes walk from the Whitechapel Gallery, which had opened six years earlier on New Year's Day 1895.

The Whitechapel Gallery in particular, which is the most austere of the three and so most easily placed within the history of modern architecture, has established Townsend as one of very few exponents of international Art Nouveau in England. As such he has been considered an English counterpart to Charles Rennie Mackintosh (1868–1928) in Glasgow. And while there is certainly truth in this interpretation, Townsend's work is far more interesting than simply as an English footnote to a fashionable continental style.

A brief exploration of the three buildings will help define their place, and that of Townsend, within the context of international modern architecture at the turn of the nineteenth- and twentieth centuries. Relationships between Townsend and America, the emerging national Romantic styles of northern and eastern Europe, and the often ignored technological and social concerns of Art Nouveau architecture can be observed. And it is with these factors in mind that it becomes possible to speculate on what led Townsend to design these remarkable buildings and, in turn, what was the wider impact of his work.

First came the Bishopsgate Institute in 1895. It was founded by the
City Parochial Foundation as an independent adult educational
institution and library for those who lived and worked in the City
and the surrounding area. As such it shared the reforming agenda
of Townsend's two later commissions. Townsend would have
commenced his designs for the Institute in 1892–3. It is not known
why the architect was commissioned, but it was a brave choice,
resulting in a building that possessed one of the most original and
striking facades of any late nineteenth-century English building.
The richly decorated terracotta frieze, bold central arch, highly
unusual minaret-like towers and dramatic overhanging eaves
were far removed from the usual Neo-Baroque revival exercise
that was the default response favoured by most architects
of public buildings of the day.

Townsend's first major building defied categorization. It did not really fit with
the spirit of simplicity of the Arts and Crafts movement, with which
Townsend, a member and future master of the Art Workers Guild,
was undoubtedly in sympathy. Nevertheless Townsend's use of a
traditional material — terracotta — and stylized floral decoration
did to some extent ally it with that tendency. At the same time the
façade was not slavishly historicist, though it certainly contained
Neo-Romanesque flavours, most notably the dominant arch.

There has been speculation that Townsend may have been familiar with
the work of the American architect H.H. Richardson (1838–1886),
whose work displays some of the same bold imagination as
Townsend. In particular Richardson favoured strictly controlled
decoration, traditional materials and the use of bold central
arches — the latter being a feature that unites the Bishopsgate
Institute and the Whitechapel Gallery. One American writer
went so far as to describe Townsend as 'Richardsonian',[2] which is
certainly a disservice to Townsend's originality and the complexity
of his influences; nevertheless there is a strong case that the
American influenced Townsend.

First the visual evidence. Richardson contributed to only one building in
Britain, a house called 'Lululand' in Bushey, Hertfordshire, built
posthumously in 1894, and based on a sketch by Richardson for the
portraitist and Royal Academician Hubert von Herkomer, who had
met the architect on his visit to London in 1882.[3] Only its entrance
survives, but its simple form — comprising a massive arch within an
austere setting punctured with limited fenestration — bears a distinct
resemblance to Townsend's later Bishopsgate and Whitechapel
facades. There is no proof that Townsend had seen this building,
though it is a distinct possibility. Townsend's brother Horace, a
journalist and critic who lived for a period in America, had met
Richardson in the 1880s. Some years later in 1894 Horace published
a significant appreciation of Richardson's work in *The Magazine of
Art*, in which he noted Richardson's 'impressionistic insistence on a
single feature — generally the single centre arch',[4] and concluded by
referring to (though not illustrating) the house in Bushey.[5]

Horace Townsend's 1894 article was one of a number of instances of
Richardson's work being published in Britain, particularly in the
architectural press,[6] and so Charles Harrison Townsend would
certainly have seen photographs of other examples of his work.
Whatever the degree of influence at play in Townsend's practice,
the very possibility of architecture from the New World — which,
at that date, was still considered by most to be wholly dependent
on European innovation — having an impact on progressive
architecture in the Old World is highly significant. In this respect
Bishopsgate and the Whitechapel Gallery are prescient of the flow
of cultural innovation from America, which asserted itself more
vigorously in Britain with the rise of cinema from the 1920s onwards.

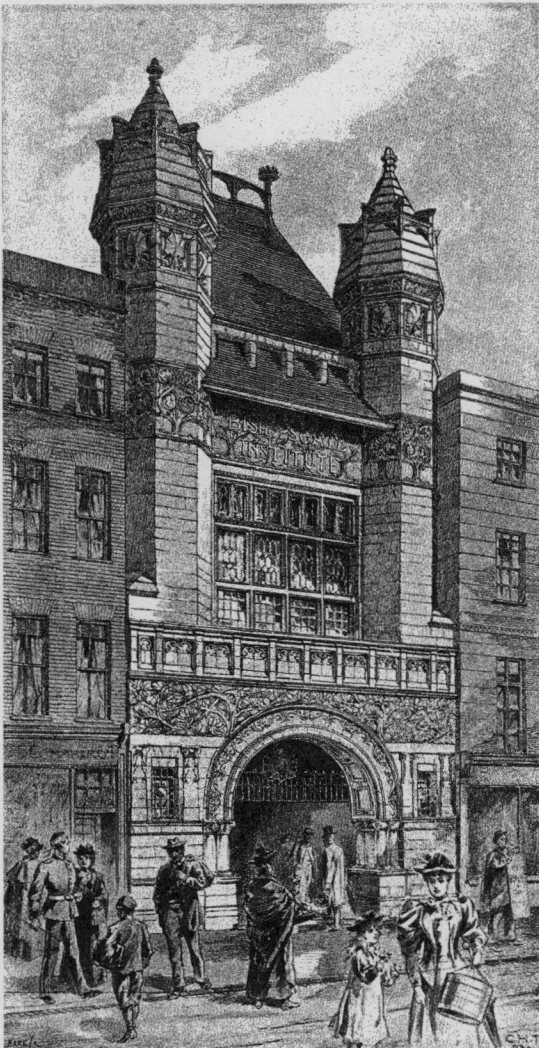

Charles Harrison Townsend, design for Bishopsgate Institute,
Bishopsgate Institute Opening Pamphlet, 1895
Bishopsgate Library

H.H. Richardson, Thomas Crane Memorial Library,
Quincy Massachusetts, 1882, the designs for which were
illustrated in Horace Townsend, 'H.H. Richardson Architect,
The Magazine of Art, 1894

H.H. Richardson, 'Lululand', Bushey, Hertfordshire, 1894
RIBA Library Photographs Collection

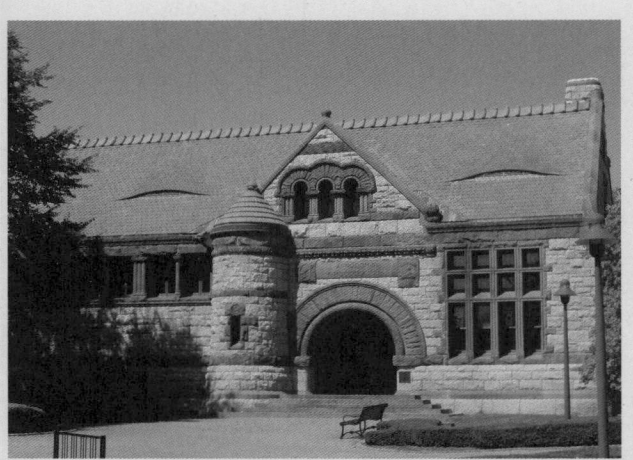

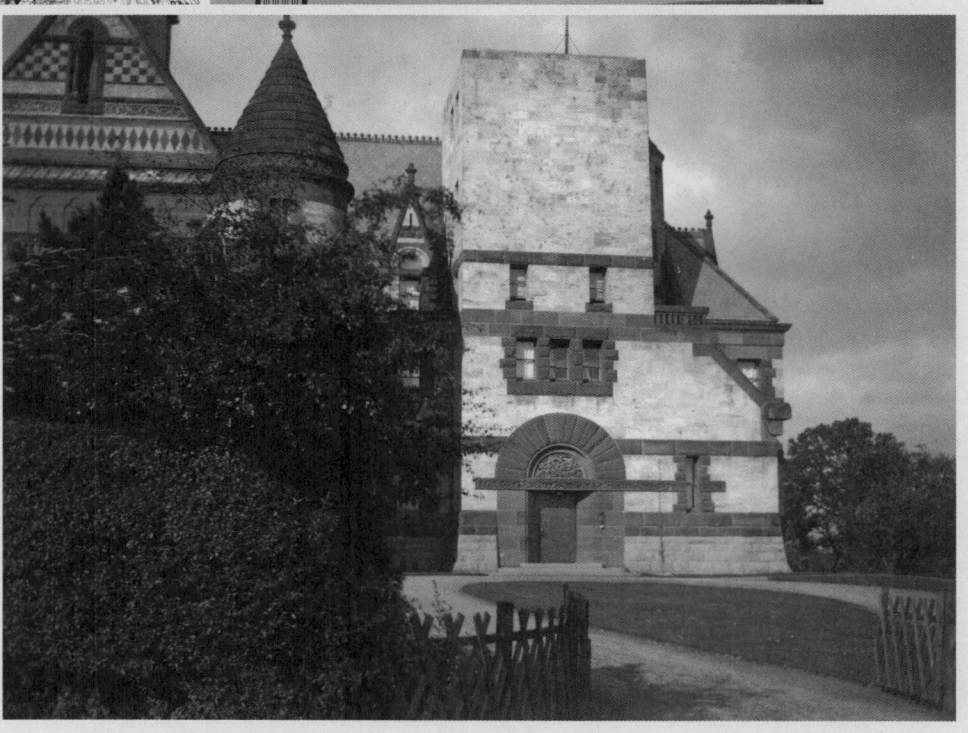

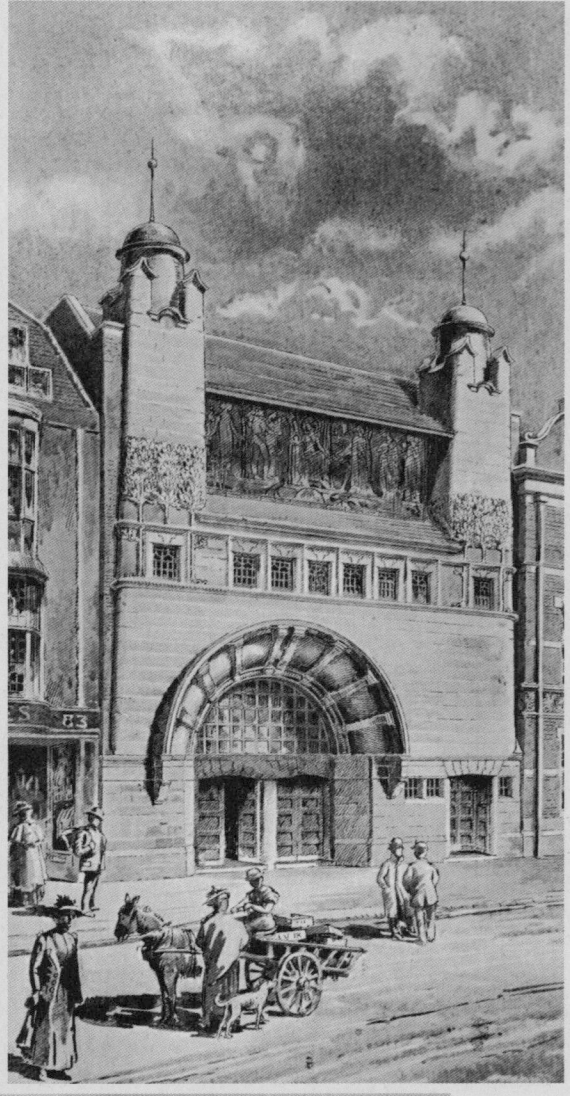

Charles Harrison Townsend, revised design
for the Whitechapel Gallery, *The Studio*, 1899
RIBA Library Photographs Collection

Charles Harrison Townsend, watercolour sketch,
San Ambrogio, Milan, 1886
V&A Images / Victoria and Albert Museum, London

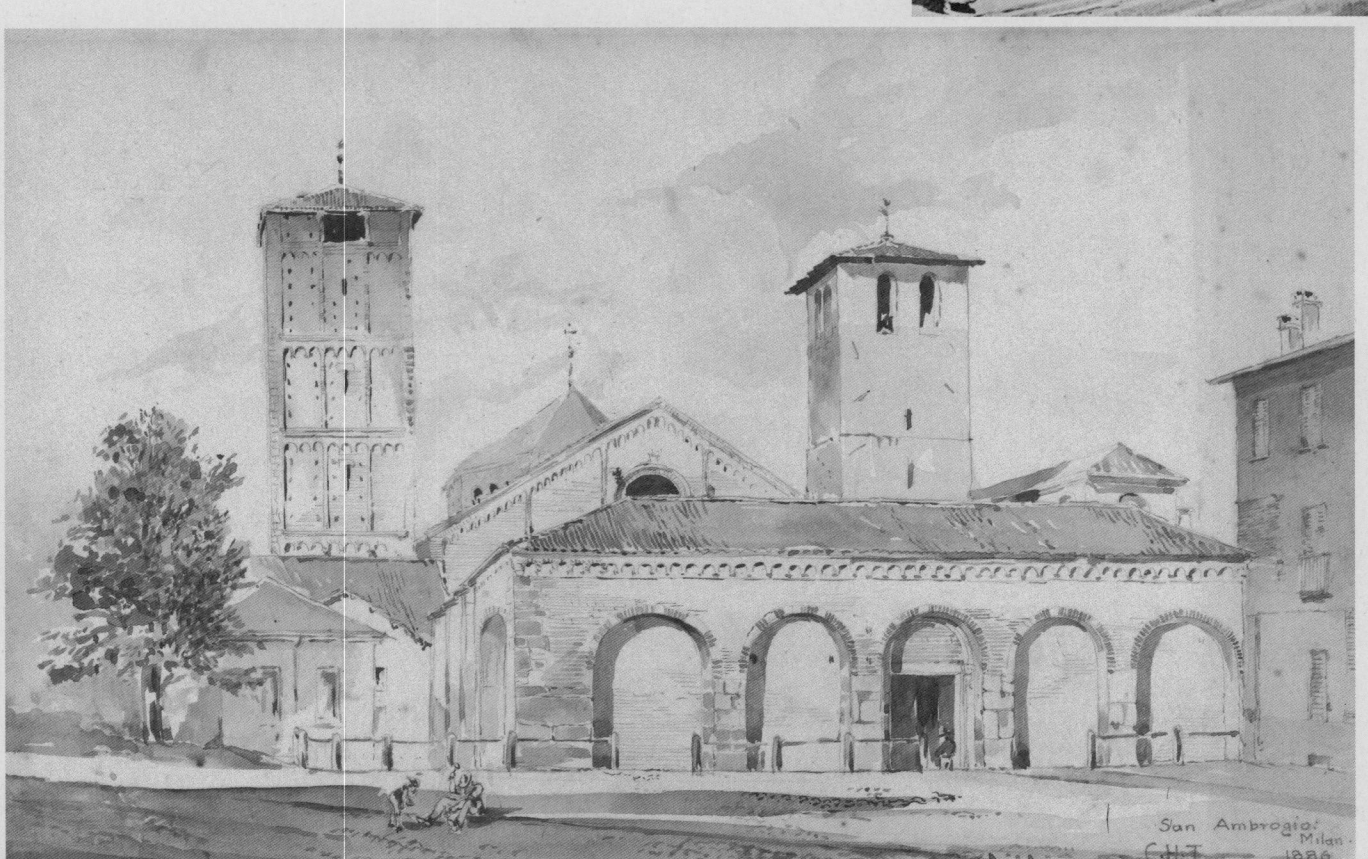

Townsend's initial design for the façade of the proposed Whitechapel Gallery, which he showed at the Royal Academy in 1896, was much more decorative than the executed building. The distinctive arched doorway was present, but its setting in the first design — surrounded by rusticated brickwork and below a balustrade, a row of arched windows and a classically-inspired decorative frieze designed by Walter Crane — suggests an Italianate heritage which is much less obvious in the context of the austere façade that was eventually realized.

The Italianate nature of the first design, and therefore of elements such as the arch, which were actually executed, is a clear reflection of Townsend's love of Italy. The architect made at least three significant visits to Italy during this period, his first recorded being in 1886, which included visits to Venice and Verona.[7] This was followed by trips that Townsend organized and led for members of the Art Workers' Guild in 1891 and 1896.[8] Surviving sketches in the Victoria and Albert Museum demonstrate Townsend's interest both in Renaissance architecture (for example his watercolour sketch of San Ambrogio in Milan) as well as in rustic architectural quirks and curiosities.[9] Letters home to Townsend's mother and sister also reveal hints of his enthusiasm for Italy above all else. In October 1891, journeying back from Italy, he wrote from Heidelberg, 'After Italy, Germany is not in it. Even the Schloss here is [like] food given to an already jaded palette, as regards its Renaissance architecture.'[10]

Walter Crane's proposed frieze, which was never executed, together with Robert Anning Bell's frieze at Horniman, which survives today, reveal another of Townsend's great interests: the art of mosaics. Townsend first published on the subject in 1887. He delivered a number of public lectures, including one entitled 'The Art of Pictorial Mosaic' which was given at the Royal Institute of British Architects four days before the opening of the Whitechapel Gallery in March 1901.[11] In this lecture Townsend outlined the history of early Christian mosaics before illustrating the Horniman mosaic frieze and the unrealized Whitechapel Gallery designs. Walter Crane was in attendance and was clearly not too downhearted at the failure of his design for the Gallery to be executed. Following the lecture he offered a vote of thanks in which he 'heartily echoed the wish which Mr Townsend expressed that more decoration might appear in London ... that the glorious vision might one day be realized and London decorated with mural designs and colour'.[12]

Townsend's next design, published in 1899, was much closer to the more austere building that was eventually executed. Nevertheless it still retained a frieze by Crane (though in the second design this was less formal) and the towers still had domed turrets (though these were less fantastical than in the initial proposal). The second design also possessed the distinctive asymmetry that was executed and which contributes to the perception of a clear modern intent in the design.

It is not known whether the gradual shift towards austerity was a result of artistic choice or client-driven cost control — or in today's terminology 'value engineering'. Whatever the reason for this shift, the result was to bring the façade closer to design developments in Vienna and Glasgow, the two cities where architecture in the Art Nouveau era found its most geometric expression. There is no evidence that Townsend was particularly interested in either Mackintosh in Glasgow or Josef Hoffmann (1870–1956) in Vienna — unlike his documented interest in Italy and almost certain exposure to Richardson — though he would have certainly been aware of developments through magazines such as *The Studio*.

Perhaps more interesting is to consider the possible influence Townsend's buildings may have had abroad. All three of his major buildings were published extensively at the time. Townsend's design for the Bishopsgate Institute appeared in 1895 in *The Architect* and *The Studio* — a highly influential publication which was read across Europe — as well as in Hermann Muthesius' book *Die englische baukunst der gegenwart*, published in 1900.[13] The first design for the Whitechapel Gallery was published in *The Studio* in 1897 and the second design in 1899 (an interesting example of the evolution of a design appearing in public). The second design also appeared in Muthesius' book.

Walter Crane, design for a mosaic frieze for
the new Whitechapel Gallery, *The Studio*, 1899
RIBA Library Photographs Collection

Townsend's designs were illustrated and praised across Europe. An element of his original design for the Whitechapel Gallery was featured in an early issue of the important avant-garde German symbolist magazine *Pan* in 1896,[14] while an article in Russia's most prestigious architectural journal *Zodchii,* published in 1902, illustrated Townsend's drawings of the Gallery and the Horniman. The author praised both their design and their purpose of bringing art to the public and lamented the lack of such a civic approach to art in Russia,[15] clearly demonstrating the perception of the link between the New Style and social change.

The appearance of the Horniman design in Russia is particularly significant. The Horniman is a considerably more monumental and stylistically flamboyant building than the Whitechapel Gallery. The rounded clock tower topped with domed turrets and the curvaceous, classically inspired main façade display Townsend's irreverent and imaginative approach to architecture, qualities which were shared by the architects of the New Style in Russia, which blossomed in the years between 1900 and 1910. The fact that Townsend's work was praised in the same context as other leading European proponents of Art Nouveau suggests that his work was among the cocktail of foreign and traditional influences that characterized the romantic and nationalist flavour of Russian Art Nouveau. The leading Russian architect Fyodor Shekhtel (1859–1926) would certainly have seen Townsend's designs in *Zodchii* and when placed alongside his design for Yaroslavsky Rail Terminal, Moscow (1902–04) there is a discernible continuity of influence and approach.

In Prague, Czech Art Nouveau after 1900 was strongly influenced by the designer Jan Kotěra (1871–1923), a Professor at the School of Applied Arts. Kotěra greatly admired the work of Townsend,[16] and one of the most important examples of Czech Art Nouveau, Prague's central railway station by Josef Fanta (1856–1954), completed in 1909, also owes a debt to Townsend, particularly his first design for the Whitechapel Gallery.

These kinds of visual similarities, coupled with the fact that Townsend's designs — which were more decorative than his executed buildings — were published across Europe in the late 1890s, just as the New Style was being adapted and adopted in central and eastern Europe, suggests that Townsend's work did exert influence in the architectural development of centres such as Moscow and Prague.

Townsend's work, in particular his design for the Whitechapel Gallery, also reveal two often overlooked aspects of Art Nouveau architecture: its relationship to technology and social reform. The style is often perceived as laden with luxury and decadence, due to the fact it was adopted by a number of elite patrons and collectors and their architects. However projects such as the Whitechapel Gallery reveal Art Nouveau's radical alter ego. The reforming agenda of the Gallery's founders — to bring great art to the people of east London — was reflected in a number of design features.

Townsend eschewed the traditional model of the museum or gallery as a temple. There are no steps leading up to a portico entrance. Instead the entrance is on street level — the visitor walks directly from the busy street straight into the gallery with no physical impediment or intimidating architectural conceit. Inside, Townsend put technology to use in the form of iron roof trusses to create the magnificent upper gallery space. More significantly, the Whitechapel Gallery was the first to use electric light in its exhibition spaces, another innovation which was used to further its inclusive agenda. Electric light meant that working people could visit outside of working hours. As a result the Whitechapel Gallery was never the sole preserve of the leisured classes. Its first exhibition attracted an astounding 206,000 in just six weeks.

Fyodor Schechtel, sketch for Yaroslavsky
Rail Terminal, *Ezhegodnik Obshchestva*, 1902

Horniman Museum, London, showing
the original 1901 Harrison Townsend façade
© Horniman Museum

Hlavni Nadrazi, Prague Central Station,
designed by Josef Fanta, 1901–1909

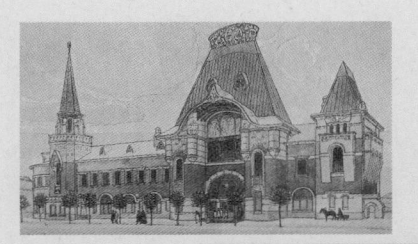

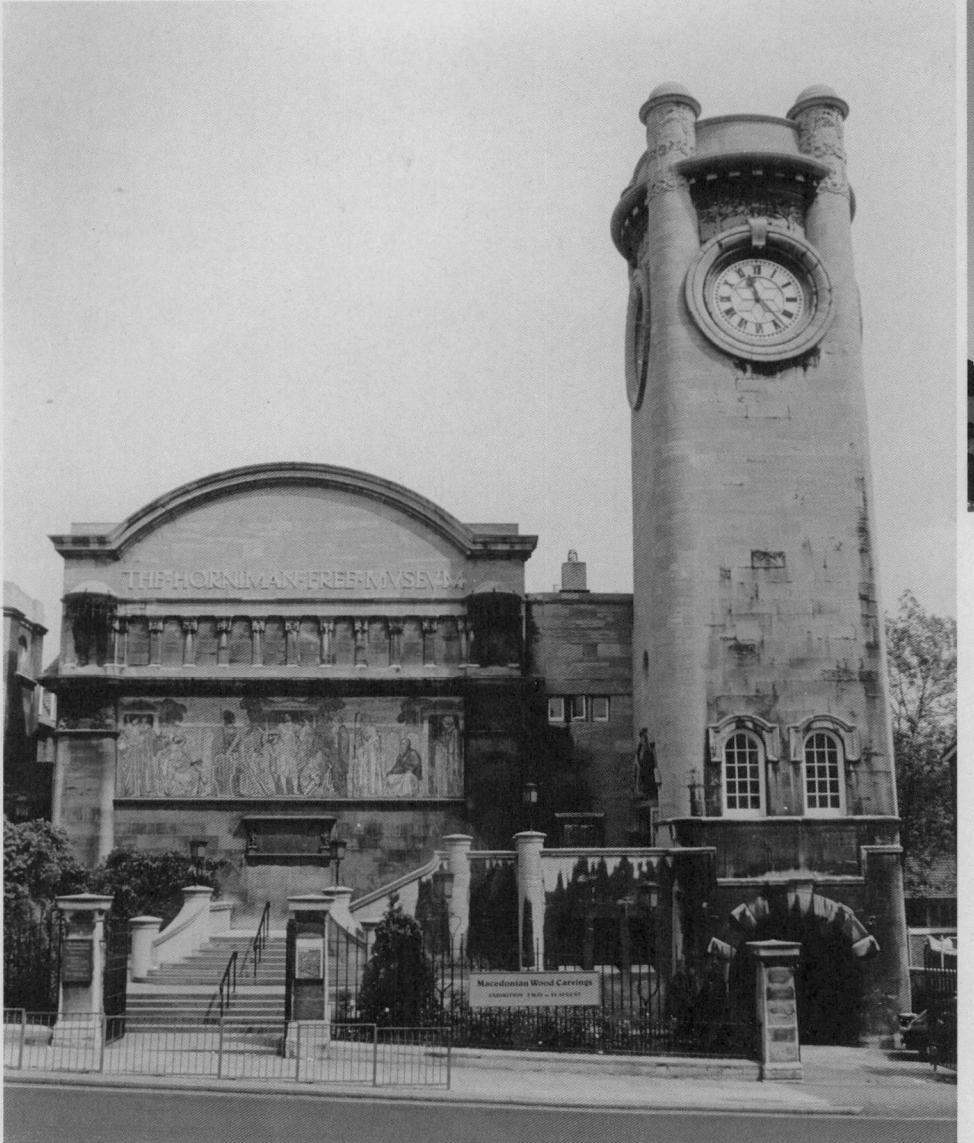

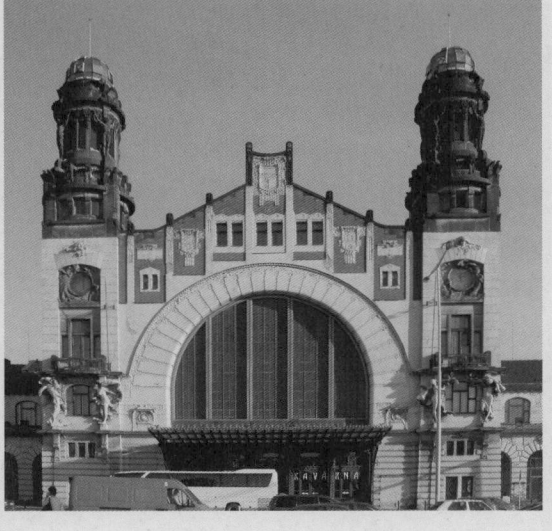

FRIEZE

DADO

Charles Harrison Townsend,
wallpaper design for 'Cliff Towers'
drawing room, *The Studio*, 1898
RIBA Library Photographs Collection

Charles Harrison Townsend,
'Cliff Towers', *The Studio*, 1898
RIBA Library Photographs Collection

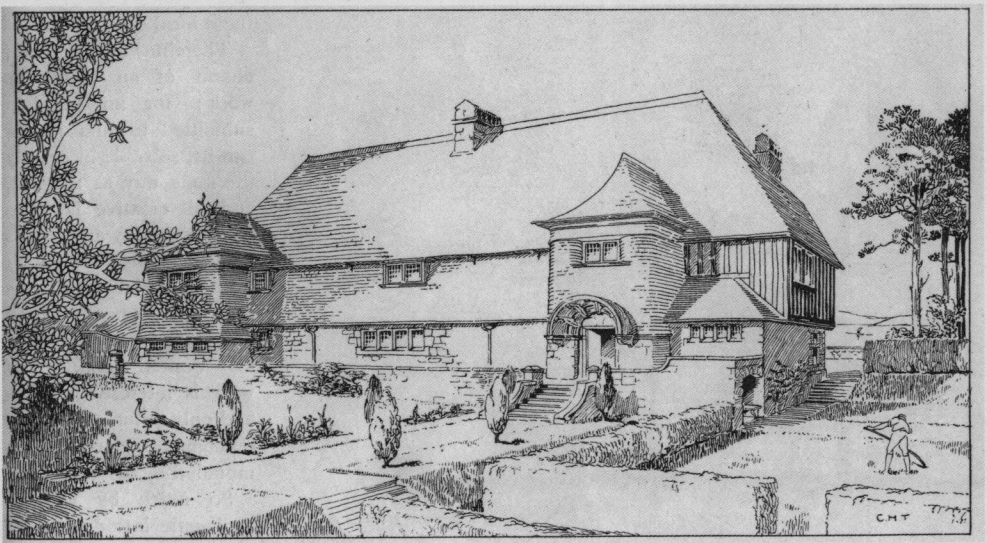

Technology can even be detected in the most decorative elements of the Whitechapel Gallery façade. The stylized foliate pattern to the façade is moulded terracotta, rather than carved work, suggesting Townsend was interested in experimenting with a reproducible technique rather than relying on traditional craftsmanship. The design of this element can even be traced back to another reproducible medium — wallpaper. It bears a very strong resemblance to a wallpaper design by Townsend for a domestic commission in Cornwall, published in *The Studio* in 1898.[17]

So the Whitechapel Gallery is part of a distinct tradition of European public building that combined technology with a modern aesthetic. Victor Horta's (1861–1947) 'Masion de Peuple' in Brussels (1892, now demolished) was a high Art Nouveau example of this, but one could also include nineteenth-century building forms such as glasshouses and railway stations in this lineage; it is notable that some of the European buildings that share most aesthetically with the Whitechapel Gallery are railway stations.

Having said this, there should be no suggestion that Townsend was a proto-modernist, dogmatic proponent of mass-produced architecture. His design for the wallpaper that informed the Whitechapel Gallery façade was for a house called 'Cliff Towers' at Polperro in Cornwall. This project was begun around the same time Townsend was working on the Gallery commission, and was envisaged as an 'imaginary project', for which Townsend conjured up an ideal client for whom no 'sordid questions of cost arise'. After his famous trio of public buildings, the rest of Townsend's career was played out largely fulfilling small domestic commissions, and perhaps Townsend's lament about 'sordid questions of cost' offers an insight into the true reason why the Whitechapel Gallery's façade was more austere in its execution than either of the architect's published designs.

The question as to why Townsend designed little else of architectural significance after the Whitechapel Gallery and the Horniman Museum is often asked. However, this state of affairs is hardly a surprise. Most of the architects of the great celebrated buildings of the decade 1894–1904 designed their masterworks in this period, subsequently producing comparatively less interesting work. The list of architects in this category is impressive: Charles Rennie Mackintosh, Victor Horta, Henry van de Velde (1863–1957) and Hector Guimard (1867–1942) to name but the most renowned. A combination of changing fashion, conservative clients, the First World War and a radical new generation of post-war architects, all contributed to this phenomenon. In fact it is perhaps more surprising that someone of Townsend's generation contributed three buildings of such contemporary vibrancy during the 189os. Townsend was forty-nine in 19oo and so was between ten and twenty years older than most of his stylistic contemporaries: in the same year Mackintosh was thirty-two, Hoffmann, thirty, Guimard, thirty-three, Van de Velde, thirty-seven, and Horta — a relative veteran — was thirty-nine. In Helsinki, Eliel Saarinen (1873–195o), who made his name at the Paris 'Exposition Universelle' in 19oo, was just twenty-seven. In this respect Townsend was unusual as a middle-aged progressive architect.

In 1925, three years before his death in 1928, Townsend took an inventory of his house in Middlesex. Hanging in the hallway and stairwell were Walter Crane's sketch for the proposed but unexecuted Whitechapel Gallery frieze, and Townsend's own watercolour, gouache and pastel drawing of the Gallery. Of the latter Townsend writes matter-of-factly, 'It has been very frequently reproduced in England and abroad'. The inventory with only these two hints of his previous glories makes for rather melancholy reading.

But while his architectural career may never have reached such heights after 19oo, Townsend occupied himself agreeably by continuing to lead visits by members of the Art Workers Guild to the continent. His obituary in the *Times* described 'a man much appreciated by his friends to whom his wide knowledge and a certain whimsical quippish humour, always accompanied by a touch of old-fashioned courtesy, endeared him'.[18] After 19oo the Low Countries became the focus of a number of his trips. In 19o4 he led an expedition to Holland, followed by Bruges in 19o9, Antwerp in 191o and Ghent in 1913. It is perhaps fitting that more than a century after the opening of the Whitechapel Gallery, a Flemish architectural team in Robbrecht en Daem Architecten has enlarged Townsend's most celebrated building.

notes

1. *Architectural Association Notes*, London, 1902, vol. XVIII, no. 181, 33–39
2. Leonard K. Eaton, *American Architecture Comes of Age: European Reaction to H.H. Richardson and Louis Sullivan*, MIT Press, Cambridge, Mass., 1972, 24
3. ibid., 19
4. Horace Townsend, 'H.H. Richardson Architect', *The Magazine of Art*, 1894, 136
5. ibid., 137
6. Leonard K. Eaton, 22
7. Peter Wentworth-Shields, *Charles Harrison Townsend (1851–1928)*, Unpublished Thesis,1963, p. 4, Archive of Art and Design, Victoria and Albert Museum, London.
8. ibid., 31–32
9. Archive of Art and Design, Victoria and Albert Museum, London, AAD/ 2003/14/4
10. Archive of Art and Design, AAD/2003/14/1
11. RIBA Journal 3.S.viii, 1901
12. Peter Wentworth-Shields, 23–24
13. ibid., 18
14. Nikolaus Pevsner, *Pioneers of Modern Design: From William Morris to Walter Gropius*, Penguin Books, London, 1991, 108
15. William Craft Brumfield, *The Origins of Modernism in Russian Architecture*, University of California, Berkeley, 1991, 51
16. Milena Lamarova, 'The New Art in Prague', in Paul Greenhalgh (ed.), *Art Nouveau 1890–1914*, V&A Publications, London, 2000, 369
17. Peter Wentworth-Shields, plate 17
18. Quoted in Peter Wentworth-Shields, 28

'Whitechapel Free Public Library and Museum', 1892
Tower Hamlets Local History Library and Archives

The Collective Imagination of the City: The Whitechapel Gallery in the Past and Future East End

WILLIAM MANN

WITHERFORD WATSON MANN ARCHITECTS

Since its foundation, the Whitechapel Gallery has had a charged relationship with the surrounding streets. Its ground-floor gallery is one of London's most memorable art spaces: because of its grand scale and proportions, and soft, even light; but also because of its incomparably direct connection to one of East London's most distinctive streets, the Whitechapel High Street, at the heart of the traditional immigrant quarter.

This resonance between Gallery and city is both intentional and unavoidable: it shaped the location and original design of the Gallery building, and has informed the content and layout of its exhibitions. But it is a complex relationship, filtered through conventions of representation and the shared or divided values of the community of visitors. The price of admission to view Picasso's *Guernica* in 1939 is emblematic of this symbolic exchange between street and Gallery: a pair of boots, fit for the front.

The Gallery's extension into the former Library next door, the work of the recent transformation, changes and complicates this relation to the city, as does the expansion of the financial district to the doors of the Gallery. As one of the architects of the project, I have reflected over the last five years on the bond between the building and its hinterland, and how this influences the visitor's experience. My essay, though concerned with the physical fabric of architecture and the city, is not about inert matter: it is about the collective imagination of the city.

Until the last decade of the nineteenth century, numbers 77 to 82 Whitechapel High Street were one-room wide terrace houses, typical of London's ancient structure. This repetitive rhythm underlies the City and the highways that radiate from its gates, stretching and quickening along the Whitechapel High Street. A series of alleys prise open slender gaps, branching out or narrowing down unpredictably, feeding a network of courts, closes and yards. These rhythms are played out against the easing and meandering of the high street, the Roman road to the east imperfectly and expediently retraced by medieval hands.

As is typical for a city edge, the area attracted foreigners. Wave after wave of migrants arrived — dissenters from Flanders and the Netherlands, Jews, the Huguenots, the Irish fleeing famine, democrats from Germany's failed revolution.[1] In Bernard Kops' topical phrase, 'This East End … is like an Olympic torch, handed from one community to the next'.[2] The area resounded with distant struggles, intertwining the local and international.

The surrounding city was rebuilt to accommodate London's prodigious economic growth in the nineteenth century: docks were carved out of the marshy ground to the south and east to transfer goods from across the world, the City to the west transformed itself into a financial centre to broker, insure and fund these transactions, and Commercial Road was cut between the two. But on the Whitechapel High Street and Brick Lane, real estate was static and the building stock deteriorating; labour was mobile, the population becoming more marginal. An influx of Jews from Eastern Europe and Russia in the 1880s filled the tightly-packed houses around Whitechapel. The impoverished conditions led to a burst of philanthropic and municipal concern. Charles Booth's 'Map Descriptive of London Poverty', completed in 1889, marks out these inner-edge slums in black, a clear rejoinder to action.

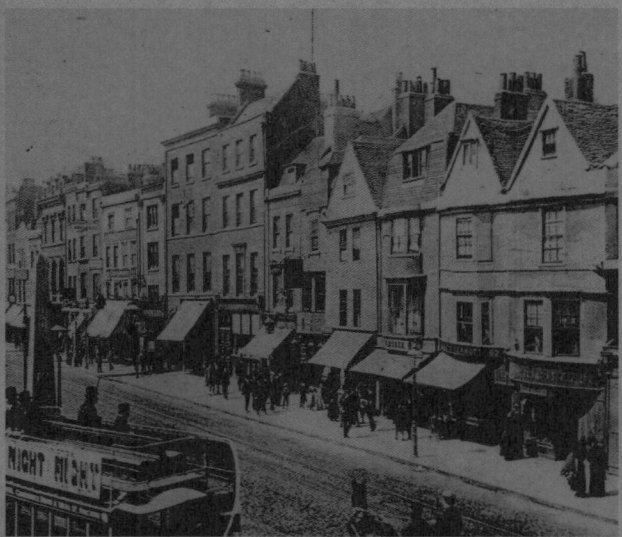

Guernica came to the Whitechapel Gallery in January 1939,
Clement Attlee, MP for Limehouse and leader of
the Labour Party gave the opening address.
Whitechapel Gallery Archive

80–82 Whitechapel High Street, 1890

Charles Booth, Map Descriptive of London Poverty, 1889

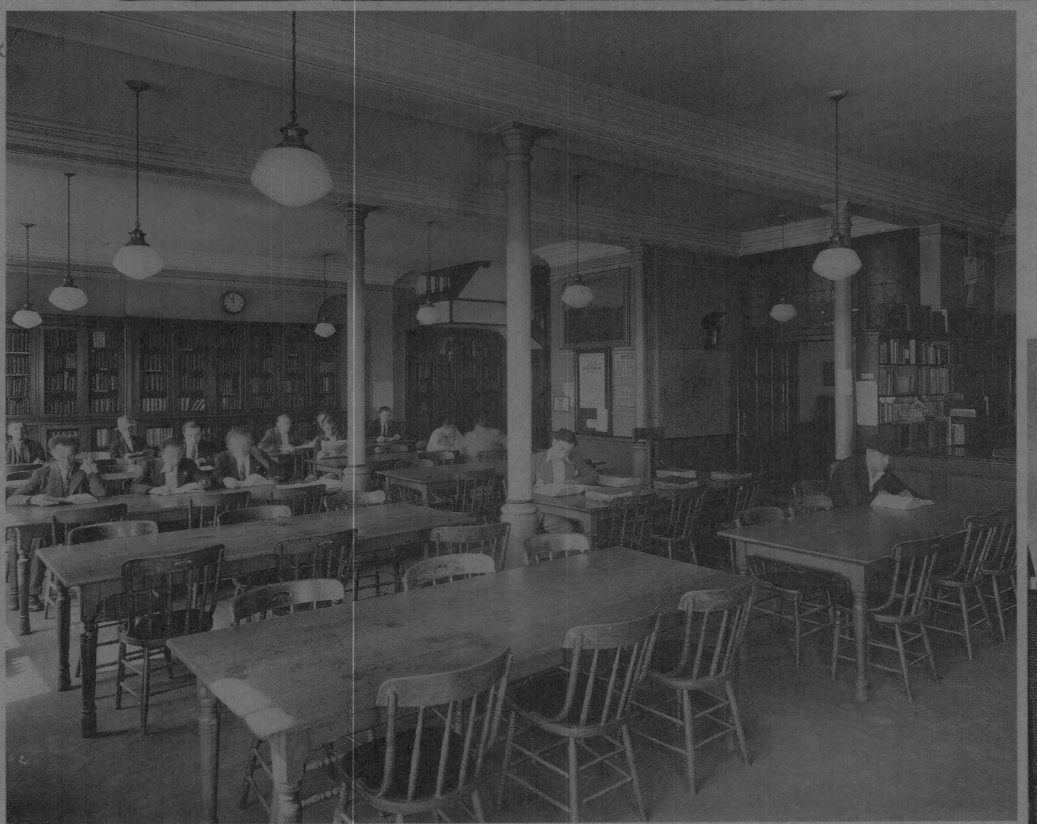

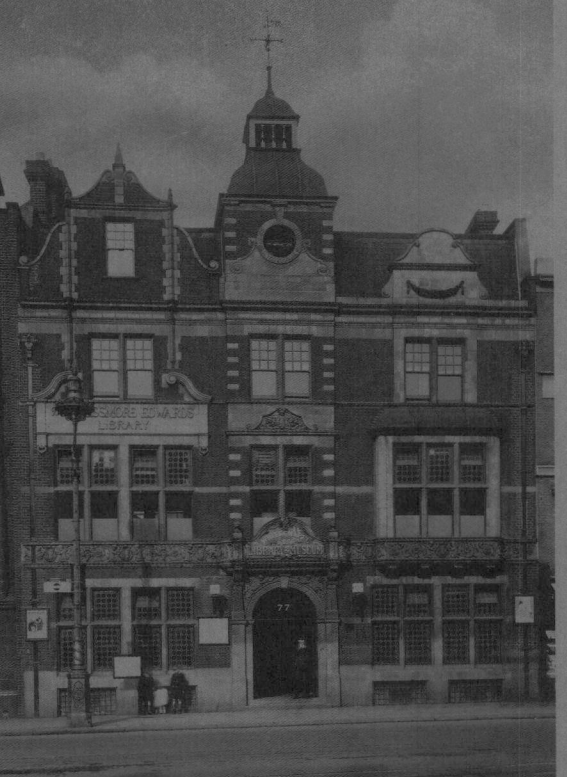

Whitechapel Library Lending Department, 1937
Tower Hamlets Local History Library and Archives

Whitechapel Library Reading Room, 1937
Tower Hamlets Local History Library and Archives

Whitechapel Library, 1929
Tower Hamlets Local History Library and Archives

Fired by Christian Socialism, a local minister and his wife used their considerable skills to initiate a series of projects in the area. Samuel and Henrietta Barnett campaigned for the clearance of the Flower and Dean 'rookery' just to the north of the current Gallery, to create new tenement housing (1875).[3] They took a lead in the foundation of Toynbee Hall, a settlement for university men to carry out educational and social work in the East End, off the newly-formed Commercial Street (1885). They led fundraising efforts for the Whitechapel Library (1892) and Whitechapel Art Gallery (1901).[4] The Barnetts' work amounted to a social project of remarkable breadth and scale, covering housing, education and art. The architectural idioms of these projects are illustrative of their 'Practicable Socialism' — with echoes of Philip Webb at Toynbee Hall, William Morris at the Gallery, and a playful reworking of the large-windowed brick Board Schools at the Library. In short, Library and Gallery were carved out of similar sites, and shared the same parentage and lofty ambitions.

The Library was both civic and domestic in feel. The substantial reading room at the rear of the ground floor was the grandest space, with its high, coffered plaster ceiling; yet it also had five open hearths to offer a certain homely comfort. Situated on the first floor were the expansively glazed reference library and the top-lit museum space. The Library facade was replete with picturesque detail, as if in compensation for the three gabled houses it had replaced, while the large windows asserted its public status.

The Gallery was a brutally direct assembly of the ceremonial and the industrial, a first breath of modern spirit. Charles Harrison Townsend's design for the street façade was that of a thinly disguised church, with its twin towers and heavy round-arched entrance; the transcultural details — friezes of laurel leaves and heavy curved turrets — dispelled or at least diluted this association. Behind the street front, there was little to it, but the building was bold, hard, generous: a large blank hall at the level of the pavement and only a few steps from it, with two slashes of glazing on either side of the ceiling. Above, served by brick and stone stairs in opposite corners, was the upper gallery, curiously narrow and long.

Both buildings adapted idealized room forms to awkward sites, and were altered over time to accommodate changes in patterns of use, making each in some sense incomplete. The Library was symmetrical, with a central corridor proceeding from the front door to the large reading room. A light-court on its eastern flank cut a corner out of this room, while the original lending library on the street front was appropriated in the 1930s to form a stair down to the District Line. The Gallery, in its translation from a drawing exhibited at the Royal Academy to construction on Whitechapel High Street, was left incomplete as well as dramatically lopsided. Domes and mosaic panel were omitted, and the arch was squeezed into a narrower facade, its curved embrasure undercutting the left turret. The Gallery widened to the rear (backyard sites were cheaper than street frontage), imbalance turning into poise as the vaulted hallway fed into the nave of the broad lower gallery.

The importance of the Library in the life of the area cannot be overstated. Generations of readers recalled its spaciousness with awe:

> What I remember is a rather — to me — very grand staircase, with a sort of iron balustrade curving upwards, as it might be a mansion that you'd see in the films …[5]

For residents of the wider area the Library offered an abundant, living educational resource, earning it the unofficial title of 'University of the Ghetto':

> Straw [from the hay market] used to float up to the door of the Library … And yet as soon as you got through the doorway it was all peace and quiet … And you knew you were somewhere which was different, and this is what they were dishing out and you could get it free.[6]

Bernard Kops is even more direct: 'I emerged out of childhood with nowhere to hide/ when a door called my name/ and pulled me inside'.[7] The Library developed an unrivalled collection of Yiddish books, and a number of clubs, including the famous Whitechapel Arts Group.[8]

The Gallery's early exhibitions were mostly didactic, a mix of the utilitarian, orientalist and canonical. With the notable exception of Picasso's *Guernica*, few pre-war exhibits took command of the gallery space. Early installations appear crowded, with panelling on the walls and works hung close together. The 1911 *Trade Schools* exhibition, with worthily utilitarian goods on display in the tall, light gallery, has the feel of a World Fair. As the finance and energy of the initial years waned, exhibitions by the 1930s tended towards the local, in the form of various art clubs, with occasional private collections.

Having been little touched by renewal in the nineteenth century, Whitechapel was, along with most of East London, down for comprehensive redevelopment in the 1943 County of London Plan.

> St Mary's [Whitechapel] was one of Abercrombie's special study areas. He recognized it needed immediate attention. The County Plan had exact diagrams showing the new ten-storey blocks, the simplified road layout, the annihilation of 'non-conforming' industries … No brick would remain standing.[9]

Reconstruction swept from Bethnal Green to Canning Town, reflected in the Whitechapel Gallery's 1952 exhibition *Setting up Home with Bill and Betty* — but failed to materialize in the streets of Whitechapel. The area was changing and, once again, people were on the move.

The slow decline of the area coincided with a period of intense vitality at the Gallery. While the annual *East End Academy* featuring the work of local artists was dropped from the calendar, a succession of monographic shows championed painters such as Nicolas De Staël, Sidney Nolan, Jackson Pollock, Mark Rothko and Robert Rauschenberg. The scale and chromatism of their paintings achieved an unrivalled fit with the Gallery space — even the crazed granolithic concrete floor provided a textural counterpoint to the harmonies and conflicts of these works. If Abstract Expressionism brought out the cathedral in the Gallery, Pop brought out its proximity to the street: the seminal 1956 exhibition *This is Tomorrow* was divided on the principle of a series of market stalls,[10] while the work of Rauschenberg, shown in 1964, was read as displaying characteristics and tonalities 'more like those of the Whitechapel High Street than like any kind of picture, abstract or naturalistic'.[11]

Like an aftershock of renewal, the 'simplified road layout' of Abercrombie's wartime County of London Plan was implemented in a highly convoluted form in the 1970s. A series of one-way loops destroyed much of the southern side of the Whitechapel High Street to form an environment that was disorienting for both motorist and pedestrian. The 'planning blight' of these changes accelerated the change of population, the Jewish presence growing ever weaker, replaced by Bangladeshis following historic ties, and fleeing civil war with the then-West Pakistan.

While these physical and social changes were not the direct cause of the Gallery's crisis of the mid-1970s, they must at least have exacerbated it. The Whitechapel Gallery was now physically cut off from the City, long a source of funding, while its ties with the locality had been weakened during the adventurous exhibition programme of preceding decades. The politics, as always, were complex, with the Board of Trustees debating 'whether to be parochial or international'.[12] One board member was unequivocal:

> The Gallery has generously done its bit towards helping the work of the Avant-Garde to be seen; and can with honour turn its efforts towards homelier forms of helping the public whom we exist to serve.[13]

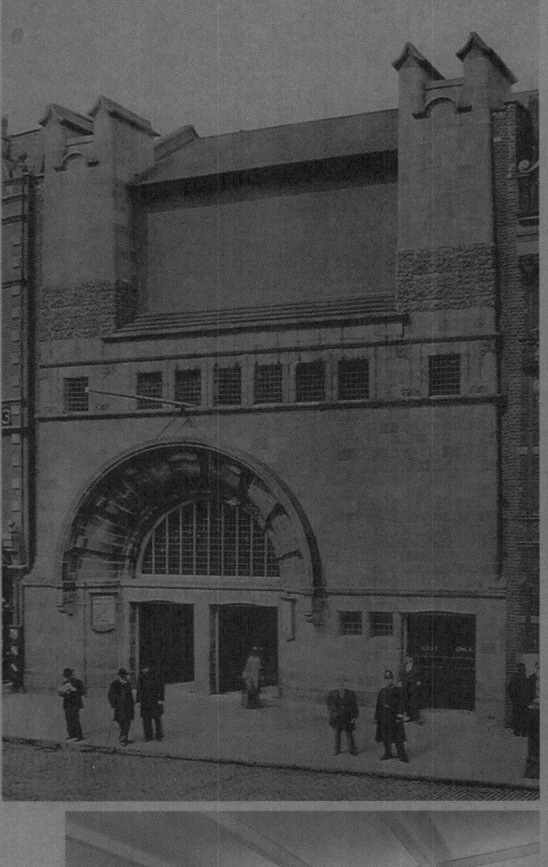

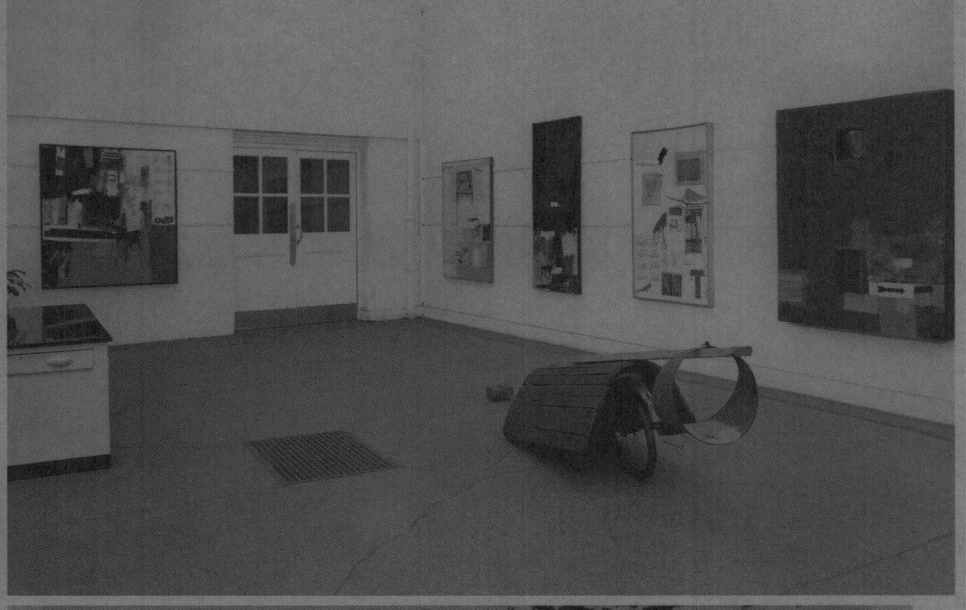

Whitechapel Gallery, 1910
Whitechapel Gallery Archive

Robert Rauschenberg,
installation view, 1964
Whitechapel Gallery Archive

Mark Rothko, installation view, 1961
Whitechapel Gallery Archive

This is Tomorrow, exhibition poster,
1956, design by Richard Hamilton
Whitechapel Gallery Archive

Whitechapel Project — competition
concept diagrams by Robbrecht en
Daem Architecten/ Witherford Watson
Mann Architects:

Existing galleries
before refurbishment

 Existing circulation
 before refurbishment

Proposed circulation:
a single lift and stair core
serving all galleries

 Proposed circulation:
 a circuit linking the galleries

Whitechapel Gallery and Library,
combined plans as originally built

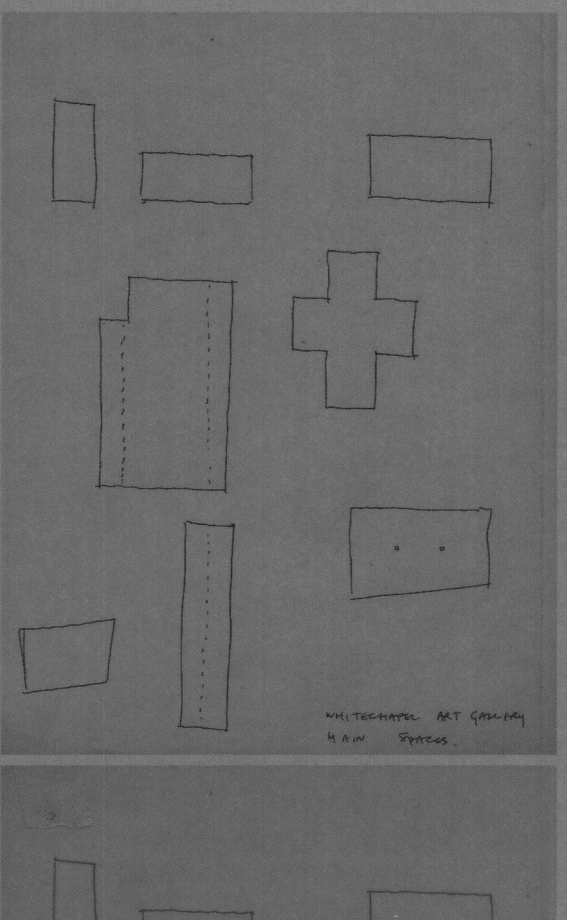

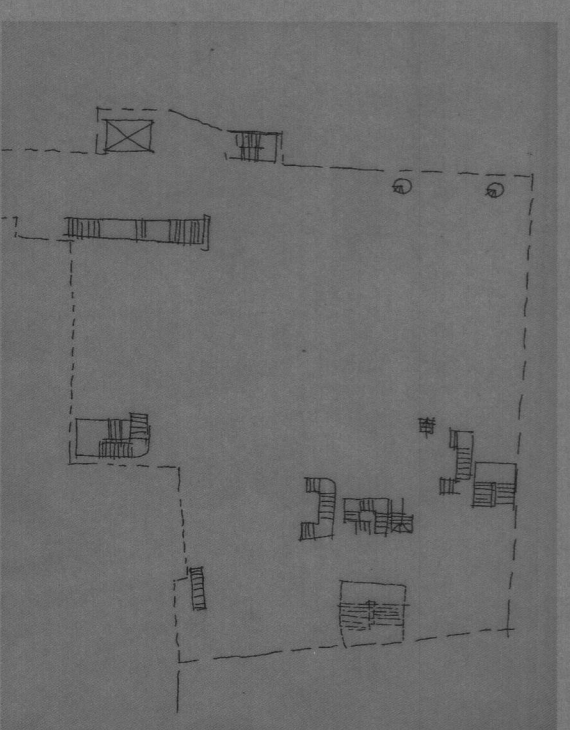

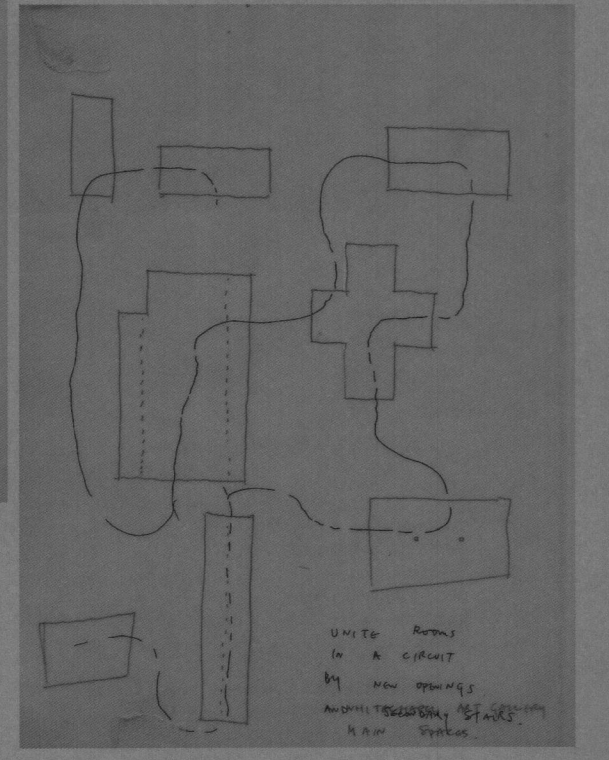

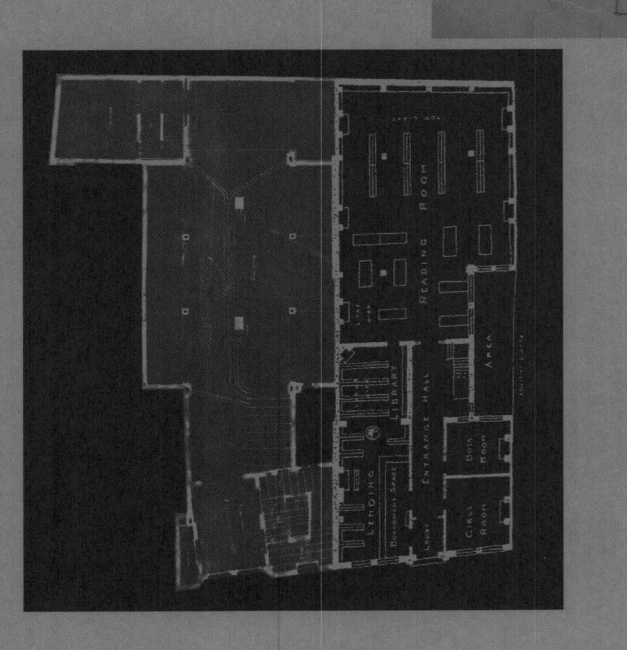

Operating on the border of City and East End had become a precarious balancing act, but the 1985 refurbishment and extension carried out by Colquhoun + Miller provided the tools to carry out a more varied programme. Partly funded by 'planning gain' contributions, the narrow alley site of the old Ragged School was used to provide a lecture theatre, café, education room and offices, with a bookshop installed at the street front. These new spaces catered for both corporate sponsors and local schools, and offered the wider range of facilities expected by visitors. The old staircases were demolished and replaced by a grand sweep of steps up to the first-floor gallery and a spiral exit stair, forming a new foyer in the process. The new rooms and circulation increased the Gallery's ceremonial formality, tempering this with moments of intimacy and picturesque detail.

The Gallery and Library had at their construction been part of a cluster of civic and commercial buildings, but were progressively isolated. St. Mary's — a red-brick Victorian church built on the site of the original 'White Chapel' — was destroyed in the Second World War; its churchyard is now the Altab Ali Park. Gardiners' department store, at the apex of Commercial Road and Whitechapel High Street, was demolished as part of the highways scheme. With these disappearances, and the construction of a large supermarket on the corner of Cambridge Heath Road, Whitechapel's centre of gravity seemed to shift eastwards. Although the Library remained well-used until the end, the move to the Idea Store along Whitechapel Road follows an inexorable logic. Brick Lane and Whitechapel High Street are no longer local centres, and the Library has followed the shops. The name and architectural language of the Idea Store are a 'Third Way' hybrid of public sector values and commercial realism.

The departure of the Library created an opportunity for the Whitechapel Gallery to renew and broaden its founding ambitions, and to alter its relation to the changed surroundings. The brief for the new space was complementary to the existing gallery, not simply more of the same: a gallery for site-specific works; a gallery for loaned collections; space to view and consult the remarkable archive; and substantially larger education facilities — now a prerequisite for arts institutions, but part of the Whitechapel Gallery's programme from the start.

In formulating our design approach for the recently completed transformation, we considered Gallery and Library as a single building, supported by the buildings' common origin as well as the logic of future use. We took clear positions on what most clearly did and did not work — or what to retain and what to change. We largely left the main rooms alone, and transformed the circulation.

By the simple act of joining the two buildings, the Gallery now has five major exhibition spaces, as well as several highly visible secondary spaces. It is not just the number of galleries, or their contrasting uses, it is the complementary spatial character of these rooms that gives the new Whitechapel Gallery a surprising richness. The scale now ranges from the intimate galleries on the first floor, to the grand scale of the original ground-floor gallery, with several steps and modulations in between: Gallery 2 on the ground floor and Gallery 7 on the first floor echo their neighbours in their details (tall square piers supporting a lattice of beams, arched purlin brackets and bow trusses). With their squarer proportions and centred compositions, the repose of the library rooms complements the more linear quality of the original galleries. The new galleries have been brought into kinship with the existing rooms through their roofs and openings, forming a 'roofscape' of well-modulated volumes, each distinctively day-lit. Within this range of unity and multiplicity, the Gallery's different strands and its diverse constituencies can each find a space. The choice between 'parochial or international' need no longer be so stark.

The new Whitechapel Gallery is made up of overlapping circuits, on the ground and first floors, and between Colquhoun + Miller's grand stair and the old Library stair. This configuration allows great versatility, for example at the changeover between temporary shows, but is also expansive in character when all galleries are in use. The incomplete nature of each building eased and enriched the task of joining them together. The imperfections and imbalances, and the adjustments of line or level required by the act of linking, become something of a binding thread. Neither the formal enfilade of an establishment gallery nor the showy

43

circulation of a new institution, a series of interlocked rooms link the main galleries — the ground-floor foyers, the project galleries and front and rear spaces on the first floor. These paired rooms, with doorways at their corners, are both easy and uncommon. The content of the Gallery becomes central and circulation subservient, maximizing the hanging space but gently decentering the room.

Throughout the renewed galleries new doors and windows allow you to register where you are, and see where you have come from: openings that are both reflective and retrospective. From the ground-floor galleries, large glazed doors make the street directly visible. As you cross over the former dividing wall between Gallery and Library, you glimpse a T-shaped light court that crosses this division, binding Gallery and Library together. Windows in the third-floor creative studio look out onto the terracotta gable and the weathervane; from the second- and third-floor education areas you can see out over the gallery roofs to the skyline of towers, warehouses and terraces beyond. The Whitechapel Gallery is an institution that is very aware of its history and its place in the city's life: these retrospective and extrovert views give physical form to the Gallery's complex collective psychology.

In sum, though discreet, the alterations to Gallery and Library fundamentally alter the Whitechapel's identity: where before it was singular, it becomes multiple; originally deep and linear, it is wide and gently dynamic; where it was once introvert but assertive, now it is more extrovert and reflective.

The unification of Gallery and Library is paralleled by changes in the wider area. With the closure of the Aldgate Gyratory in autumn 2008, it is now possible to walk from the City to the Gallery at street level. The maze of subways across the gyratory are now redundant, and new public spaces are being planned in spaces liberated from the highway.[14]

These transformations are accompanied by — indeed, in London's opportunistic development model, paid for by — new office construction. This seems likely to create some jarring contrasts of scale, with the once grand 'Whitechapel Art Palace' dwarfed by twenty-storey construction. At the same time that it is linked in to a network of public spaces, the Whitechapel Gallery will sit on a sharpened edge between the City and the East End.

The City becomes ever more restless, the population of East London ever more multinational. All around, the patterns of development follow the demolish-and-rebuild model that Richard Sennett has described as the 'Brittle City'.[15] Canary Wharf, Stratford, the City are made and remade fast and tall. This stands in stark contrast to the adjacent conservation areas, and the danger of branded ossification that these face.

Situated in between these two poles of rapid change and total preservation, the slow, additive change that has taken place in the recent transformation of the Whitechapel Gallery is emblematic of the adaptive city. Its approach is one of continuity and change in equal measure, with the city incrementally remade on its existing structures and foundations. Newness is filtered through a careful understanding of the host structure — each graft to the existing building offers new possibilities, but is judged on its compatibility with the existing base structure.

The Gallery and the city around it stretch outwards and upwards — wider, higher. Adapted to new circumstances, more diverse, the buildings of the Whitechapel Gallery will quickly recede into the background. They will serve as a vivid frame within which the politics and aesthetics of the city outside will be translated by artists, to be interpreted by the Gallery's community of visitors.

Whitechapel skyline from the gallery roof
photograph Patrick Lears

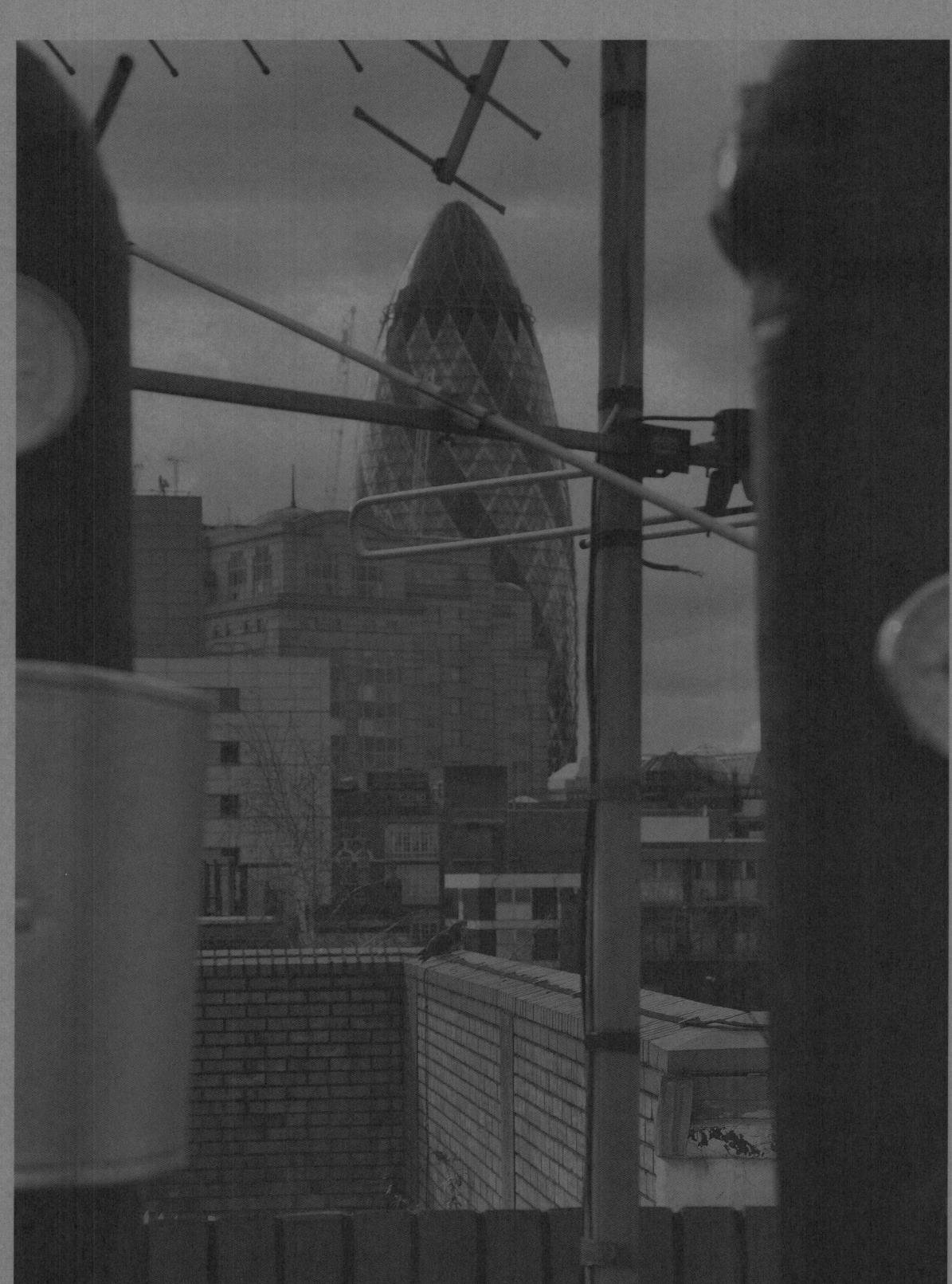

notes

1. The area practically deserves its own chapter in Robert Winder's informative and balanced *Bloody Foreigners: the Story of Immigration to Britain*, Brown, 2004
2. Bernard Kops, 'Returning We Hear the Larks', *Bernard Kops' East End*, Fine Leaves, 2006, 174
3. It took until 1887 to build affordable housing, since the Metropolitan Board of Works was empowered only to buy and clear the land, but not to develop it. The gateway, marked 'the Four Percent Industrial Dwellings Company Ltd', a reference to the steady returns from philanthropic investment, is all that survives. See Jerry White, *Rothschild Buildings: Life in an East End Tenement Block 1887–1920*, Routledge and Kegan Paul, 1980
4. Henrietta went on to found Hampstead Garden Suburb and to safeguard Hampstead Heath Extension (1905); she remained a Trustee of the Whitechapel Art Gallery into the 1930s.
5. Harold Rosen, speaking to Alan Dein for the Radio 4 programme 'Voices from the Reading Room'. With thanks to Alan for providing me with a disc of this vivid broadcast.
6. Stan Sokolow describing the Library in the 1920s, ibid.
7. Bernard Kops, 'Whitechapel Library, Aldgate East', in *Bernard Kops' East End*, 7
8. The Whitechapel Arts Group counted Mark Gertler, Isaac Rosenberg, David Bomberg and Jacob Bronowski among its members. See Rachel Lichtenstein and Alan Dein 'The University of the Ghetto: Stories of the Whitechapel Library', *The Whitechapel Art Gallery Centenary Review*, 2001, Whitechapel Art Gallery, 9–11
9. Charlie Forman, *Spitalfields: A Battle for Land*, Hilary Shipman Ltd, 1989, 18
10. 'We … agreed that each group should have the equivalent of a stall-space in a market in which they could do their own thing': Colin St John Wilson on 'This is Tomorrow', in article of same name by Jeremy Millar in *The Whitechapel Art Gallery Centenary Review*, 68
11. Andrew Forge, review in the *New Statesman* quoted in Brandon Taylor 'The Rauschenberg Retrospective in 1964', *The Whitechapel Art Gallery Centenary Review*, 74
12. Draft letter from Viscount Bearsted to the *Times*, 1971, quoted in Janeen Haythornwaite, 'Roller-Coasters and Helter-Skelters, Missionaries and Philanthropists: A History of Patronage and Funding at the Whitechapel Art Gallery', *The Whitechapel Art Gallery Centenary Review*, 18–22
13. Letter from Lady Henriques to Viscount Bearsted, 1971, ibid.
14. See the 'Aldgate Public Realm Strategy' prepared by Witherford Watson Mann Architects and General Public Agency, available on Design for London's and London Borough of Tower Hamlets' website.
15. Richard Sennett, 'The Open City', essay published by Urban Age, 2006, available at www.urban-age.net

My thanks to colleagues at Robbrecht en Daem Architecten and Witherford Watson Mann Architects, and to the consultants, client team and contractors for the Whitechapel expansion, for what has been a rewarding collaborative work.

Swiss Re Building
'The Gherkin'
Foster+Partners
30 St Mary Axe
2004

Tower 42
(former Natwest Tower)
Richard Seifert
25 Old Broad Street
1980

Denning Point
Commercial Street
1968

Canon Barnett
Primary School
(former Commercial
Street Board School)
Gunthorpe Street /
Commercial Street
1901

Nido student residential
accommodation
ORMS Architecture Design
100 Middlesex Street
2010

The Broadgate Tower
Skidmore, Owings & Merrill
201 Bishopsgate
2009

Christ Church
Nicholas Hawksmoor
Spitalfields
1714–1729

Panorama of London seen from the Clore Creative Studios
photographs Patrick Lears

48

The Whitechapel Gallery
Gallery 7
(former Library building)
1892

Old Truman Brewery
(former Black Eagle Brewery)
91 Brick Lane
c. 1724

City Hotel
12–2o Osborne Street
1997

Georgian House
(now surrounded on all sides
by later developments)

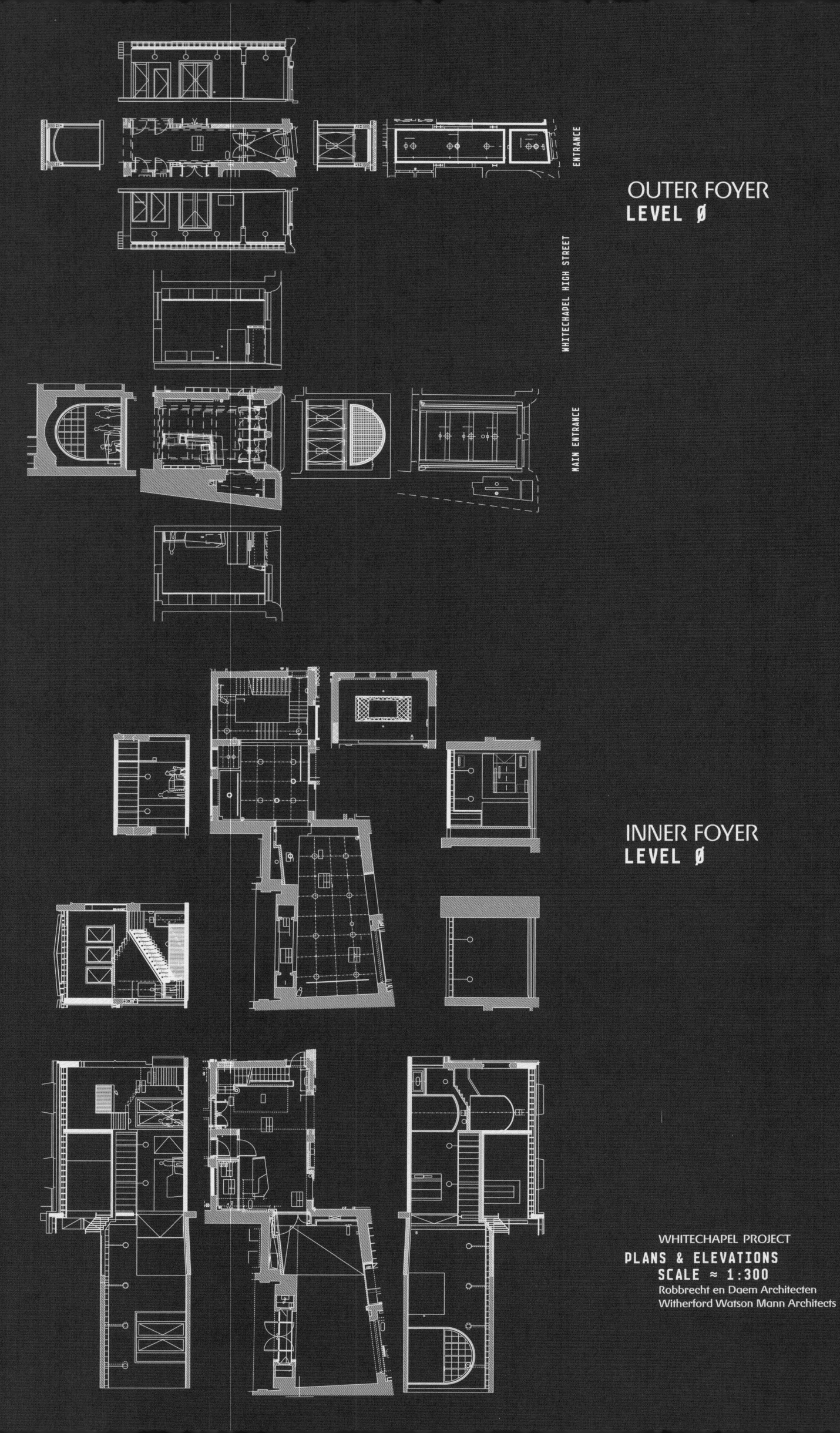

OUTER FOYER
LEVEL Ø

WHITECHAPEL HIGH STREET

ENTRANCE

MAIN ENTRANCE

INNER FOYER
LEVEL Ø

WHITECHAPEL PROJECT
PLANS & ELEVATIONS
SCALE ≈ 1:300
Robbrecht en Daem Architecten
Witherford Watson Mann Architects

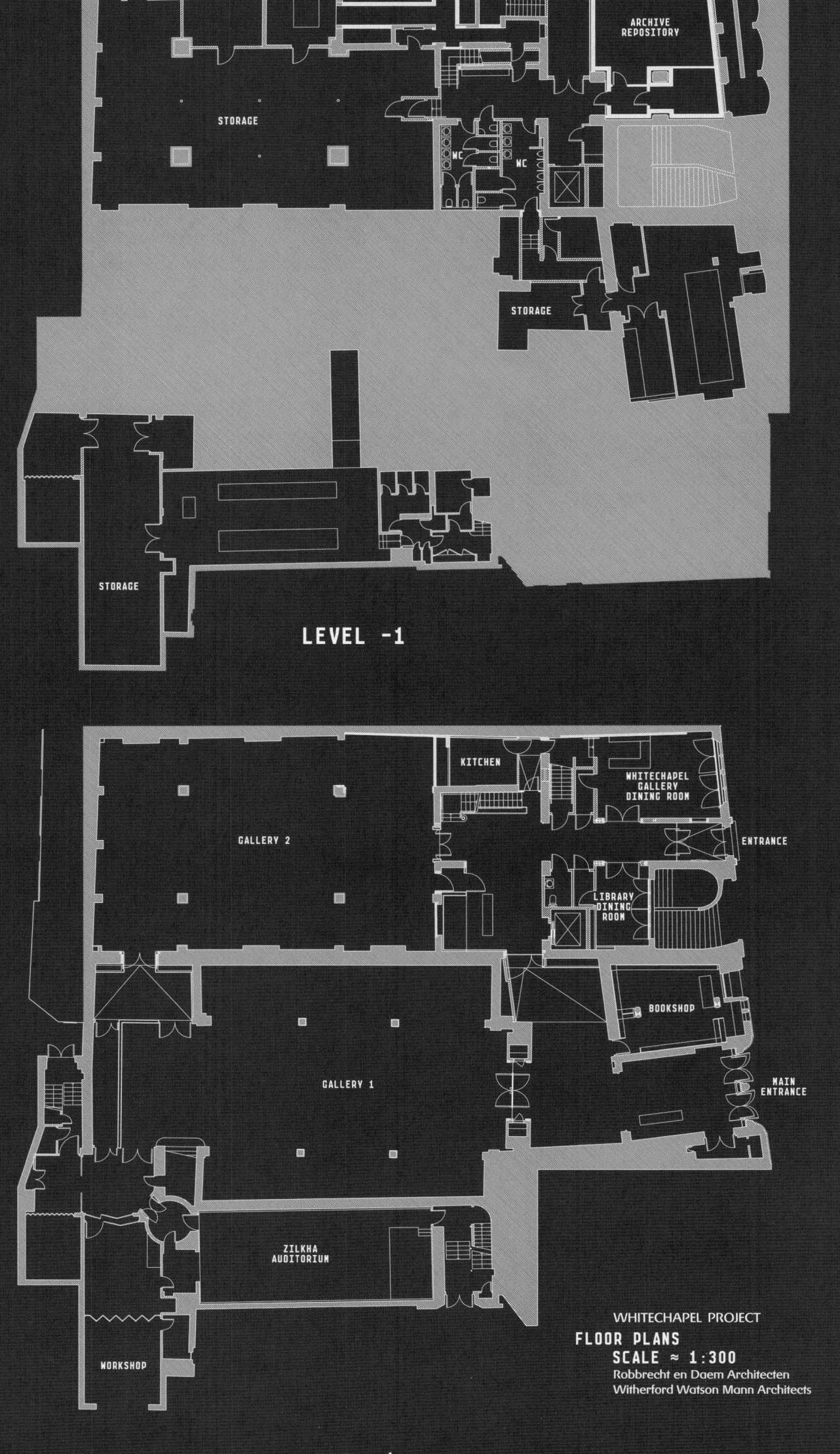

ARCHIVE
REPOSITORY

STORAGE

WC

WC

STORAGE

STORAGE

LEVEL -1

WHITECHAPEL HIGH STREET

KITCHEN

WHITECHAPEL
GALLERY
DINING ROOM

GALLERY 2

ENTRANCE

LIBRARY
DINING
ROOM

BOOKSHOP

GALLERY 1

MAIN
ENTRANCE

WHITECHAPEL HIGH STREET

ZILKHA
AUDITORIUM

WHITECHAPEL PROJECT
FLOOR PLANS
SCALE ≈ 1:300
Robbrecht en Daem Architecten
Witherford Watson Mann Architects

WORKSHOP

LEVEL 0

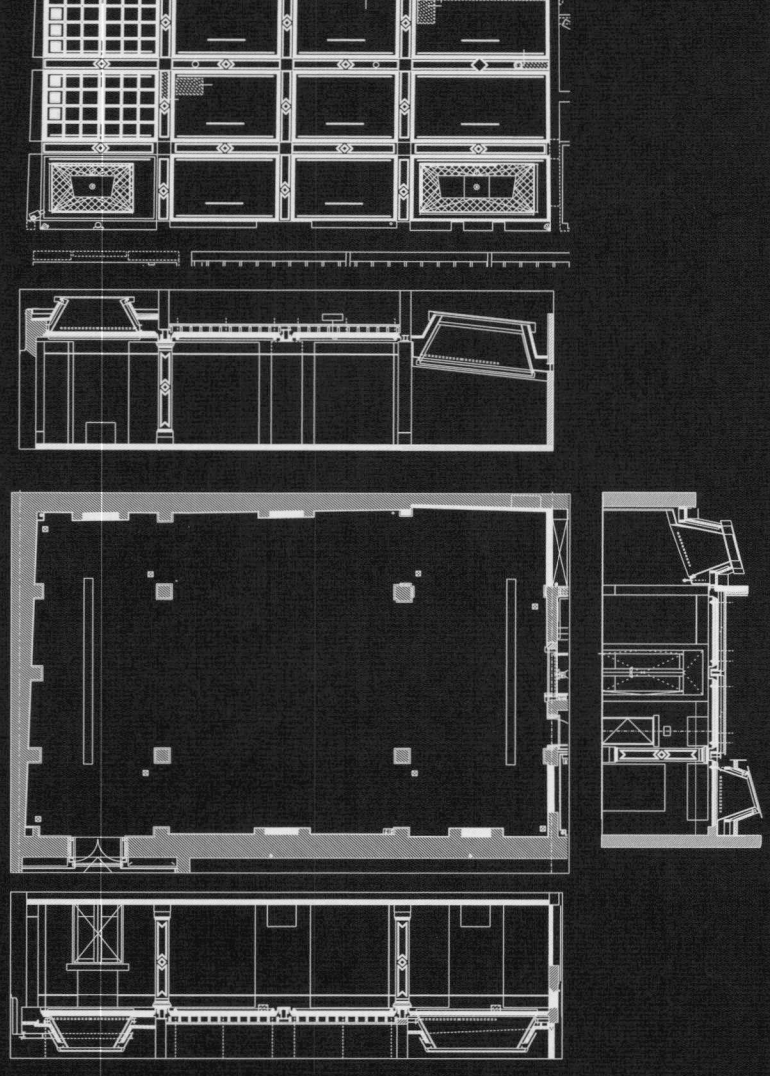

**GALLERY 2
LEVEL Ø**

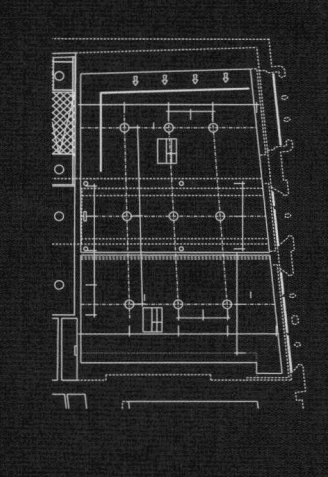

**GALLERY 4
FOYLE READNG ROOM
LEVEL 1**

WHITECHAPEL PROJECT
PLANS & ELEVATIONS
SCALE ≈ 1:300
Robbrecht en Daem Architecten
Witherford Watson Mann Architects

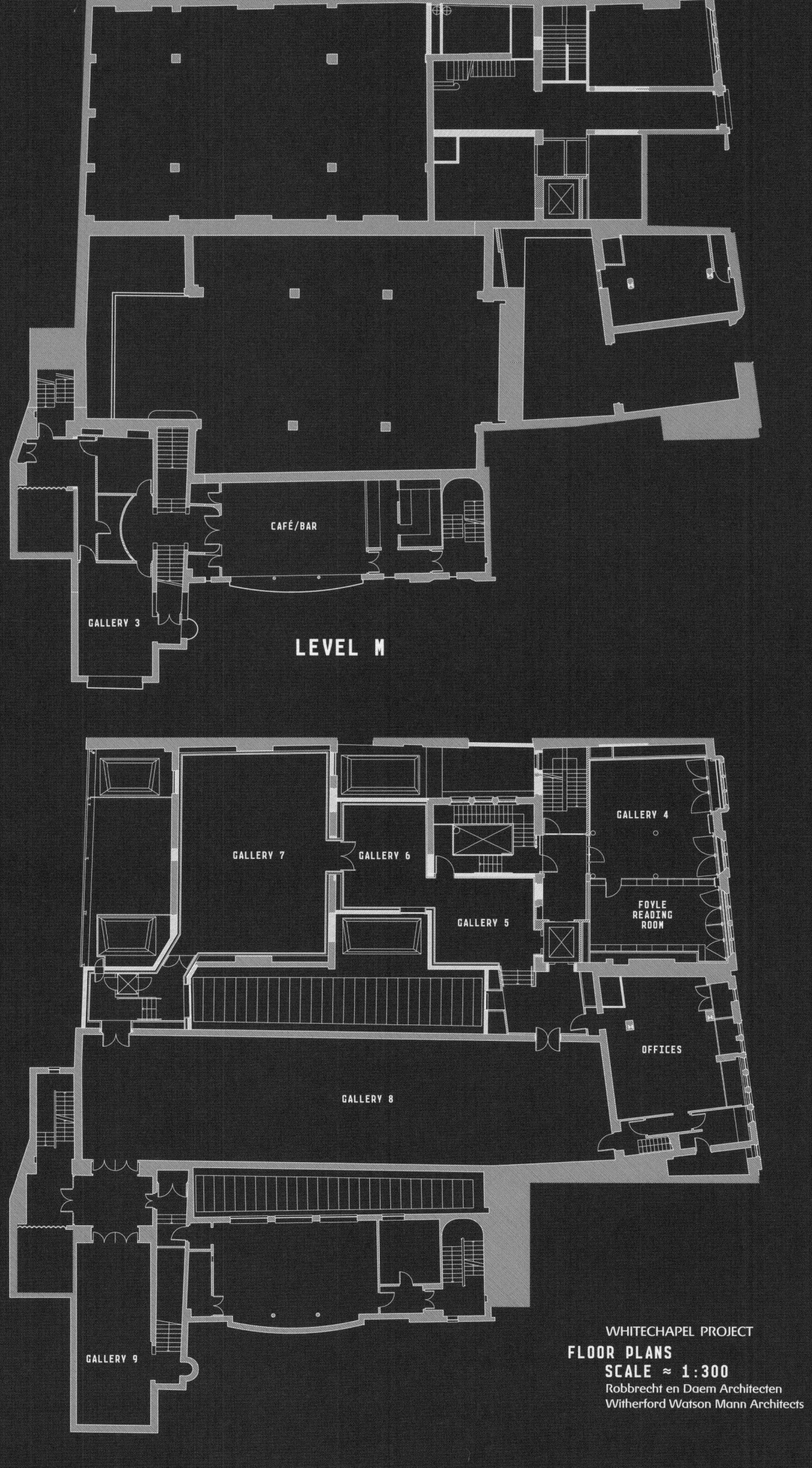

GALLERY 9

GALLERY 3

CAFÉ/BAR

LEVEL M

GALLERY 7

GALLERY 6

GALLERY 5

GALLERY 4

FOYLE
READING
ROOM

OFFICES

GALLERY 8

WHITECHAPEL HIGH STREET

WHITECHAPEL HIGH STREET

WHITECHAPEL PROJECT
FLOOR PLANS
SCALE ≈ 1:300
Robbrecht en Daem Architecten
Witherford Watson Mann Architects

LEVEL 1

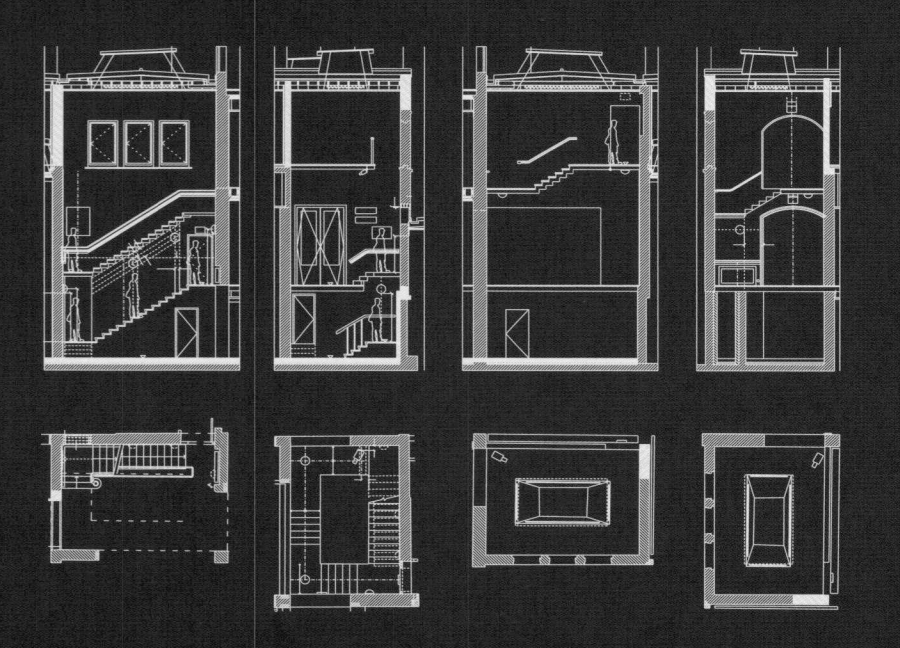

MAIN STAIR

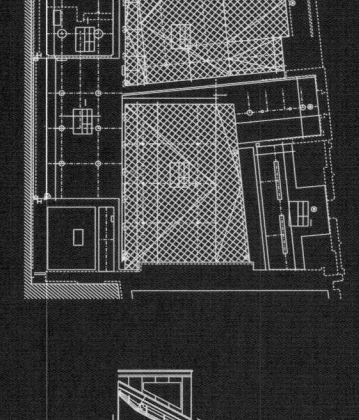

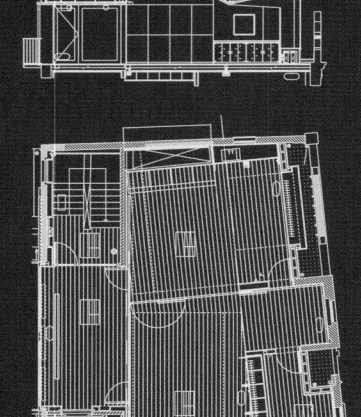

**CLORE CREATIVE
STUDIOS 1 & 2
LEVEL 3**

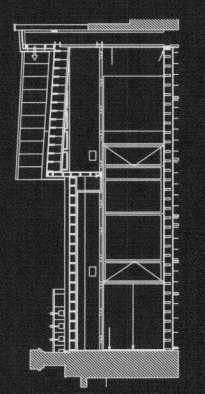

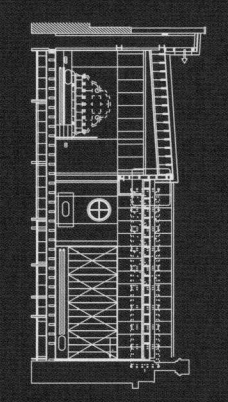

WHITECHAPEL PROJECT
PLANS & ELEVATIONS
SCALE ≈ 1:300
Robbrecht en Daem Architecten
Witherford Watson Mann Architects

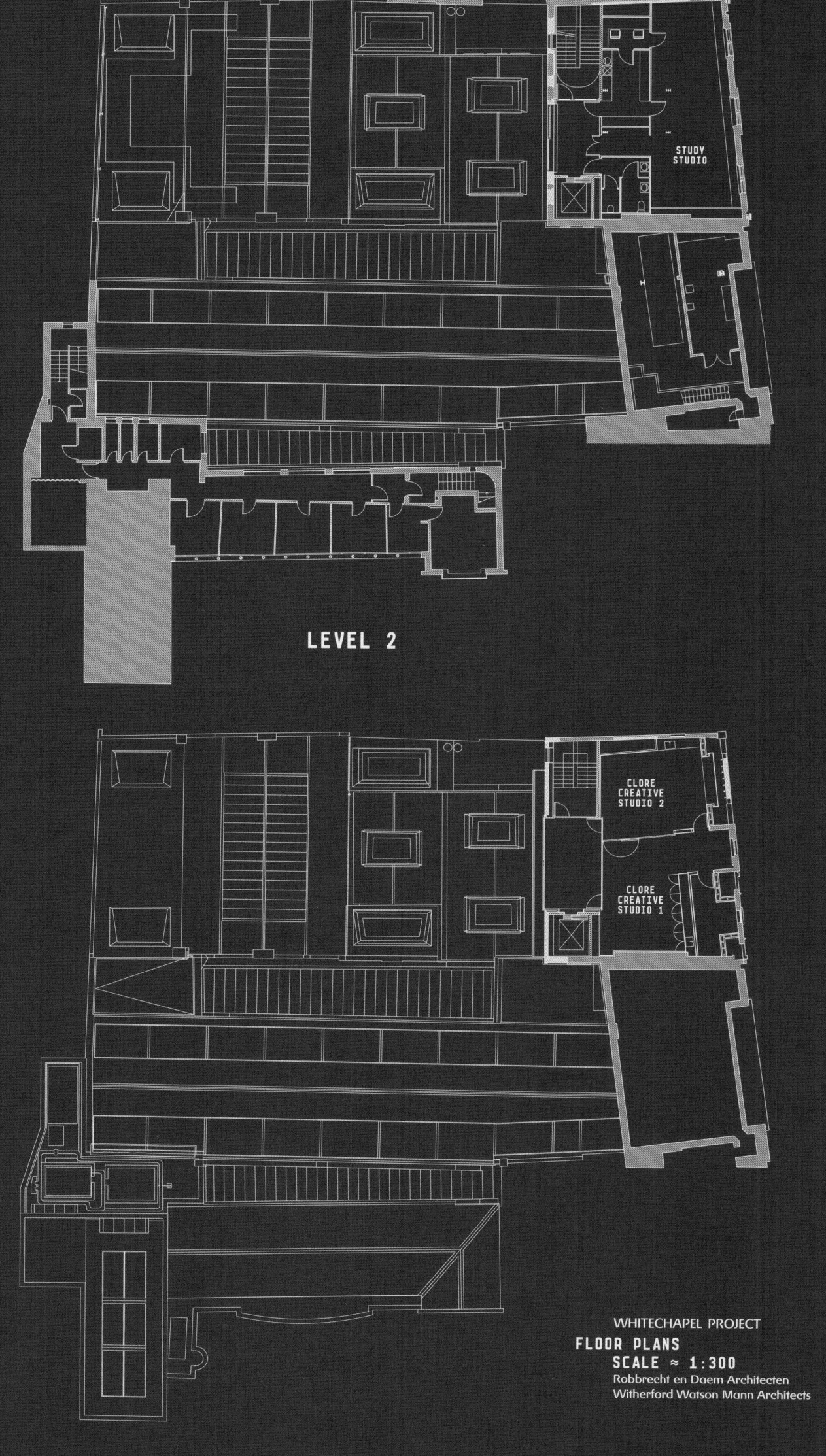

LEVEL 2

STUDY STUDIO

CLORE CREATIVE STUDIO 2

CLORE CREATIVE STUDIO 1

WHITECHAPEL PROJECT
FLOOR PLANS
SCALE ≈ 1:300
Robbrecht en Daem Architecten
Witherford Watson Mann Architects

LEVEL 3

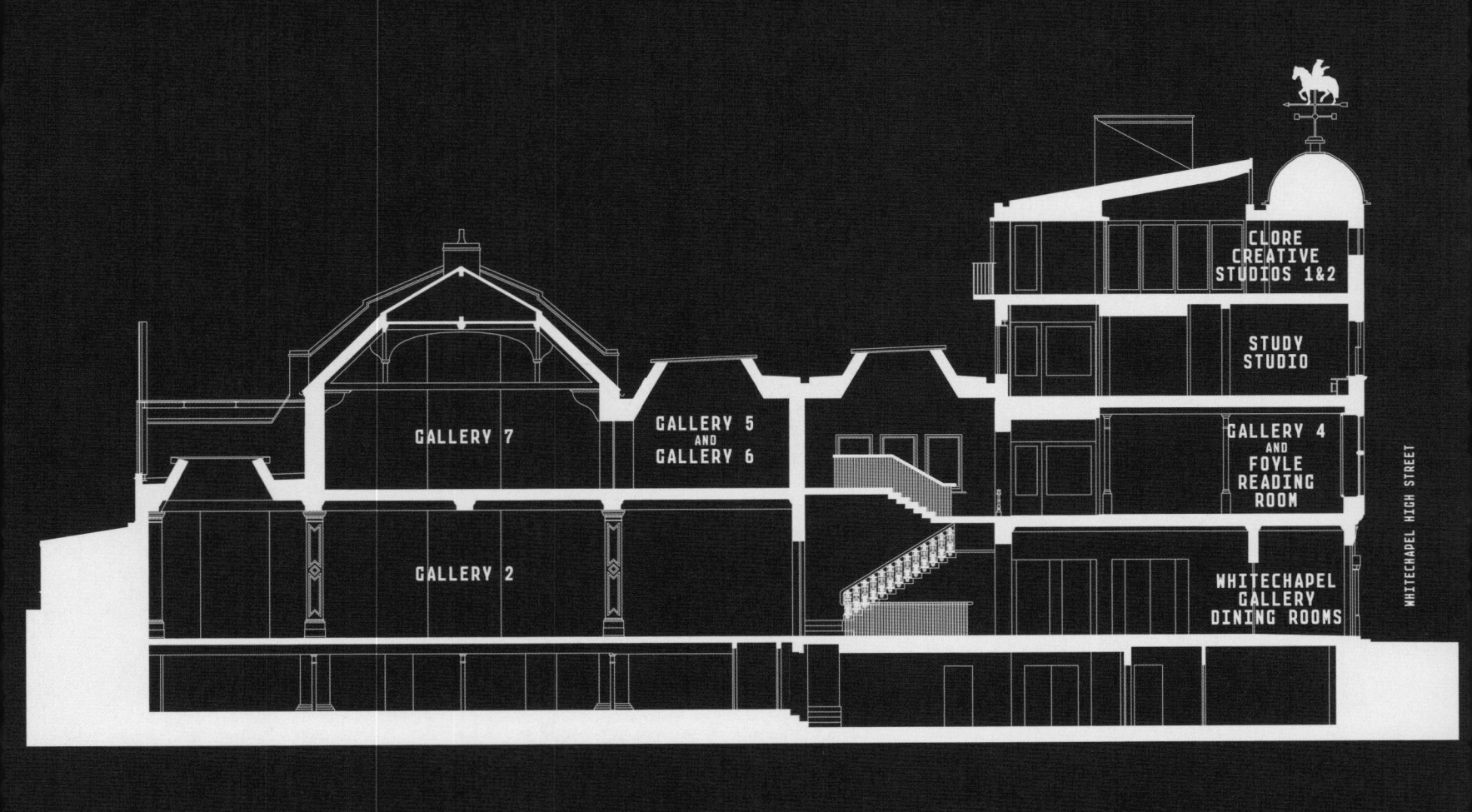

GALLERY 7

GALLERY 5
AND
GALLERY 6

GALLERY 2

CLORE
CREATIVE
STUDIOS 1&2

STUDY
STUDIO

GALLERY 4
AND
FOYLE
READING
ROOM

WHITECHAPEL
GALLERY
DINING ROOMS

WHITECHAPEL HIGH STREET

WHITECHAPEL PROJECT
CROSS SECTION
SCALE ≈ 1:200
Robbrecht en Daem Architecten
Witherford Watson Mann Architects

LIBRARY EXTENSION

construction chronology

Established in 19o1 to 'bring great art to the people of the East End of London', the Whitechapel Gallery occupies a distinctive Arts and Crafts building designed by Charles Harrison Townsend.

The adjacent Library, by Potts, Son & Hennings, opened its doors in May 1892 and was one of several free public institutes and libraries funded by John Passmore Edwards, Editor of the Building News. After 113 years, the Whitechapel Library closed …

JO DUNNETT
PROJECT CO-ORDINATOR

2oo1

AUGUST	Trustees of the Whitechapel Gallery purchase the Whitechapel Library building	
NOVEMBER	Passmore Edwards Building Committee formed	

2oo2

SEPTEMBER	Building Conditions Survey of the Library	
OCTOBER	Capital Campaign launched with the Founding Partners Dinner	

2oo3

APRIL	Notice for Design Team posted in *OJEC* (Official Journal of the European Community)	
OCTOBER	Competitive interviews from shortlist of six design teams: Lacaton & Vassal Architects, Paris / Robbrecht en Daem Architecten, Ghent / Foreign Office Architects, London / Patel Taylor Architects, London / dRMM Architects, London / Caruso St John Architects, London	
NOVEMBER	Robbrecht en Daem Architecten, Lead Architects, and Witherford Watson Mann, Executive Architects, accept the commission to unite the Whitechapel Gallery and Whitechapel Library	
DECEMBER	Conservation Architects, Richard Griffiths Architects appointed / Brief formulated with design team	

2oo5

JUNE	A fortnight of public consultation takes place with an exhibition of Robbrecht en Daem Architecten's proposed scheme	
JULY	A memorial stone from the New Road Synagogue is removed from the Library basement and taken to the Local History Library on Bancroft Road	
AUGUST	Measured survey of Gallery and Library buildings	
SEPTEMBER	Idea Store, designed by David Adjaye, opens on Whitechapel High Street	
NOVEMBER	Whitechapel Library on the 'Buildings at Risk' register	

2oo6

JANUARY	Conservation Management Plan completed / Cataloguing of the Whitechapel Archive commences	
MARCH	Planning and Listed Building Consent received	
APRIL	Project team move into the Library building / Photographic record of the transformation of the Library commences	
JUNE	Jason Bruges appointed as external lighting designers	
AUGUST	Reading Room shelves dismantled for restoration	
SEPTEMBER	Historic paint survey completed / Holmes Wood appointed as Wayfinding Designers / Exhibition of auction works in the Library Reading Room	
OCTOBER	Whitechapel Gallery Auction raises £2.7million at Sotheby's	

2oo7

JANUARY	Angel Alley transformed into the new Whitechapel Gallery entrance / Temporary foyer installed in the original Gallery workshop	
FEBRUARY	Main galleries close / Auditorium film programme 'Whitechapel Laboratory' launched	
MAY	Appointment of Contractor, Wallis	
JUNE	Original terracotta for east gable discovered in the basement of the Library building / Original Library safe removed by crane	
JULY	Historic elements of the Library building dismantled for restoration: / Original parquet floor / Leaded glass screen door surrounds / Whitechapel Hay Market 1788 ceramic tile picture / Manhole cover / Main stair balustrade / Spiral staircases / Reading room tables / Reading room shelving / Original library card holders / Original museum display cabinet / Original internal signs / All commemorative plaques and stones	
SEPTEMBER	Scaffolding now encases the entire Library building with temporary roof erected / Underground drainage system complete / Lift pit complete — no dinosaur remains discovered / First breakthrough from Gallery foyer to Library foyer — ground floor south link / Repair and restoration of historic facades commences	
NOVEMBER	Repair and restoration of original Library Museum Room begins	
DECEMBER	Work commences on new staircase to the Education Tower / Project Orange appointed to design the Whitechapel Gallery Dining Rooms	

2oo8

JANUARY	Gallery entrance arch re-strengthened / Construction of new Education Tower commences	
FEBRUARY	Gantry and hoardings painted grass green and embellished with reproductions of art from the Whitechapel Gallery Archive	
MARCH	Work on new Archive Repository begins	
MAY	Restoration of the Library east gable commences using original terracotta	
SEPTEMBER	Lime wash applied to external elevations within courtyard	
OCTOBER	New roof lights installed / Marble Memorial Stone laid by the Lord Mayor of London in 1891 reinstalled on main stairwell	
NOVEMBER	Roof line of Library façade complete / Planning Permission and Listed Building Consent received for external lighting design	
DECEMBER	Liam Gillick's *Adjustment Filter* (2oo2/2oo9) installed in the Café/Bar / New reading desk installed in the Café/Bar, designed by Dunnett Craven / Rodney Graham's *Weathervane* (2oo7) installed on restored cupola / Liam Gillick's *PROTOTYPE CONFERENCE ROOM* (1999/2oo9) installed in the Zilkha Auditorium	

2oo9

FEBRUARY	External lighting scheme installed	
MARCH	Internal signage including all historical plaques installed / External signage scheme installed	
APRIL	Whitechapel Gallery reopens	

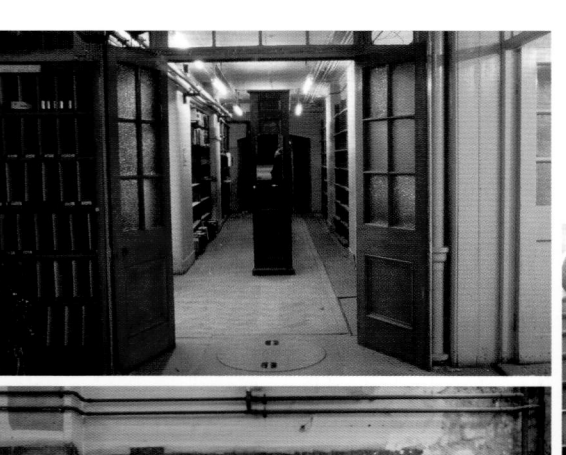
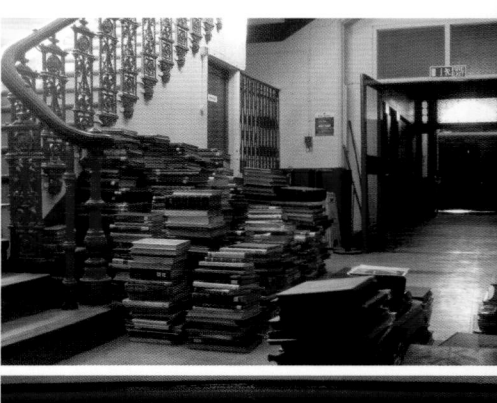

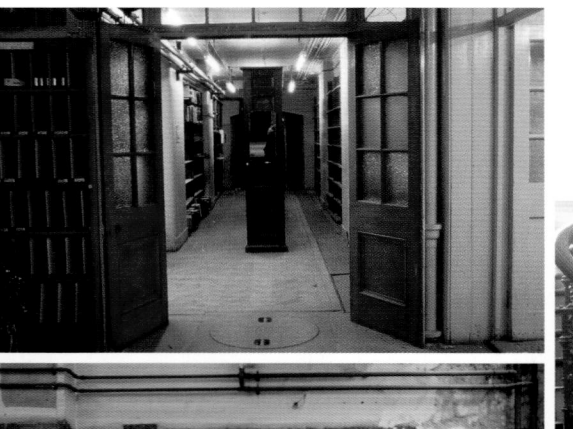

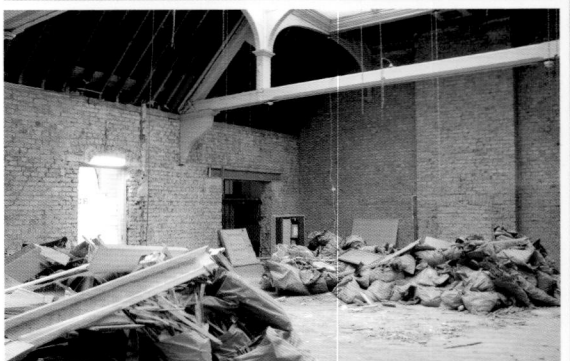

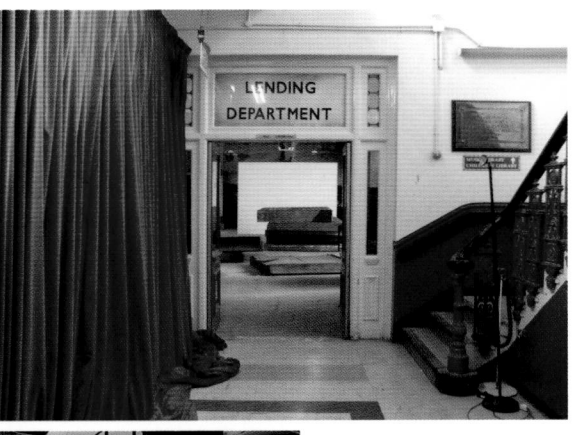
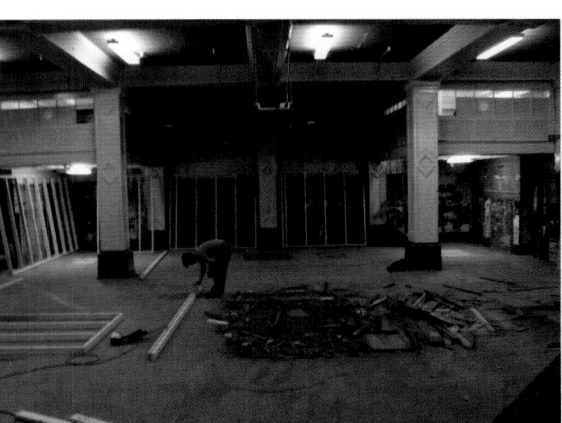

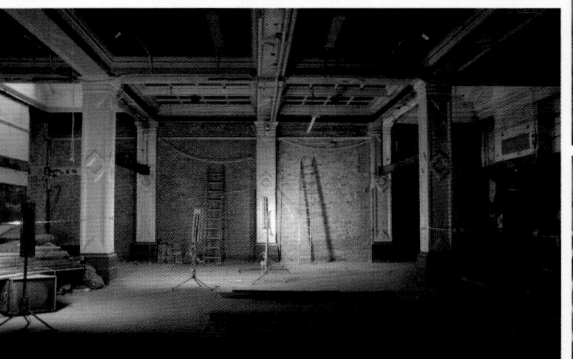
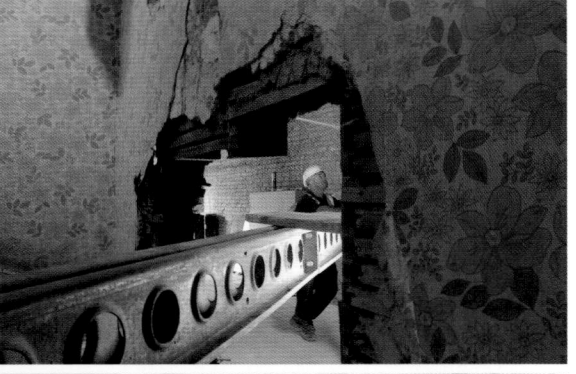
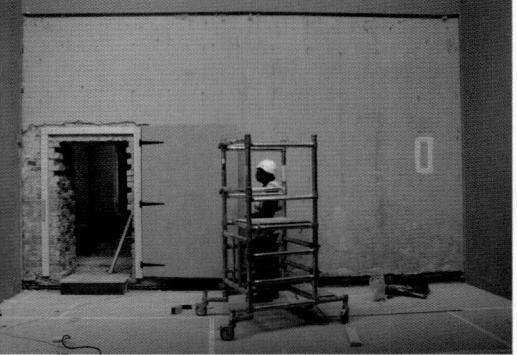

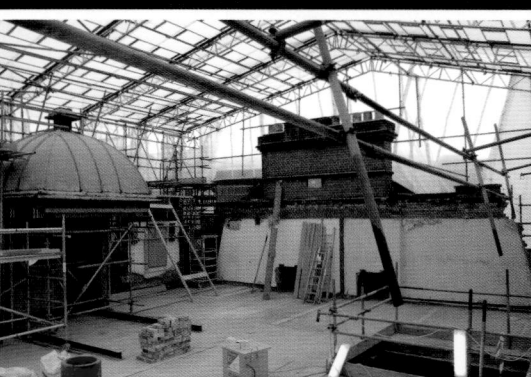

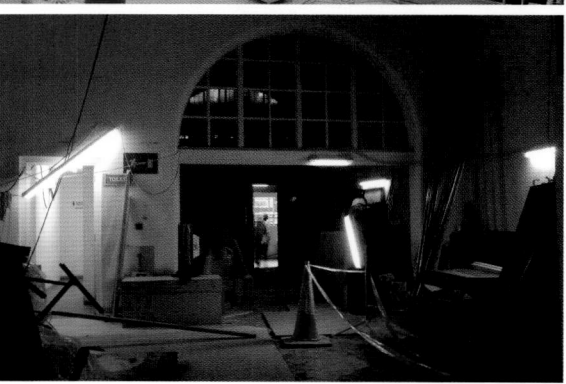

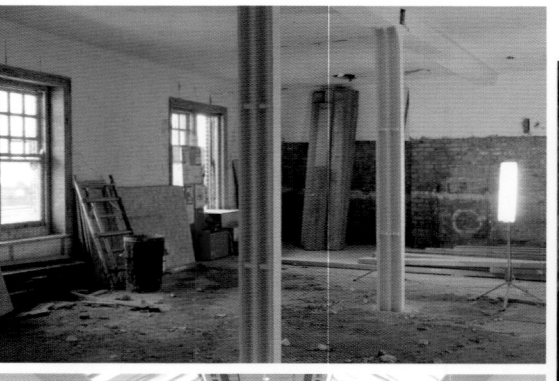
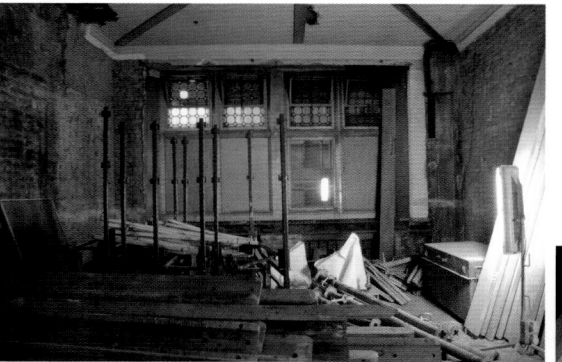
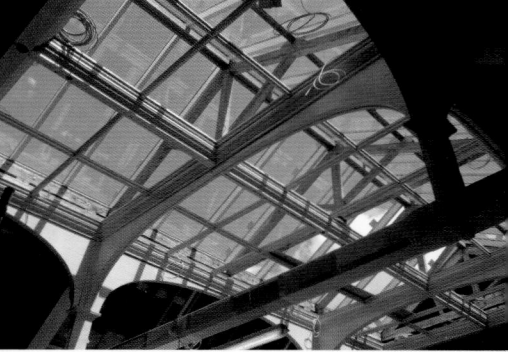
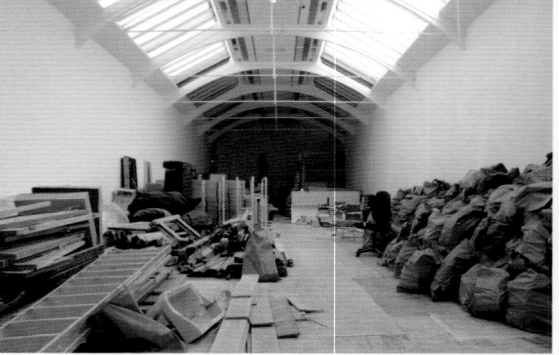
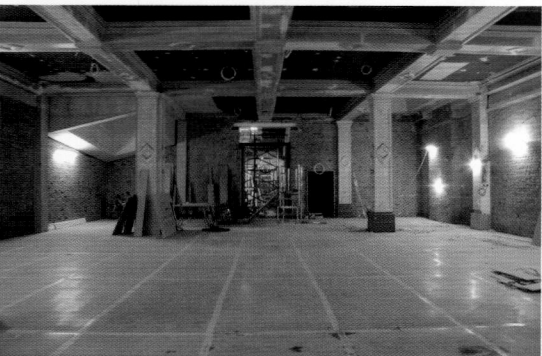
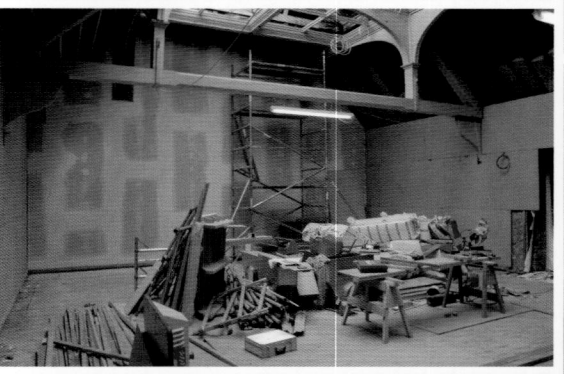
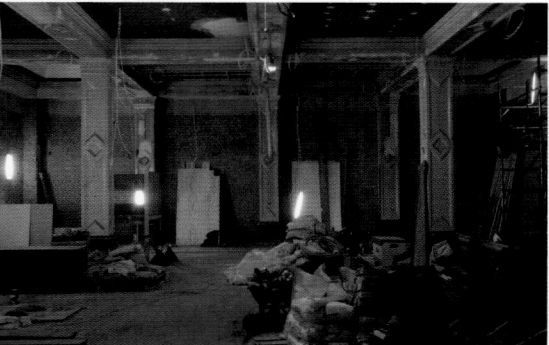
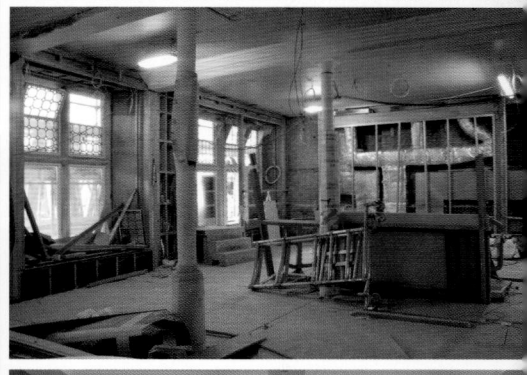

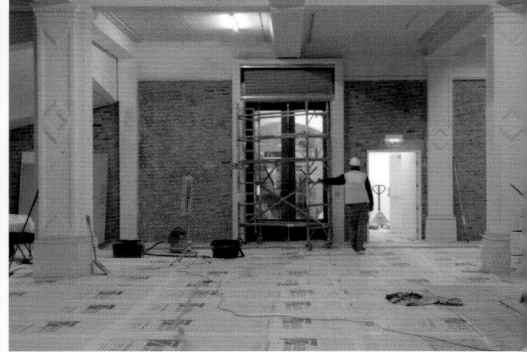

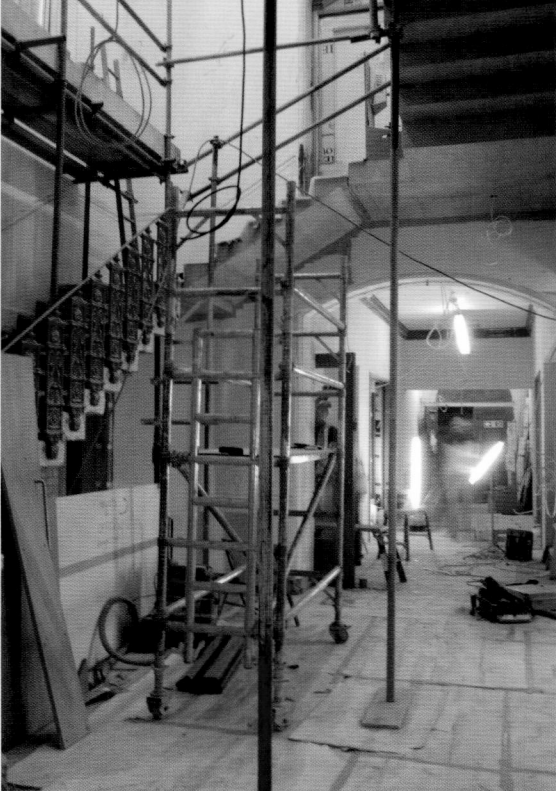
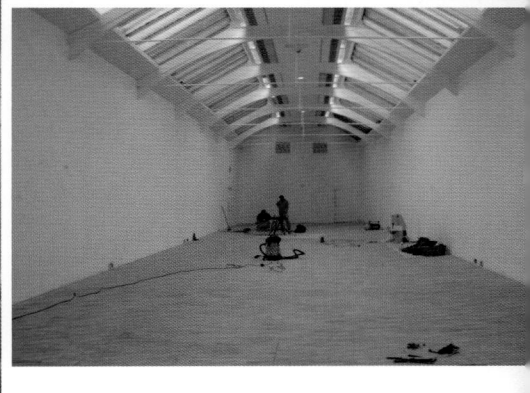

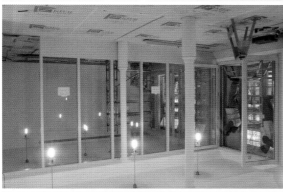

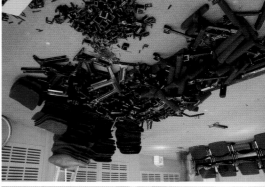
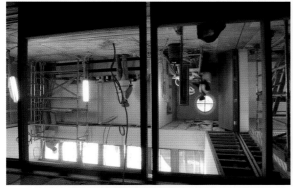

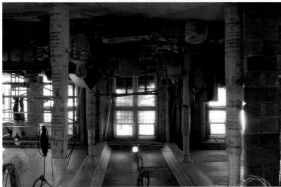

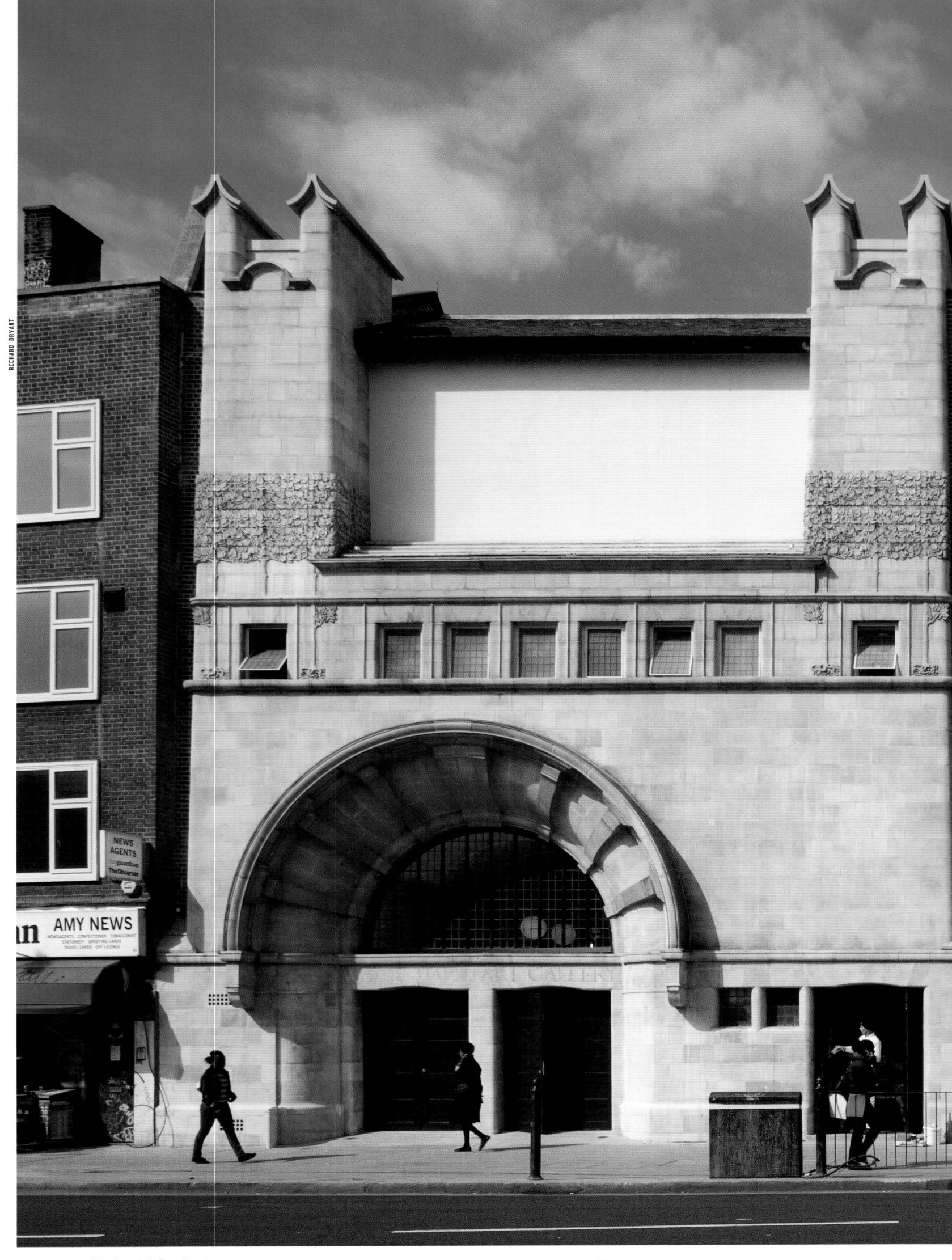

Whitechapel Gallery, 2009

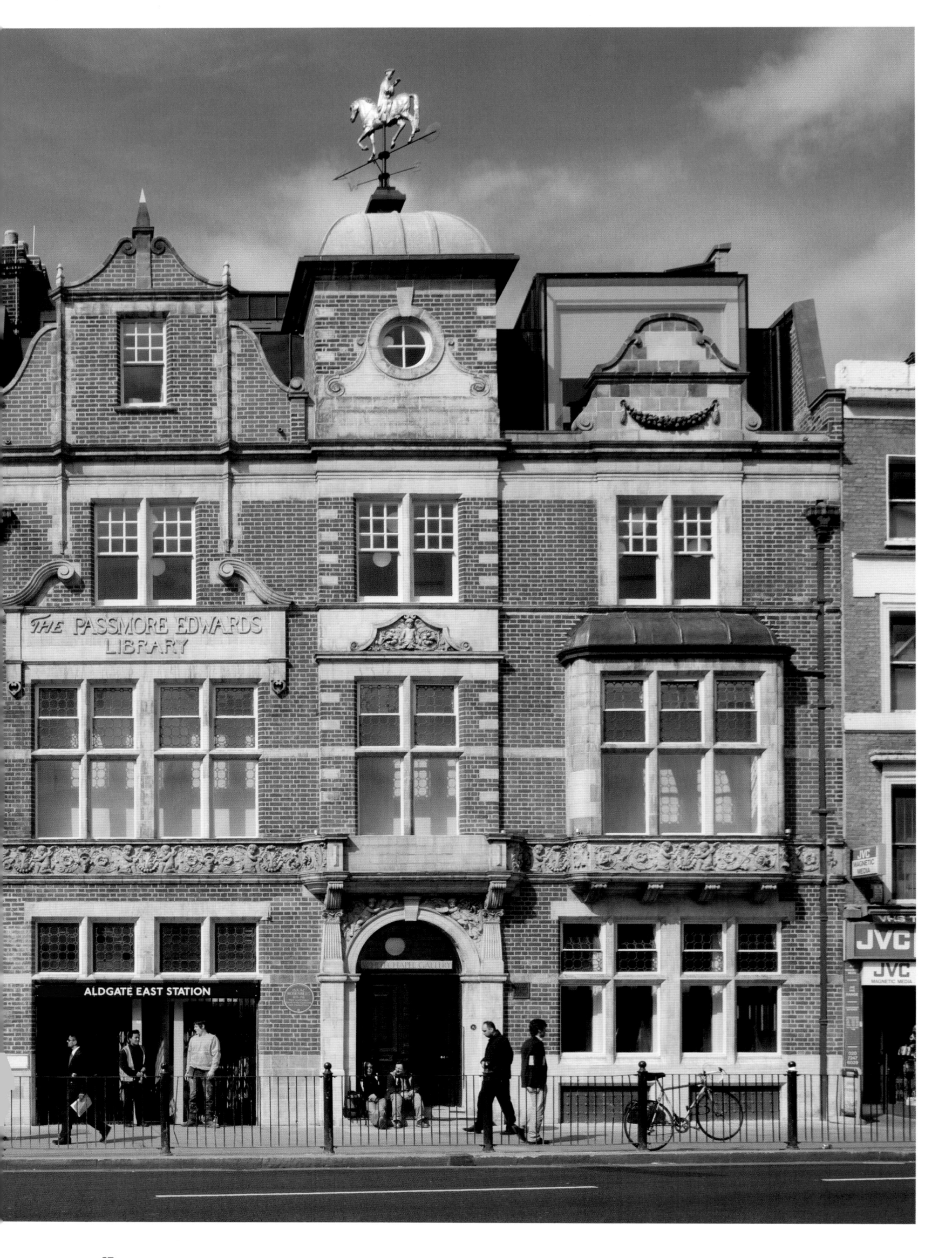

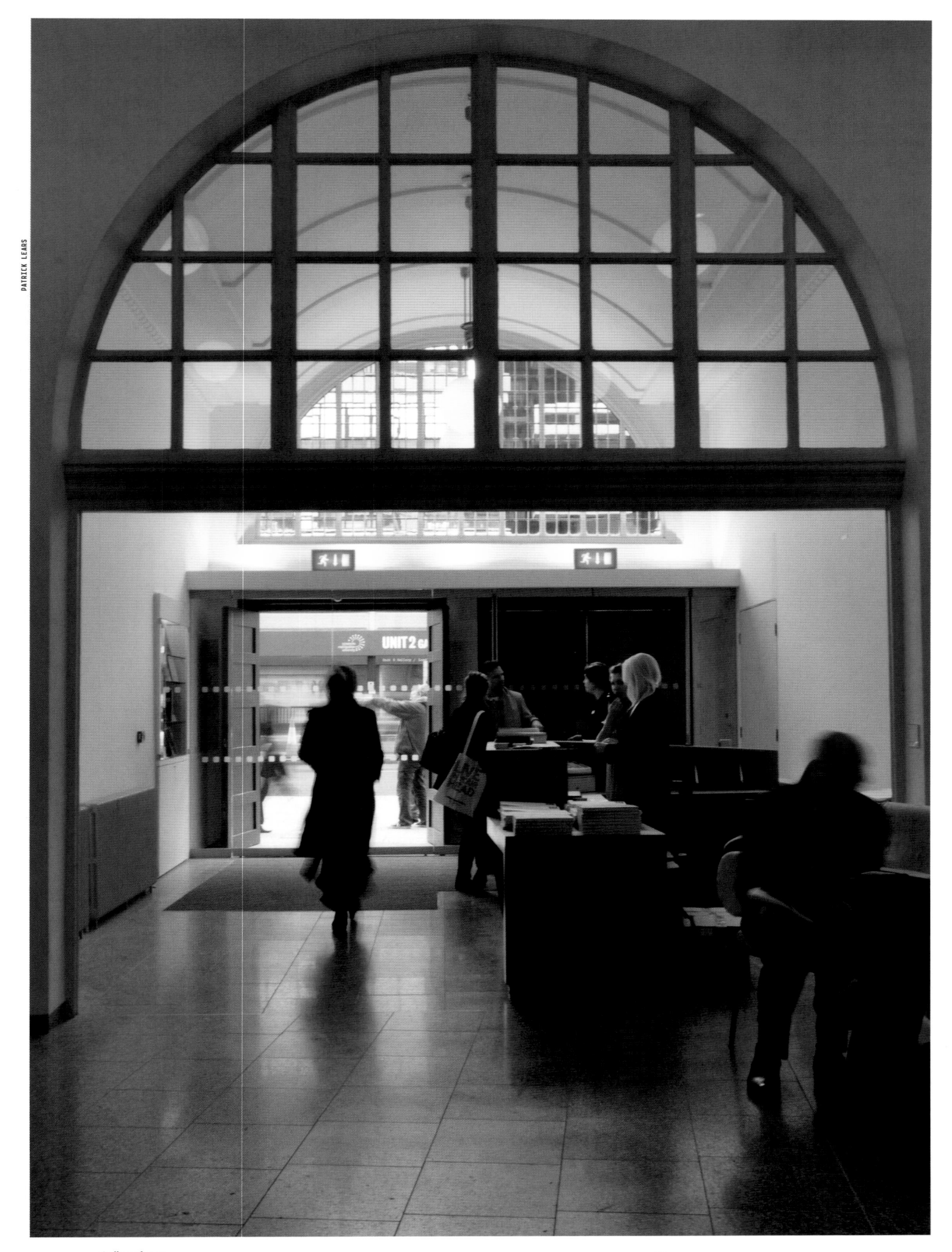

Gallery foyer

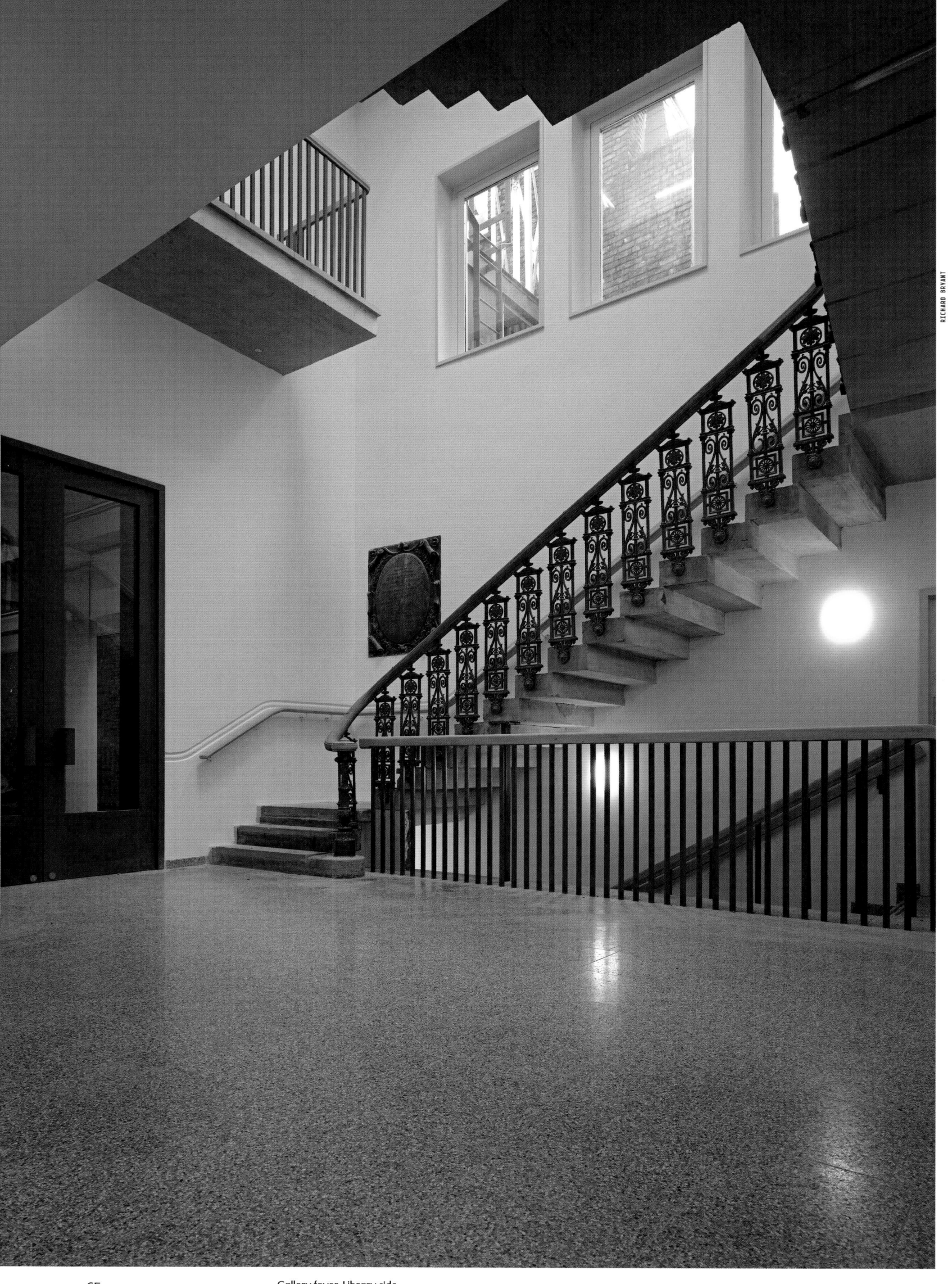

Gallery foyer, Library side

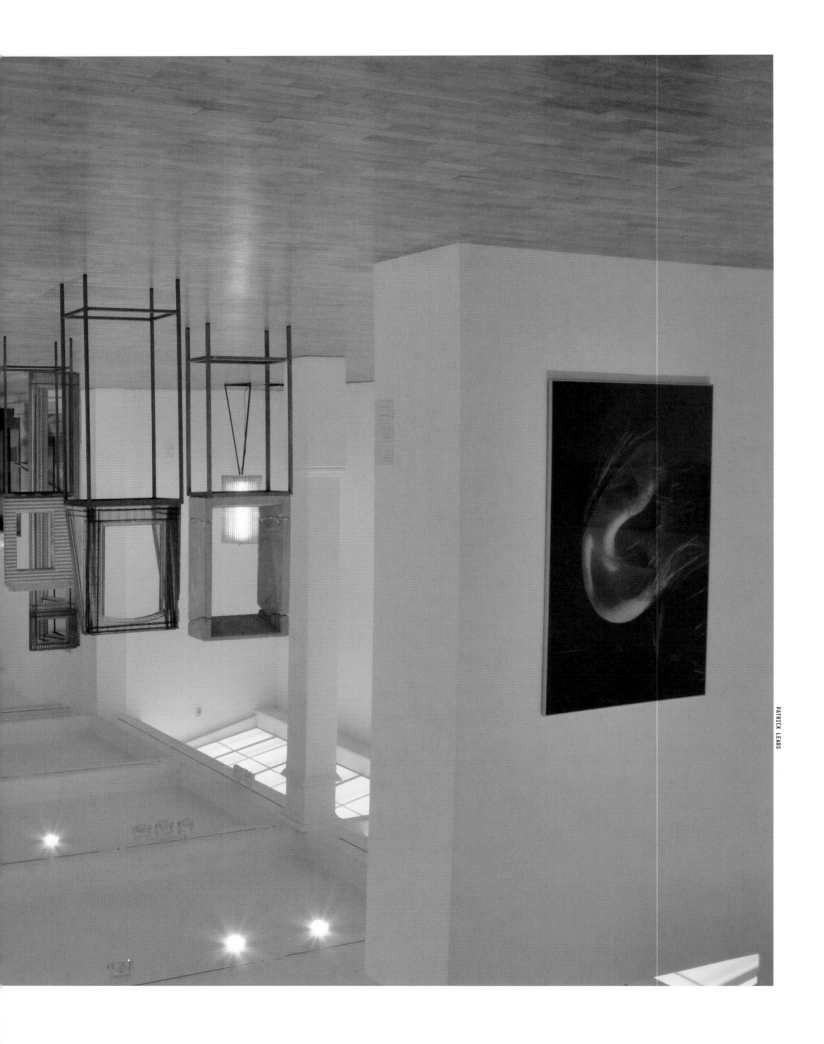

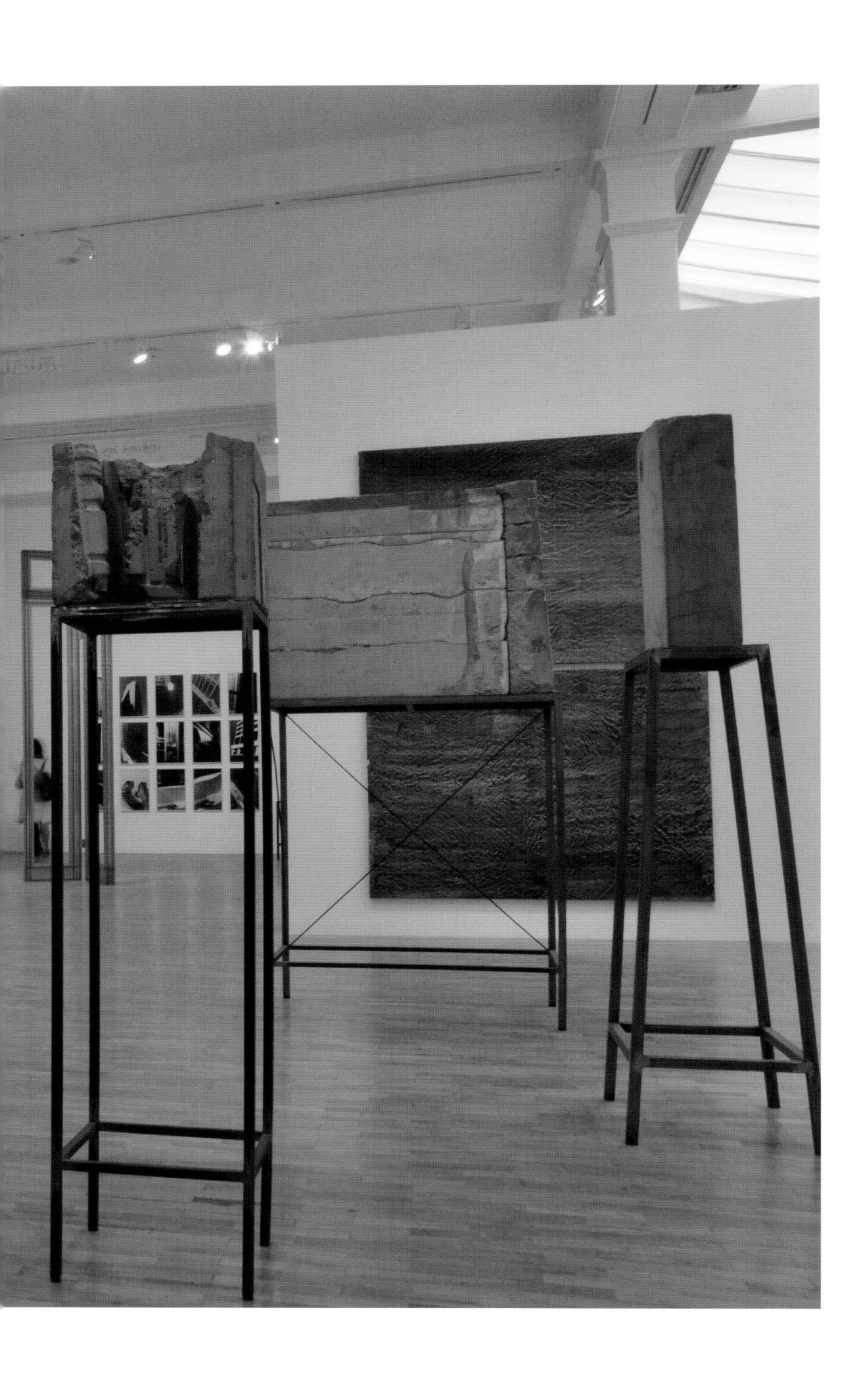

Isa Genzken, *Open, Sesame!*, 2009

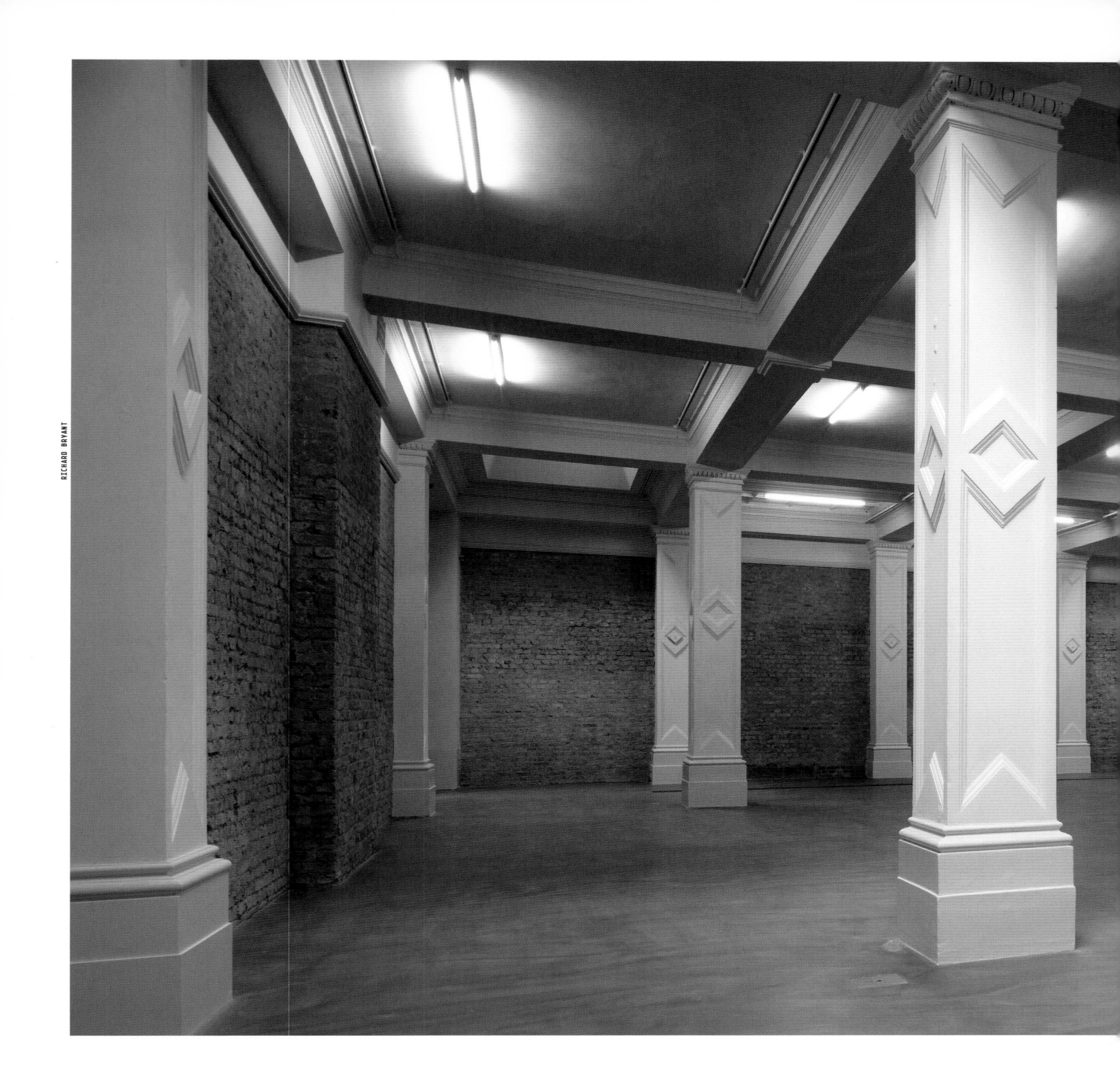

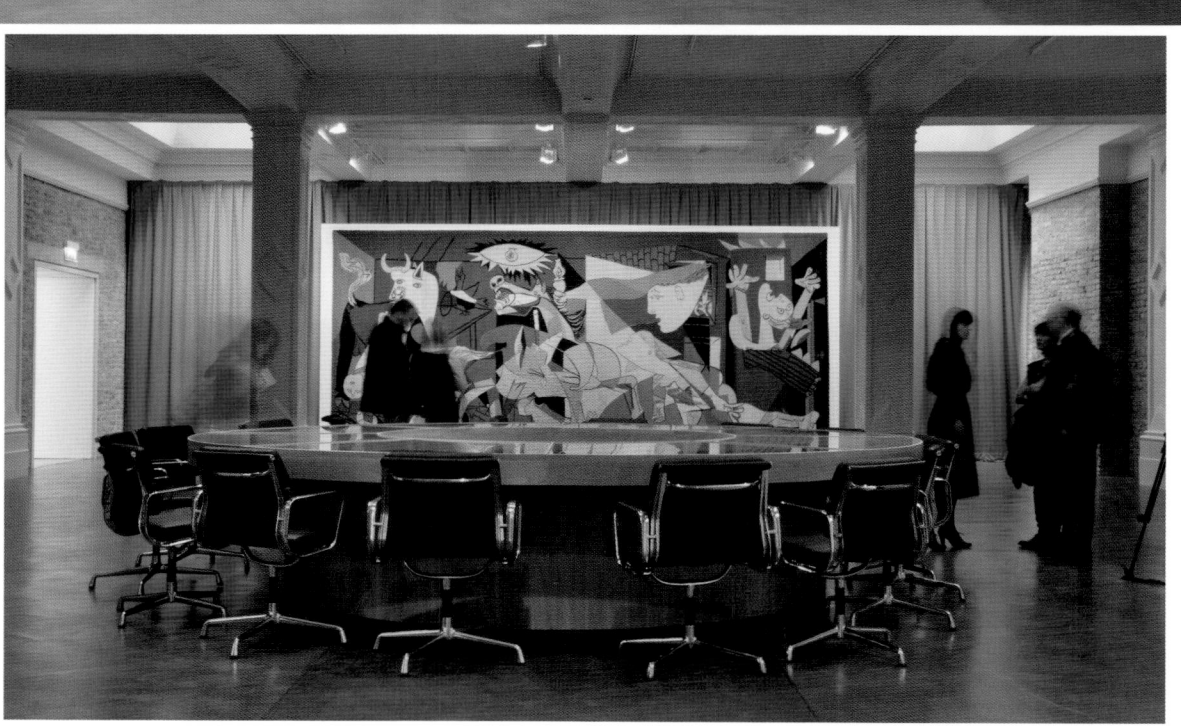

69 The Bloomberg Commission: Goshka Macuga, *The Nature of the Beast*, 2009

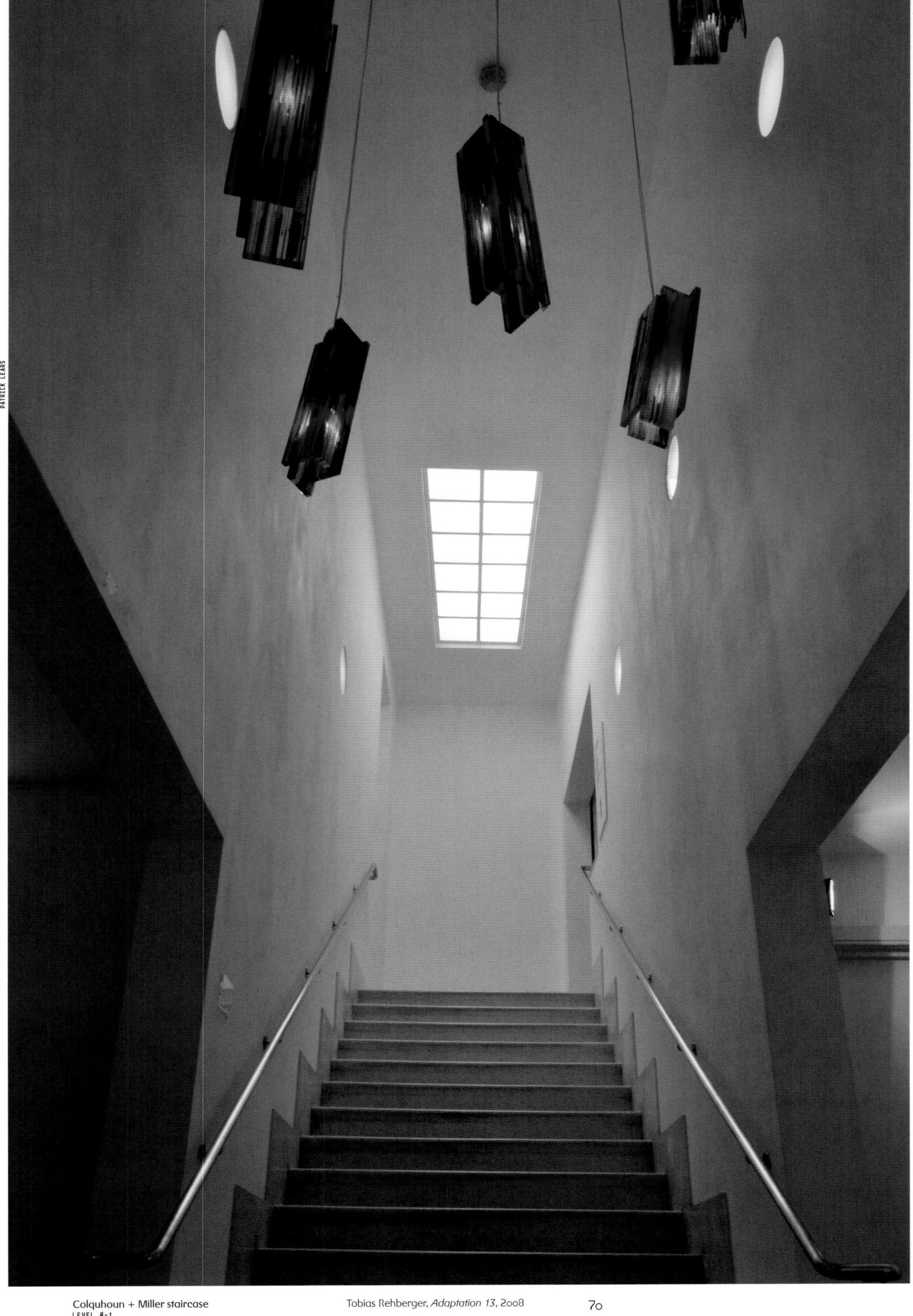

Colquhoun + Miller staircase
LEVEL Ø-1

Tobias Rehberger, *Adaptation 13*, 2008

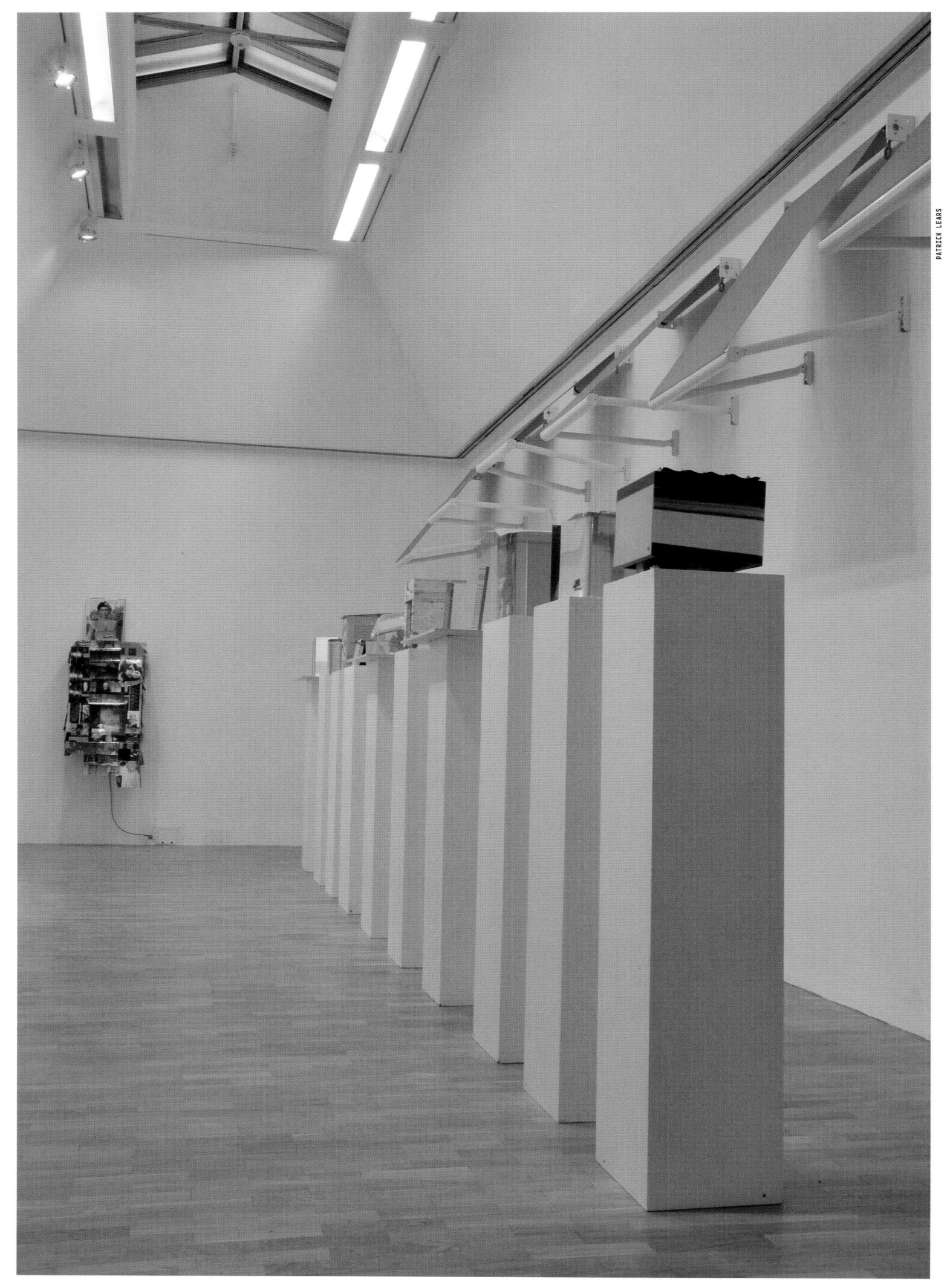

Gallery 9
LEVEL 1

Isa Genzken, *Open, Sesame!*, 2009

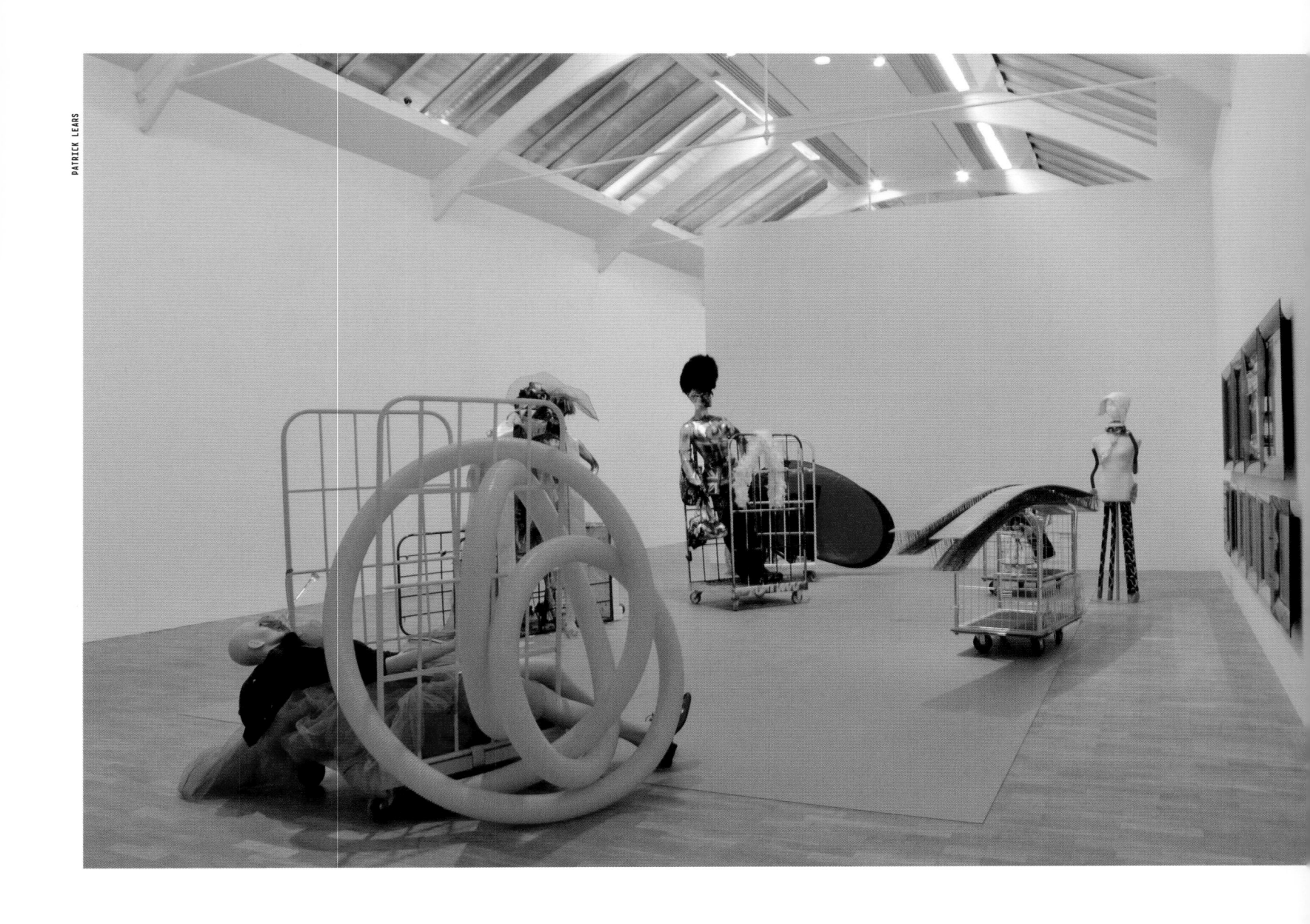

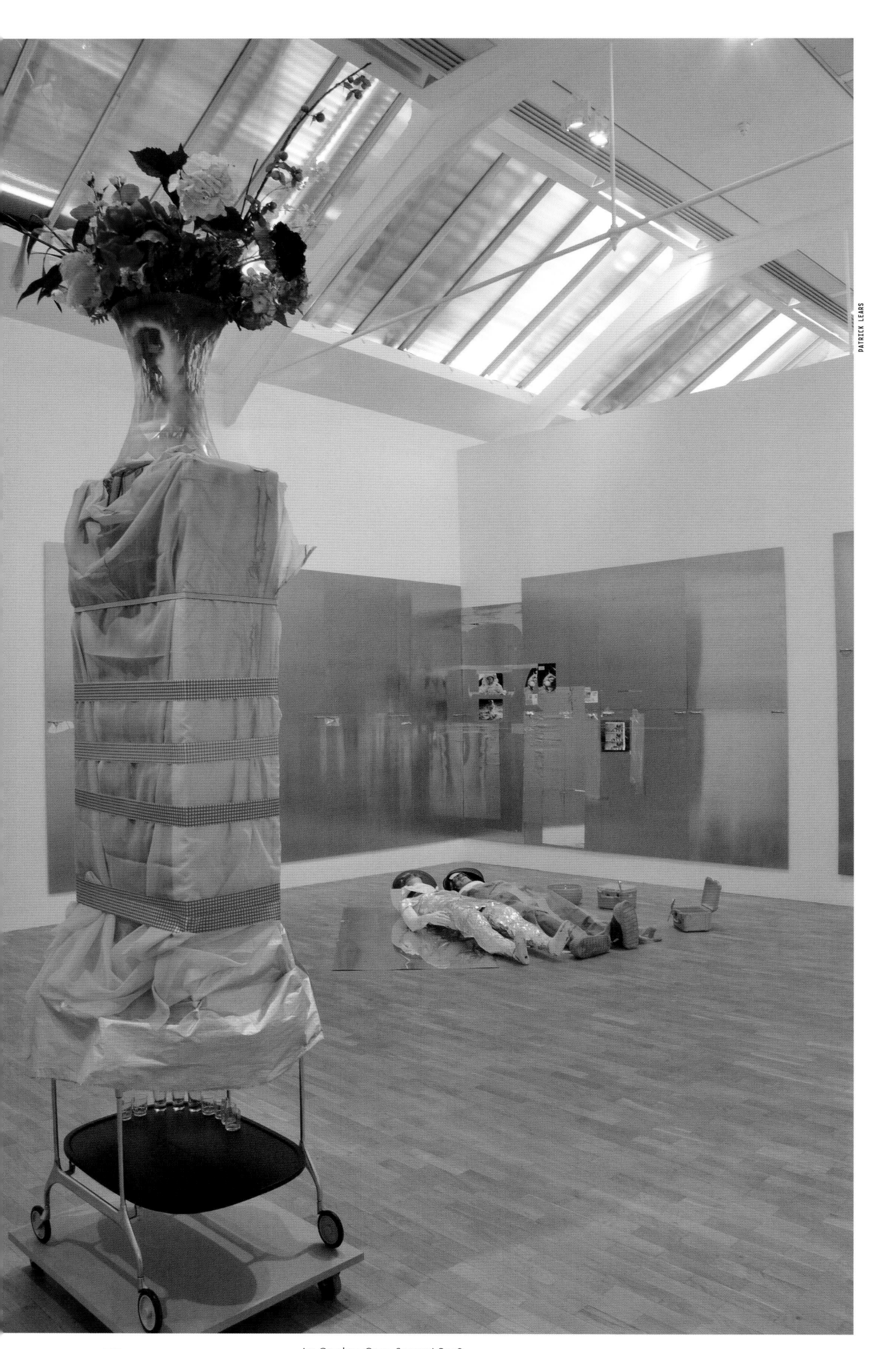

Isa Genzken, *Open, Sesame!*, 2009

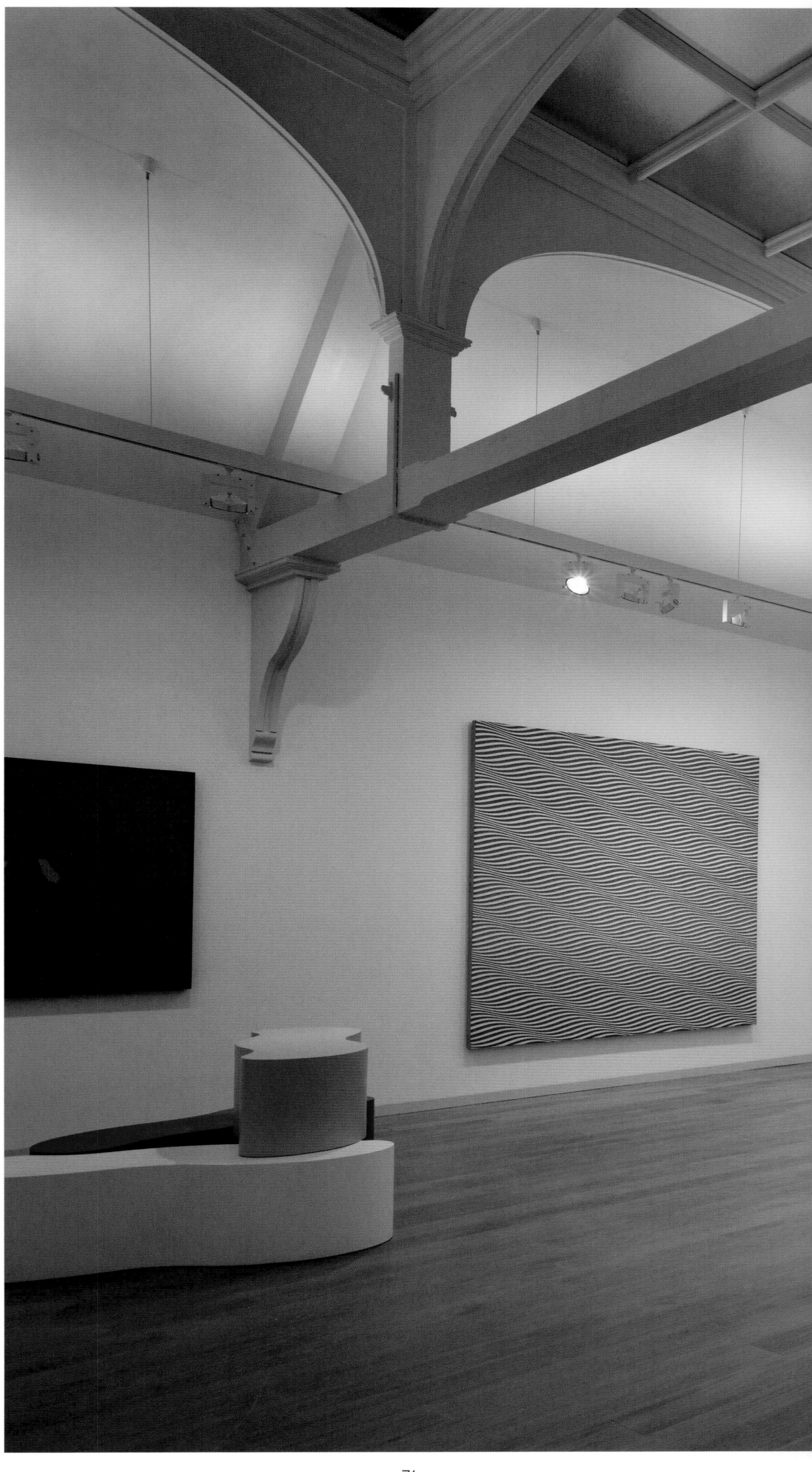

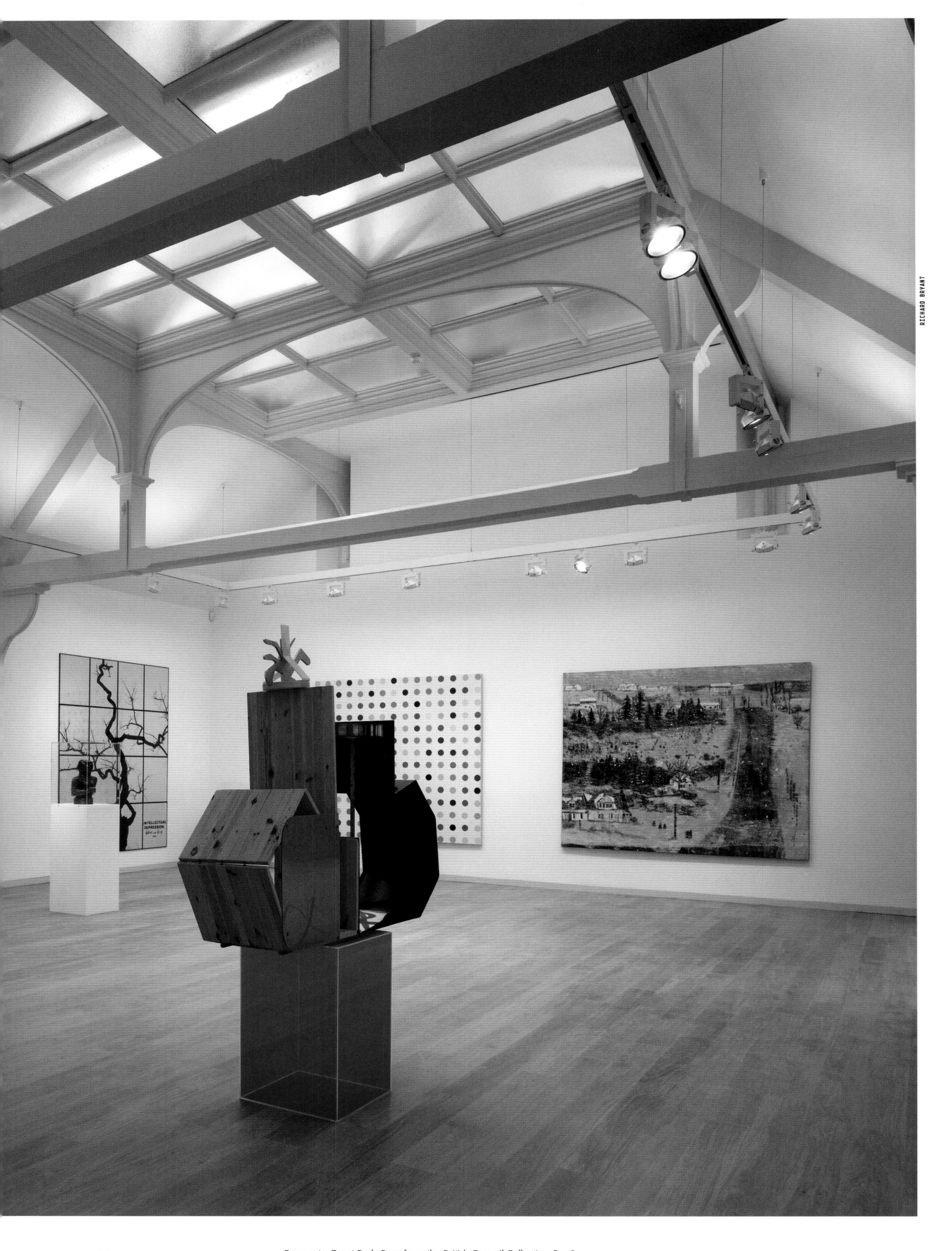

Passports: Great Early Buys from the British Council Collection, 2009

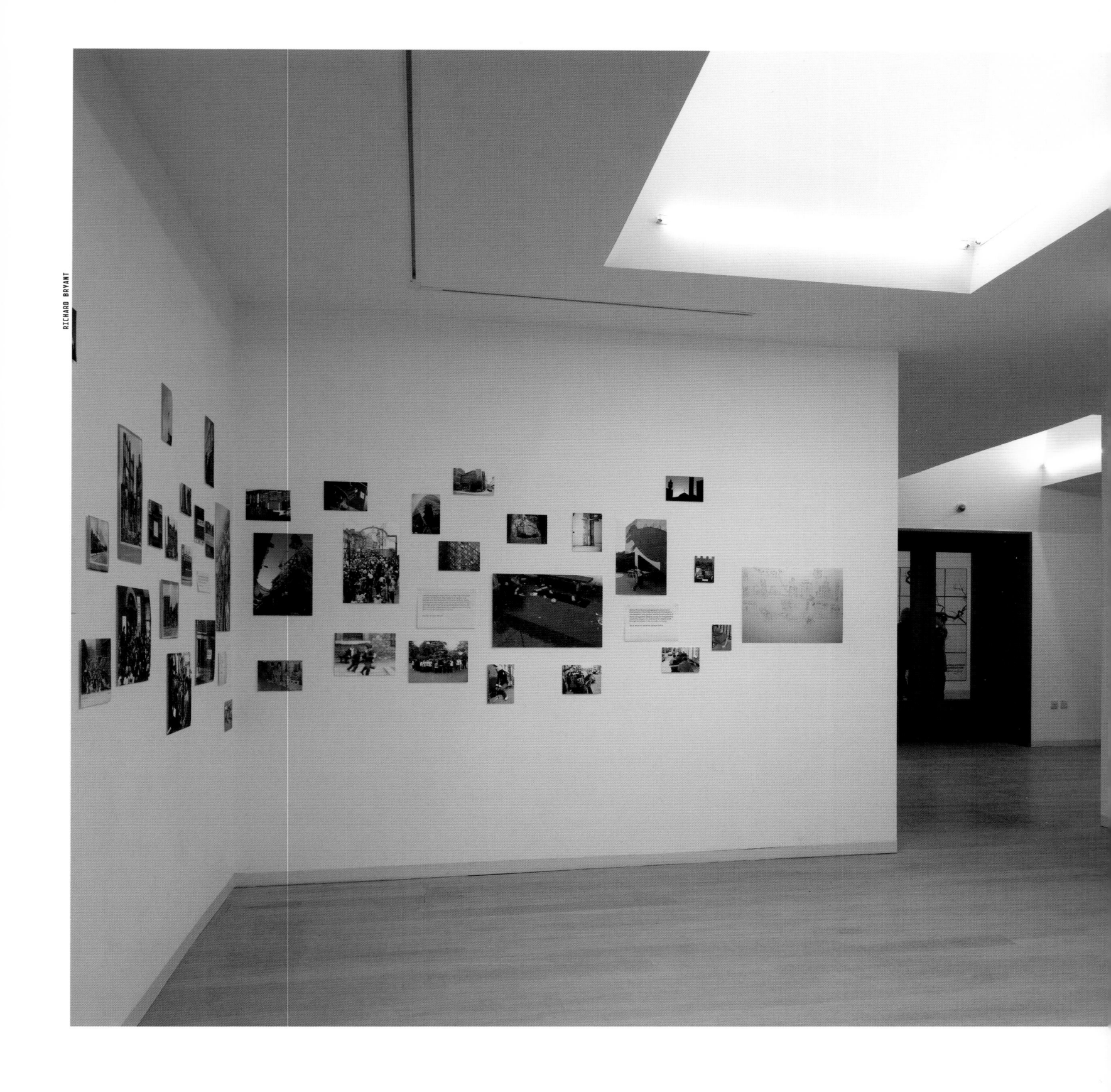

Library staircase

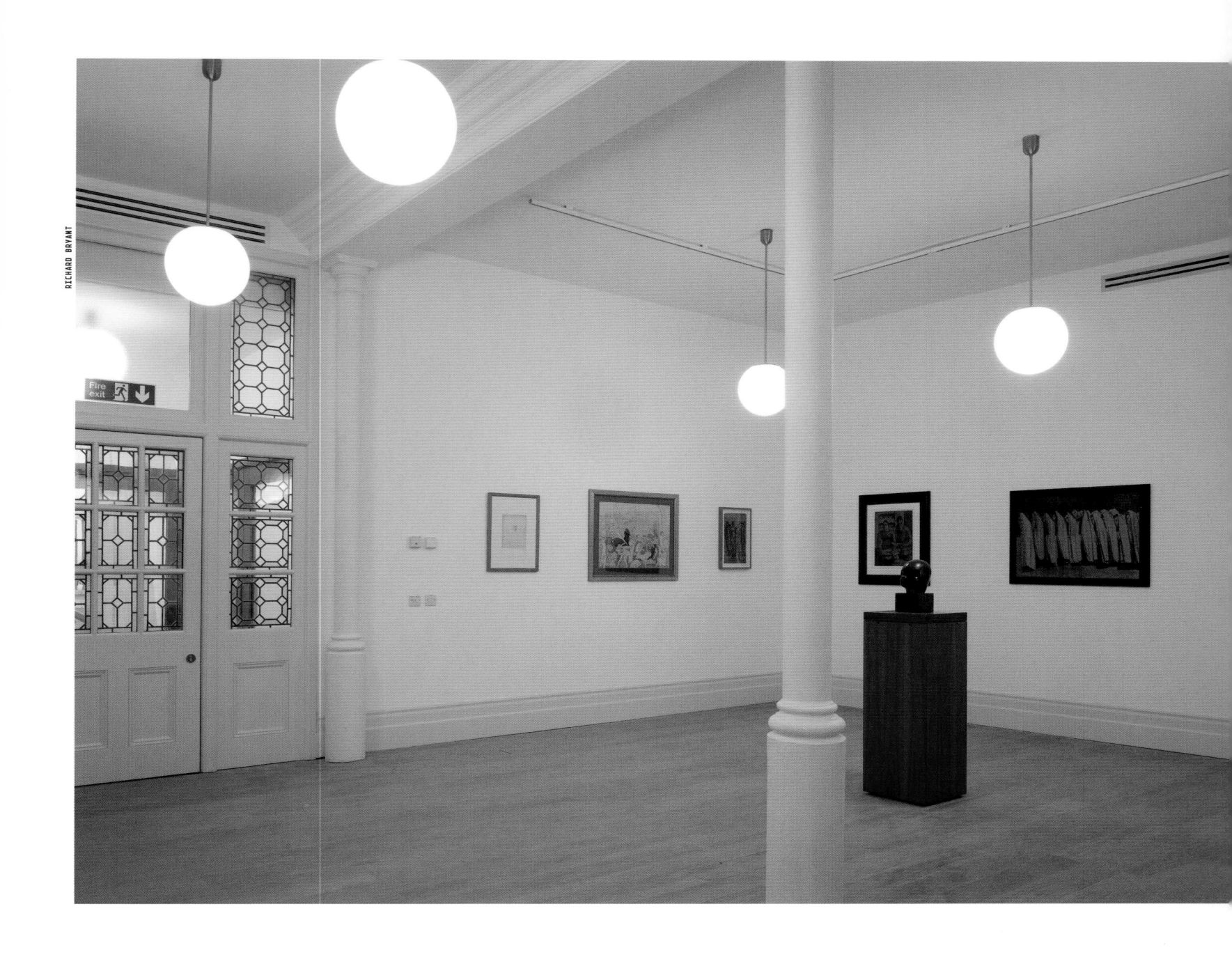

RICHARD BRYANT

Fire exit

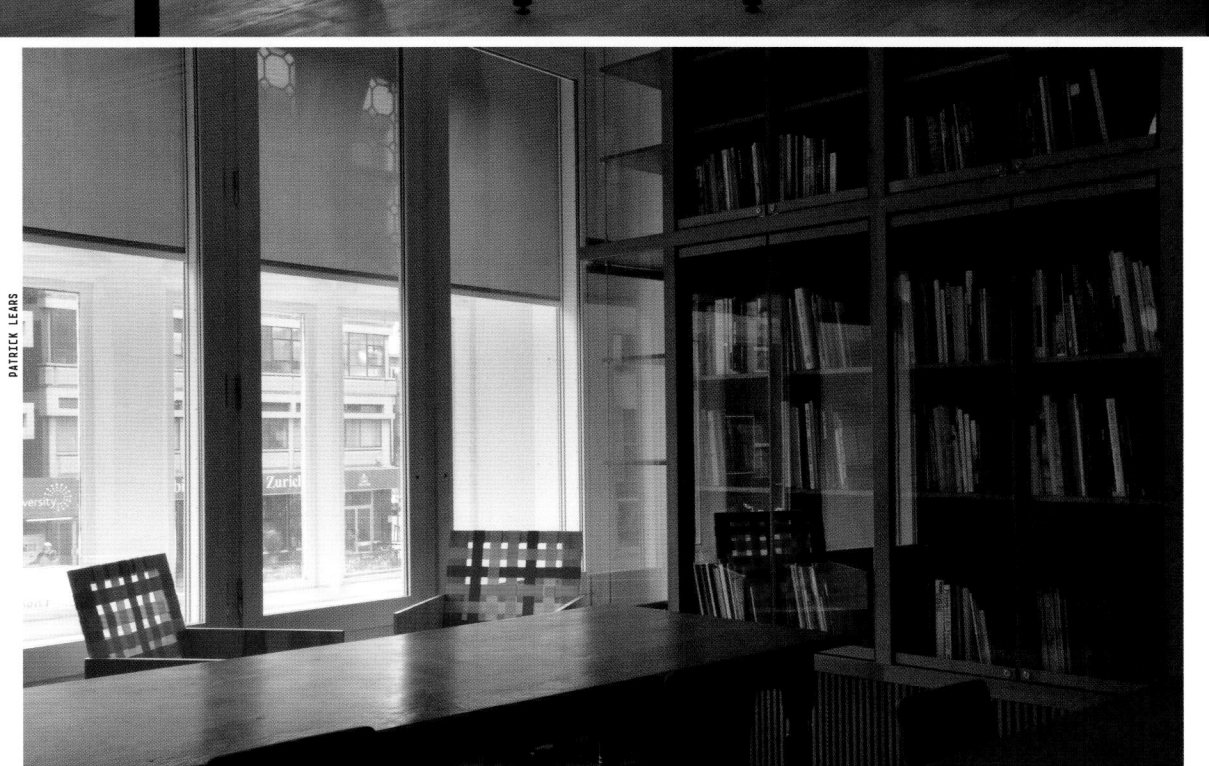

Foyle Reading Room
LEVEL 1

Mary Heilmann, *Clubchair 62* and *Clubchair 63*, 2009

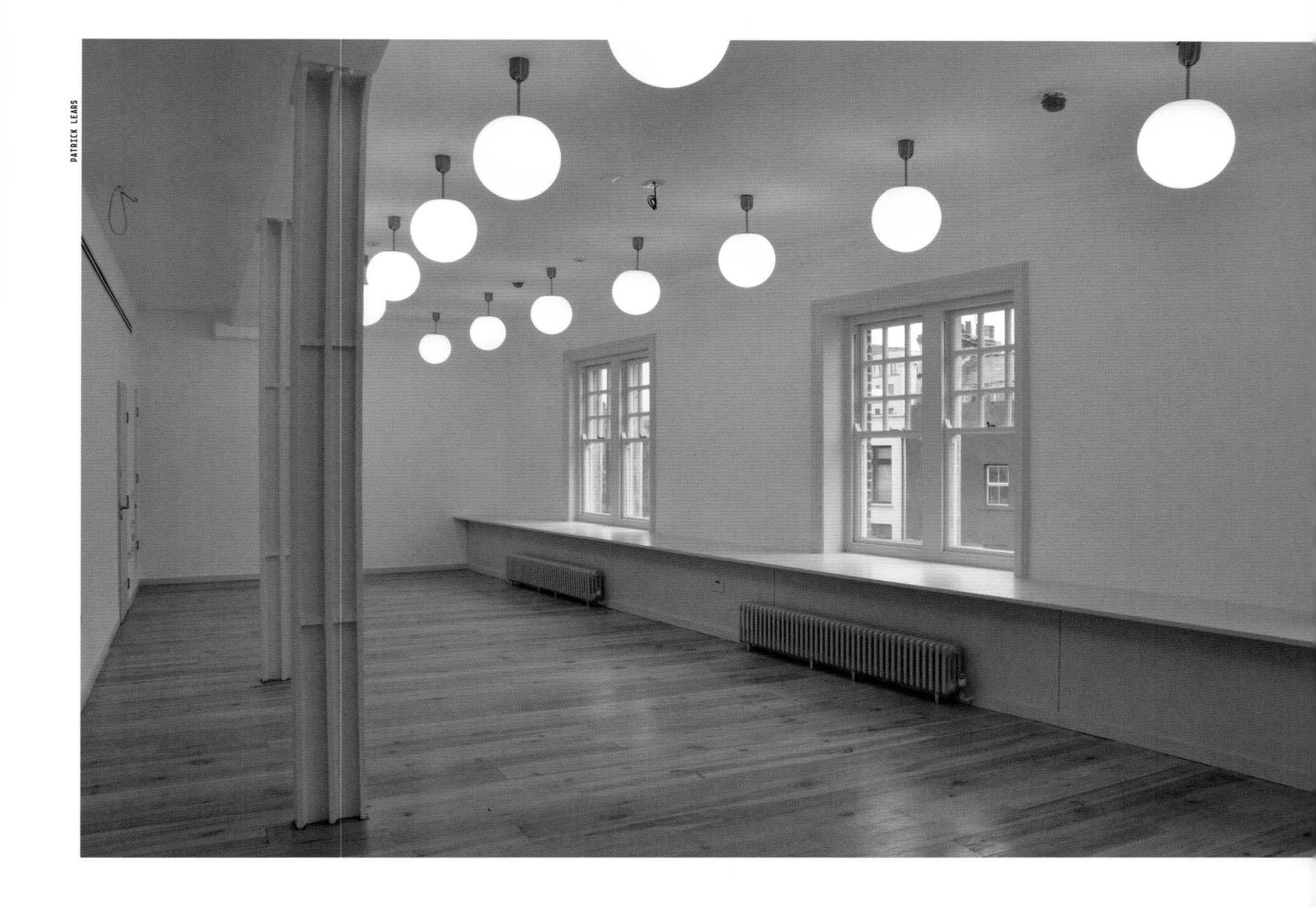

Study Studio
LEVEL 2

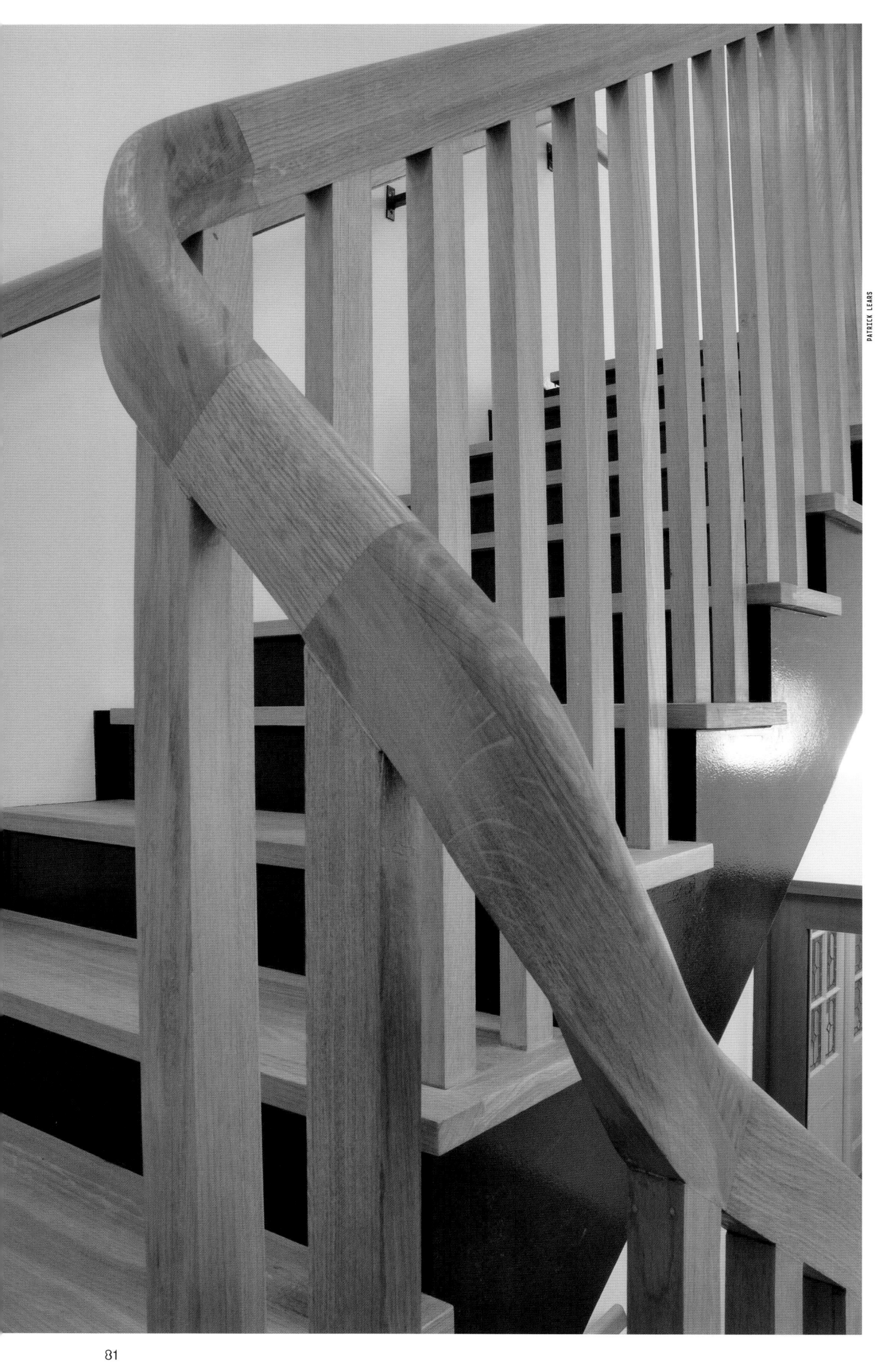

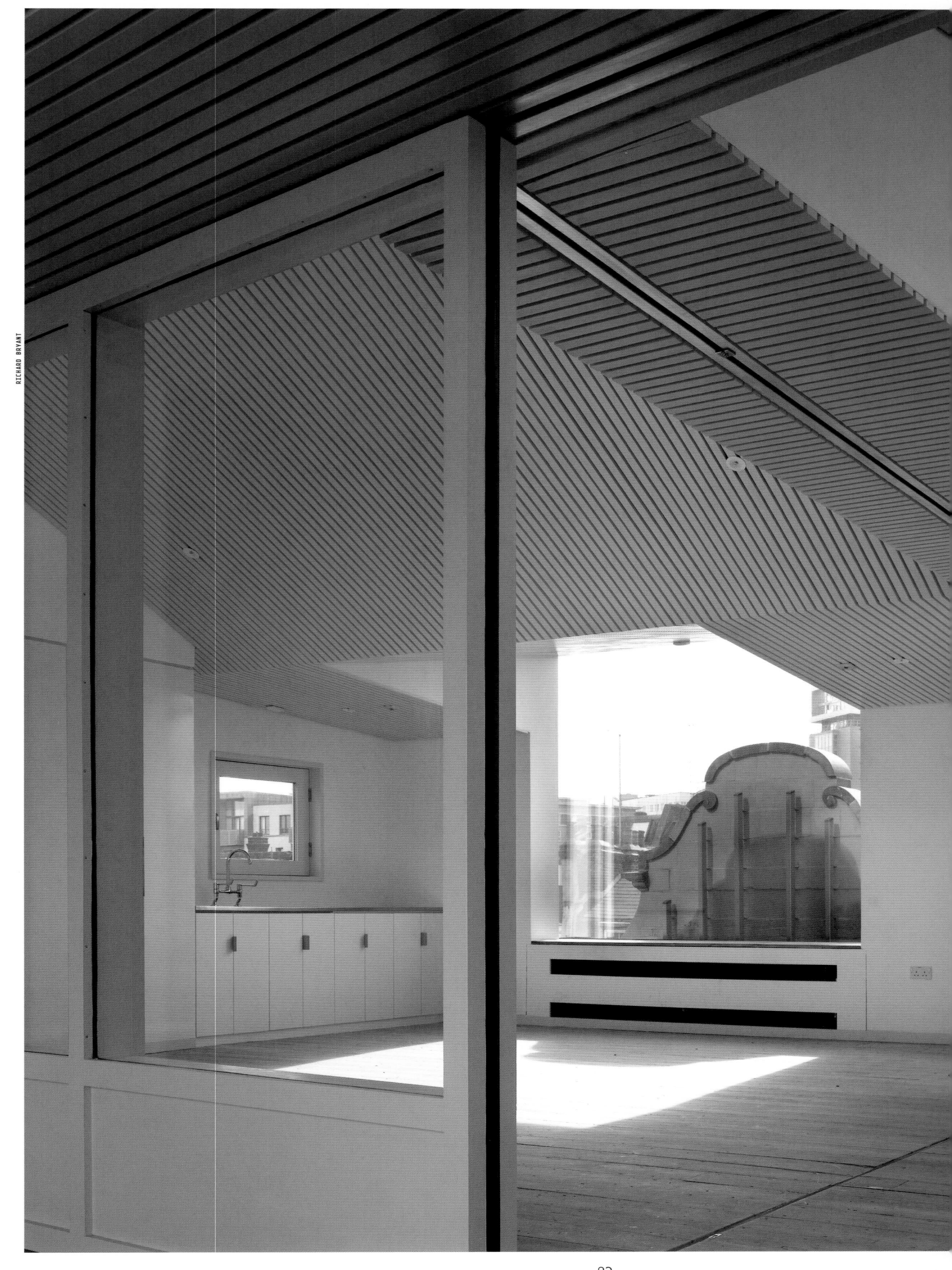

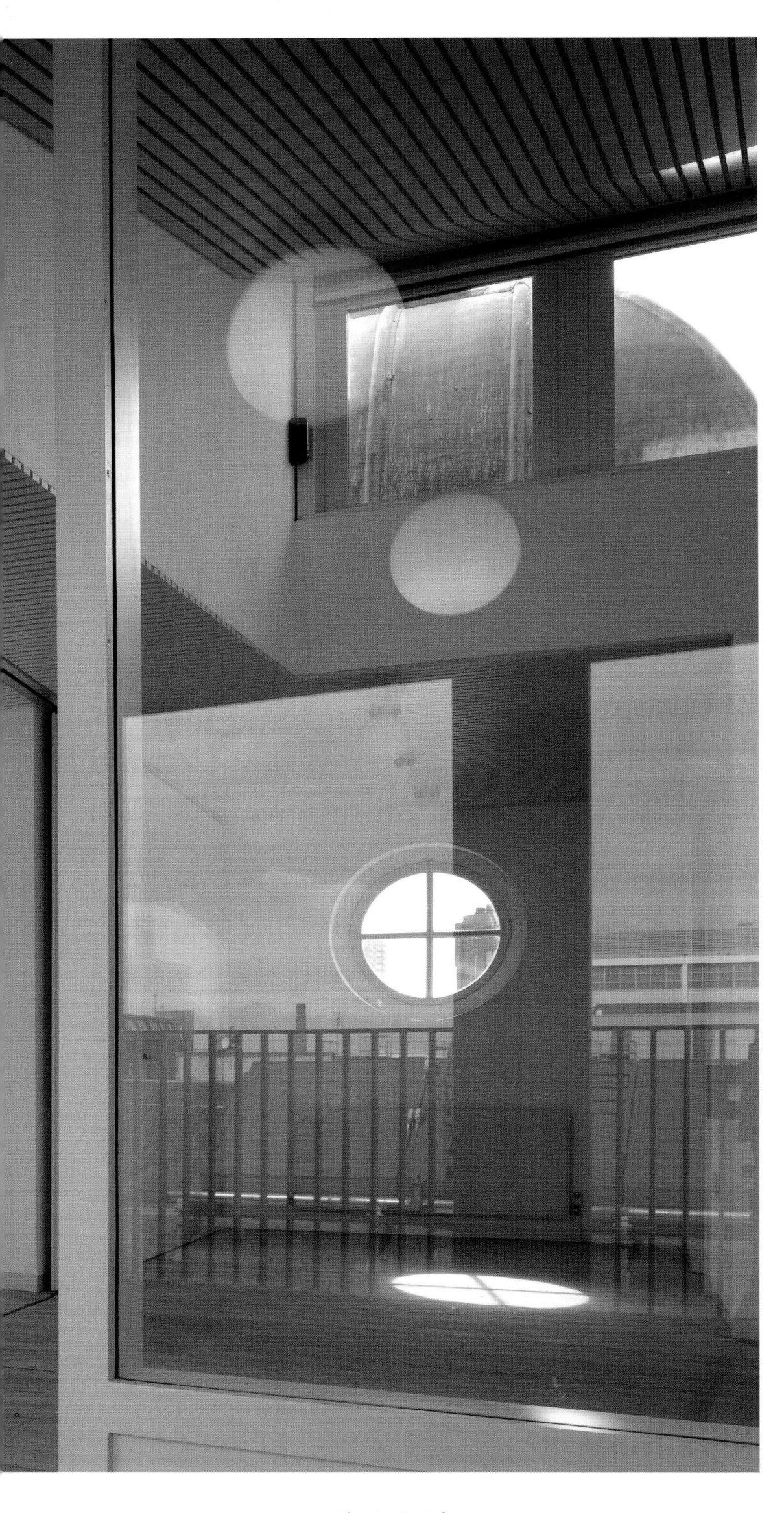

Clore Creative Studios
LEVEL 3

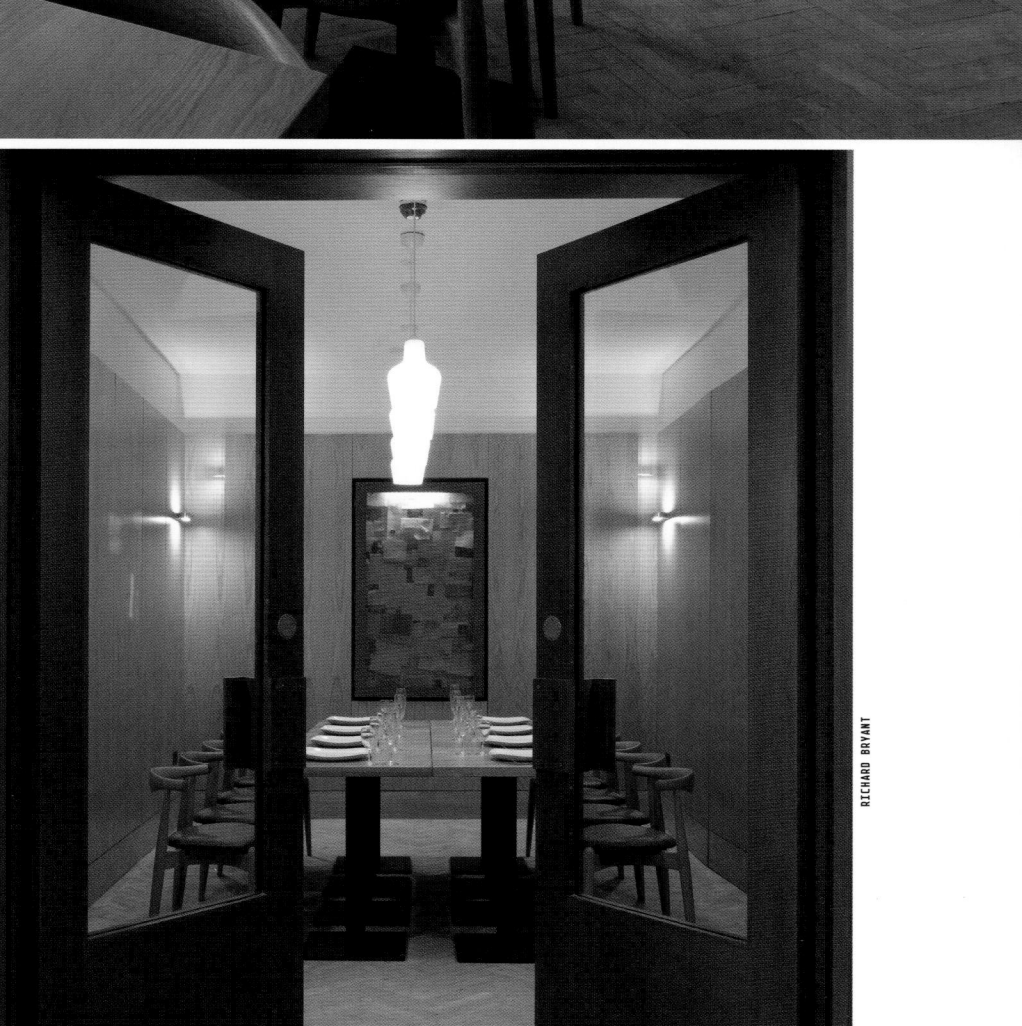

Whitechapel Gallery Dining Room
LEVEL Ø

Library Dining Room
Christian Boltanski, *Vie impossible Whitechapel*, 2002-06
LEVEL Ø

Bookshop
LEVEL Ø

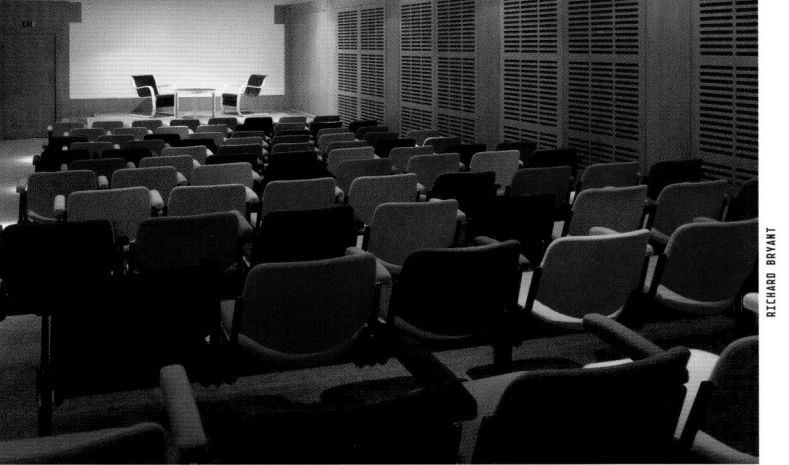

Zilkha Auditorium
LEVEL Ø
Liam Gillick, *PROTOTYPE CONFERENCE ROOM WITH JOKE
BY MATTHEW MODINE (ARRANGED BY MARKUS WEISBECK)*,
1999/2oo9
(joke located in Café/Bar)

Café/Bar
LEVEL N

Liam Gillick, *Adjustment Filter*, 2oo2/2oo9

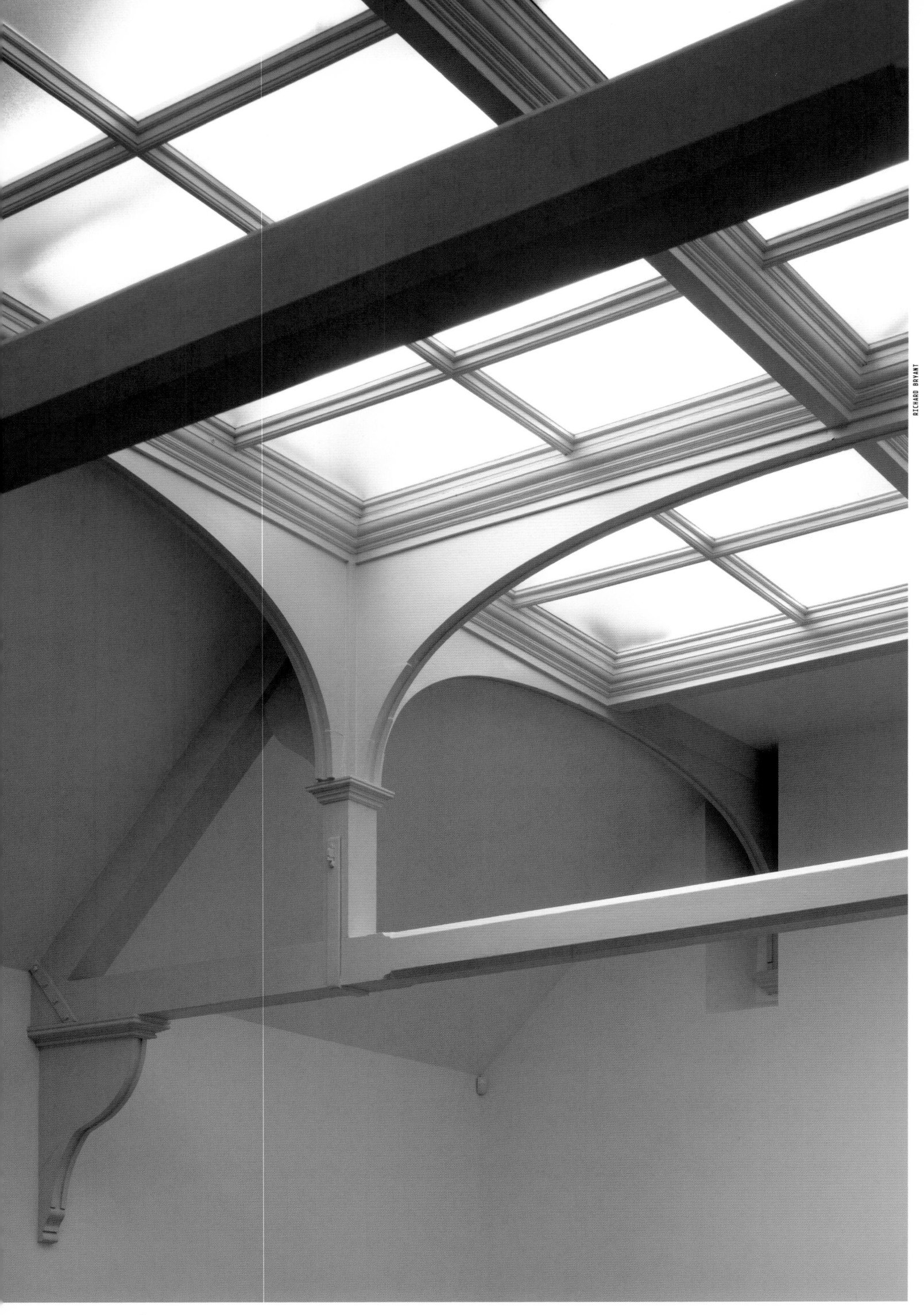

Gallery 7
LEVEL 1

Alice Rawsthorn, Paul Robbrecht and Rachel Whiteread discuss the latest phase in the evolution of the Whitechapel Gallery, its landmark status and the process of the Gallery's expansion.

PAUL ROBBRECHT
from the Ghent-based practice, Robbrecht en Daem Architecten was selected from a shortlist of architects to lead the design team.

ALICE RAWSTHORN
Chair of the building committee and a Trustee throughout the project, chaired the selection panel that chose Robbrecht en Daem Architecten.

RACHEL WHITEREAD
Member of the selection panel and former Trustee, worked as artist advisor on the redevelopment project.

in
conversation

HANNAH VAUGHAN What do you each see
as the main parameters defining the
Whitechapel Gallery redevelopment?

RACHEL WHITEREAD I live in the East End, have for decades, and so have always seen the
Whitechapel Gallery as a fantastic resource. It is especially interesting to be involved in an advisory
role in the Gallery's expansion, because of my interest in contemporary architecture and awareness
of the potential pitfalls when architects design contemporary art spaces. I am thinking of strange
angular walls and things that might be fantastic sculpturally, but which don't necessarily aid the
viewing of art. A more positive example is Tate Modern, where they consulted a number of artist
advisors and it became clear that, in general, artists didn't want brand new buildings. They'd rather
work within a converted site and try and find a way of maximizing a space … somewhere with
lots of light and room for the artist to express themselves, not the architect.

PAUL ROBBRECHT I also have a long relationship with the Whitechapel Gallery. Long before
I took part in this competition, I was a regular visitor. For me, it is an important place of
reference for contemporary art and so I visited often. In 1996 I designed an exhibition at
the Gallery: *Inside the Visible*, 1996, for the former Director [Catherine Lampert],
so I already had a relationship with the very particular, beautiful spaces that the
Whitechapel has — its long galleries, one on top of the other. In the first stages of the
competition, I was particularly excited about visiting the Library. It was inspiring to see
the place still in operation and that very first visit already directed our thoughts.
Looking at the people who were using the Library, they had a very different way of
being — it wasn't like in a museum or an art space where your movements are directed.
This observation would lead to the discovery of a scheme to unite the original
Whitechapel Gallery with this older building.

ALICE RAWSTHORN Like Rachel, I've lived in East London for many years
and have had a very close relationship with the Whitechapel Gallery.
When I came to London as an art history graduate in 1980, the exhibitions
staged there under the directorship of Nicholas Serota were intellectually very
influential and helped to form my sensibility. So this was a fascinating project
— to build on the Whitechapel Gallery's extraordinary history and its particular
reputation. Iwona Blazwick [Director of the Whitechapel Gallery] had very
clear functional requirements for the new Gallery, which to some degree
defined the parameters. Iwona wanted to develop a more experimental,
improvisational approach to showing collections, and to expand the Gallery's
potential for commissions and exhibitions. The Gallery's dynamic community
and education programmes were operating from a postage stamp-sized space
and the poetry and music programmes also needed more physical space.
 If I had to distil the character of the Whitechapel Gallery and the
qualities that make it special, I would say it's all to do with intellectual romance.
That applies to the Library as well as to the Gallery, and I think that given
that they are neighbouring buildings, which are otherwise physically divorced
from each other in every possible way, the architectural challenge of melding
them together was a fascinating one. I felt passionately that it should be
an extraordinary architectural solution. I absolutely cannot see the point of
beginning a project like this unless the results are going to be remarkable.
This was all the more essential for an institution like the Whitechapel Gallery,
which has such a particular, special history that is linked to its location
and curatorial heritage.

RACHEL WHITEREAD There really needs to be a sympathetic melding when you have two such
different buildings. It has to work like that or you might as well just make two separate spaces.

ALICE RAWSTHORN We also have to remember that these are not buildings of
great architectural distinction and it would be silly to be overly pompous
and precious about that. They are, however, buildings of great architectural
character. The Gallery certainly has an imposing façade, and the exhibition
spaces, I think, are among the most beautiful in the world, they're very graceful.
As for the Library, it wasn't particularly innovative, technically or aesthetically.
Townsend was not an extraordinary architect, but it's a gutsy, characterful part
of a very special area of London.

KATRINA SCHWARZ You all seem to view the Whitechapel Gallery with a degree of romantic attachment. Did the fact that people have such a strong, almost nostalgic, connection to the Gallery cause any trepidation when it came to redesigning the space?

RACHEL WHITEREAD We still need to see what happens at the Whitechapel Gallery. I've got every faith Iwona will do a great job — but a lot of people said to me 'why does the Whitechapel need to be bigger? Why do we need more lottery money put into yet another space?' All over the country there are spaces, drawing upon vast amounts of money and effort, which have, quite frankly, failed. But the Gallery has such a strong history and its in a very particular place in London, a place that is really the heartbeat of the art world, with thousands of artists, hundreds of interesting galleries, and I think that will be reflected in Iwona's programme.

ALICE RAWSTHORN Iwona has always had a crystal clear, very inspiring, vision for the Whitechapel Gallery and that is the single most important thing. She could deliver that vision from a barn in Suffolk, or a shack on Brick Lane, and it would be fine. I find the spirit of the Gallery and Library incredibly romantic: the wonderful stories of David Bomberg's poetry readings, the relationship to the Toynbee development, its broader links to the Unitarian movement and the socialist strands of the Arts and Crafts movement in Britain, I find very evocative and inspiring. I felt it was essential to reflect that physically and architecturally in the Gallery. There has been a very interesting volte face in the heritage movement in Britain. A decade, two decades ago, heritage was seen as restoration of the sumptuous, the precious, the special. The heritage bodies have done an excellent job of reclaiming vernacular heritage, which is much more relevant to the family histories of the vast majority of people in the country. So whilst the Whitechapel Library is not a distinguished building, it is a characterful building and every element of it, even the dodgy chimney breasts, tells us something about the social history of Britain. They don't tell us very much about the architectural and aesthetic history of Britain, but that social history really is worth preserving.

I think in a way Paul has reinvented those spaces in a rather dreamlike spirit. It is not what people conventionally think of as the intervention of a contemporary architect into a historical space. You don't suddenly see a dazzling new structure with shiny glass and gleaming metal. Almost all the interventions are subtle, in some cases physically, so that you actually have to crane your neck to see them, but they do affect the experience of being in the space. They have a very strong emotional impact. As construction has continued, this has become more and more apparent. I think it is also important to remember that the Whitechapel Gallery is a gallery that has been reinvented with every exhibition. If you look at the incredible footage of shows from the 1960s, when Bryan Robertson was Director, they were building the temporary walls from breeze blocks and the curators were painting them themselves! You know, back in the bad old days …

RACHEL WHITEREAD (*laughing*) Maybe we can go back to that again …

ALICE RAWSTHORN To return to the question, every visitor does has a very particular response to the Whitechapel Gallery, but repeat visitors will have had myriad responses, partially shaped by the elemental conditions of the building, and partly by the spatial reconfiguration of each show. I think for an architect, that is a particularly invigorating experience. I think it's also worth pointing out that in the competition, not one team of architects proposed changing the existing galleries in any way. They were seen as special, beautiful and sacrosanct. And also perfectly functional.

HANNAH VAUGHAN I'd like to pick up on
that point and direct the conversation
towards Paul

PAUL ROBBRECHT The first thing is understanding the place. What we found interesting was the polarity between the two buildings. The original Whitechapel Gallery had a longitudinal typology while the library, the new main gallery, and the gallery on top are of a more central scheme. Different possibilities, different dimensions and different energies. That lower gallery in the old Whitechapel has four corners. Gallery 2 also has four corners but they're completely different — like a square and a Greek cross. Those two polarities were of tremendous influence to what happened next. We had to connect them, so we had to find spaces in between. We created spaces for art — they're quite small spaces, but small spaces can also be strong. Before, the Whitechapel had the lower gallery, with its big long staircase, and the upper gallery. Now there will be a sense of passing through space, from the huge wide galleries with natural light, through the between spaces. We created a slower relationship between ground and upper floors. When exhibitions are curated, these two different spaces will create a challenge. Some kind of dialogue will exist, maybe opposite things can be happening at the same time …

HANNAH VAUGHAN Alice touched upon the
fact that these were not grand, sumptuous
buildings. Was the idea of the domestic
important to you?

PAUL ROBBRECHT Very much. That is an important element in the education rooms — they are smaller and high above street level. The higher you go, the more house-like the spaces become, the more domestic. We changed the roof completely and introduced wooden planks to the ceiling so that everything is not the abstract white cube. We used materials that you could imagine in a house. Also with regard to dimensions and proportions — you can almost touch the ceiling. When you take the long walk up to the higher space, it's like a tent. Everything feels very close to you, but at the same time it's the place in the gallery where you can actually see the city, all of the city, fragmentally. You're looking over the whole area and onto Whitechapel High Street. From the back you have a really panoramic view — you see the Hawksmoor, you see the Gherkin. You look back to the roofs of Whitechapel as well. It's like you're in the air. On the one hand architecture is this thing that you have to protect you, and on the other — and for me this is an essential element — it is also a tool to understand the world, to situate yourself towards something bigger and that's actually happening upstairs in the Whitechapel Gallery.

ALICE RAWSTHORN I think this picks up on two very important strands in current thinking about the spatial configuration of museums and galleries. One is that traditionally, the education spaces have been the least glamorous, the least salubrious, the least exciting, and Iwona and the team were absolutely adamant that going there had to be a hugely exhilarating experience for those kids, many of whom will come from communities local to the Gallery, so often from very deprived backgrounds. Visiting the Whitechapel Gallery should be an adventure for them, something that really opens their imaginations to the possibilities of architecture and the urban experience. And so it was essential that visiting the education spaces was every bit as thrilling as walking into the very graceful, imposing galleries. The second point is that for much of the twentieth century, museums and galleries were designed to guide the visitor efficiently through those spaces in a prescribed route …

RACHEL WHITEREAD to the shop (*laughs*)

ALICE RAWSTHORN Exactly. That was postmodernism. (laughter) There was a collusion between the administration of the museum or gallery and the architect to really define and dictate the experience of the visitor. This has changed completely because for all sorts of cultural reasons, people are no longer willing to have their experiences dictated to them. You only have to think about the way we use the internet as our primary source of information. We're sort of meandering around, steering our own course, foraging for bits of information here and there. So it's absolutely essential that we give people many, many

different choices in other contexts, including visits to cultural spaces. It will be very interesting to see where people twist and turn, which parts of the building they visit first and how they develop their relationship to it …

RACHEL WHITEREAD But also using it as a resource of a different kind. Not just going to an exhibition any more, but looking at an archive, a specific collection, the education rooms … It's one of the things that I'm looking forward to — using the Gallery and not having to go and submerge yourself in an exhibition. You can just go and do one thing, have a coffee and leave. I think that's quite special.

ALICE RAWSTHORN Yes, it becomes a much more interactive space rather than a passive predetermined one.

HANNAH VAUGHAN The Whitechapel Gallery is often referred to as the 'artists' gallery'. How do you think the redevelopment will effect this claim?

RACHEL WHITEREAD There will be eight great galleries to see stuff in and different exhibitions in those galleries, which will be great. That's only going to expand the experience. Places need to settle into themselves. It's going to have a lead in period but I'm sure people will greatly appreciate it.

KATRINA SCHWARZ And how will the commissions programme alter the way artists and visitors relate to the Gallery?

PAUL ROBBRECHT It will be a long-term, evolutionary process, with the audience able to experience the growing of certain works over time. In the other spaces there will be monthly or bimonthly changes, but with the commissions, there will be this continuous existence of a work of art by a specific artist.

ALICE RAWSTHORN It offers opportunities for reflection but also for revision. One of the wonderful things about London over the last two decades has been this explosion of activity in the visual arts. We're now spoilt and pampered because we're deluged with things to see. I think this creates cultural consumers, people who behave quite voraciously. They run around grazing the art scene, never really staying with anything for that long. Within the course of a year, you would expect to go back to the big new exhibitions at the Whitechapel Gallery, and while there, you would probably pop back in to see the year-long commission, so your thoughts and response to it might change which I think will make it a much deeper, richer experience.

RACHEL WHITEREAD I think that's one of the really exciting things, for me as an artist, to have a place to go back to and see something. The only place that really does that is the Turbine Hall [at Tate Modern] …

ALICE RAWSTHORN … and people have responded so positively and enthusiastically to that. I think it has been a really encouraging benchmark.

RACHEL WHITEREAD (to Alice) You were saying that people 'graze' around London, which they do, but there is also a tendency to have a village that you live and work in, and my village is definitely the East End, so it's great to have this extra resource being put in there.

KATRINA SCHWARZ How do you envisage the relationship between the Whitechapel Gallery and the East End?

ALICE RAWSTHORN The Whitechapel Gallery's relationship to its locality is one of its most important, defining qualities. There are other institutions you can think of internationally, and locally in London, that have a similar sort of rapport. I mean it's impossible to think of the Camden Arts Centre anywhere but in Shrinkville, North West London, whereas …

(*much laughter*)

RACHEL WHITEREAD And this is an East Ender speaking!

ALICE RAWSTHORN … and part of the thing that makes the Camden Arts Centre so special is that it's rooted in that local community. The Whitechapel Gallery has a tremendously complicated and diverse local community. It has an important social responsibility to the broader community, as well as a very special relationship to the artists within that community. Charles Booth's poverty maps [of the late nineteenth century] focused on Whitechapel because the social polarities, between wealthy merchants and bankers, and the poor weavers and seamstresses, were so extreme. The contemporary East End is exactly like that. You have extremes of wealth and poverty, and the Whitechapel Gallery is one of the rare beacons that tries to meld those worlds — which is an important responsibility.

HANNAH VAUGHAN Architecturally, how did you address those concerns?

PAUL ROBBRECHT One of the important things is the way the street and interior will be related. There are three thresholds in this facility: the original Gallery entrance, the entrance to the Library, and the entrance to the subway. There aren't so many art spaces that have this direct relation to the street. Thinking of the High Street in relation to the quietness of an art space in which it is necessary to concentrate, we decided to make a foyer space — again like an in-between space or an incubator. This relation to the street, it's very special — and all the things that happen on Whitechapel High Street — you cannot imagine!

ALICE RAWSTHORN Interestingly, in our research amongst the local community, people did not want the new Gallery to have too direct a relationship to the street, because one of the things they valued most about the Gallery was that it offered a kind of sanctuary. These are not cultural tourists zipping in and being exhilarated by the eclectic, scuzzy, grungy neighbourhood, they deal with the reality of it everyday and they realize how tough and stressful it can be and so want something different from the Gallery. Whereas the Library, when it was open, I always found a very inspiring place because …

RACHEL WHITEREAD It was a bit like a Tardis, wasn't it? You opened these big cranky doors and then you were in …

ALICE RAWSTHORN … One of the long term directions for visual arts institutions like the Whitechapel Gallery is to become much more rooted in their local communities. If you look at the way institutions like the Tate, even the V&A, have taken on talks, debates, symposium, gigs, performances, dance — that's a much more dynamic strand of their programming now. The Whitechapel Gallery was a pioneer of that, which creates a very different relationship with the local and broader community, rather than the very specific relationship of people going there to look at exhibitions. So if you talk to say, avant-garde poets buffs in London, they don't think the Whitechapel is the 'artist's gallery' at all. They think it's theirs. And there's a whole alternative community of young unsigned bands who again feel that sense of total possession. And that's exactly as it should be. They should all co-exist quite comfortably.

HANNAH VAUGHAN In researching Harrison Townsend's original plans and the obstacles he faced, we were interested to note that so many architectural details presumed integral to his original designs were really the result of budget restraints. What comparable encounters have informed your designs, Paul?

PAUL ROBBRECHT More money would always be OK. I'm used to working on the continent, and I can only do half with the money here, it's so expensive! That was maybe a bit of a shock to us. But of course, the building is the building and we explored it completely. We're using every corner of it …

RACHEL WHITEREAD Could I just interrupt, because I worked with Paul on this and I think he did an amazing job before anything even started in actually visualizing, and it's quite rare in my experience as an artist, to be able to actually visualize space and try and work out, looking through that wall, and that wall, and that wall, what you can do with it. And I really think he was able to make that concrete before he even put pen to paper. So you didn't have any shocks, and it was very sensitively done.

HANNAH VAUGHAN How do you think the 1980s redevelopment sits alongside this more recent work?

ALICE RAWSTHORN I think that again that's part of the story because that was an enormously important period in the Whitechapel Gallery's development. Its curatorial reputation had been augmented by Nick Serota during the 1980s and at a time when there was no lottery funding for capital projects in Britain, it was very, very unusual to get any money to build anything in the arts sector, somehow, miraculously, he and the board managed to raise money to expand the Gallery. That obviously then defined the Whitechapel Gallery through the 1990s and in the early years of this century. And as Paul says, the key architectural features of that development — the Colquhoun + Miller development — were the staircases. I mean you look at them and you can date them to the mid-1980s instantly. Its sort of subtle postmodernism. Now Paul demolished one of those staircases but the other will be part of the redevelopment and I think that is an example of the honesty of the restoration. If you had a vision of a purist early-twentieth century building, you would have undoubtedly removed that staircase from the equation, but it is symbolic of that important part of the Gallery's history …

RACHEL WHITEREAD But also, if it ain't broke don't fix it, you know, because the galleries have beautiful proportions, they're classic, great art galleries so why change that? And I think that's what everybody realized.

ALICE RAWSTHORN One thing that will surprise and hopefully delight people about the solution is that it's not a new building or a contemporary architectural project in the conventional sense. They won't go in and see dazzling contemporary structures. Paul's approach to architecture involves choreographing the sensory experience of being in different spaces and the experiential nature of those spaces changing. So your relationship with them evolves. His interventions are physically very subtle. They're very intelligently, elegantly and quietly done … I think there is such disillusion now with one-shot iconic architecture and not only within the architectural community but among the broader public, and mercifully the new Whitechapel Gallery will fit very neatly into that.

RACHEL WHITEREAD It needs to be comfortable …

ALICE RAWSTHORN Exactly. It's subtle, it's substantial and there's nothing showy, shallow, sparkly or superficial about it. I think people will feel much more empathetic towards it than they would a more sparkly, spangly, glittery, iconic architectural statement. I think that would seem very inappropriate right now and that's not what they're going to get.

Photographs:
Alice Rawsthorn, courtesy *International Herald Tribune*
Paul Robbrecht © C.Olsson
Rachel Whiteread, photograph Johnnie Shand Kydd

Detail of the frieze on the gallery façade

social sculpture

For the Arts and Crafts movement of the 19oos the
domestic artefact offered the potential
of making the union of function with
craftsmanship and aesthetics available
to everyone. This ambition has resonated
through many of the avant-gardes of the
twentieth century such as the Bauhaus
and Constructivist movements; and
in the post-war period, artists such as
Donald Judd, Scott Burton, Jorge Pardo
and Andrea Zittel, who expanded
their sculptural ethos into the making
of furniture.

In the 199os and early twenty-first centuries numerous
artists have looked to furniture, graphics,
product design and architecture
to find ways of incorporating a
phenomenological and social
dimension in their work.

They offer objects, spaces and situations which may
be occupied and acted upon. We can
become absorbed into their works, which
may offer a space for contemplation,
discussion, illumination — or just
an opportunity to sit down.

Throughout the public spaces of the Whitechapel Gallery
— the foyers, landings and stairwells
that articulate the building, as well as
the external façade and environs —
visitors will encounter works by
Christian Boltanski, Janet Cardiff
and George Bures Miller, Liam Gillick,
Rodney Graham, Mary Heilmann,
Henry VIII's Wives, Annie Ratti,
Tobias Rehberger, Richard Wentworth
and Franz West.

IWONA BLAZWICK

CHRISTIAN BOLTANSKI
b. 1944

Vie Impossible Whitechapel

2002–06
Painted wooden box with papers, wire mesh and light fitting
144 × 84 × 7 cm
Courtesy Whitechapel Gallery, London

Christian Boltanski's acclaimed practice encompasses installation, photography, artists' books, mail art and film. His materials often make reference to a person's lived experience, with second-hand objects forming an essential element of his work. Boltanski is known for his interrogation of concepts of selfhood and, in relation to this, the malleability of memory and the unreliability of autobiographical narrative.

Vie Impossible Whitechapel, 2002–06, draws upon the artist's solo exhibition at Whitechapel Gallery in 1990. The work functions at one level as a record of Boltanski's experience. Assembling a variety of objects, including photographs, notes, letters and critical texts, *Vie Impossible Whitechapel* is a memorial — or rather an anti-memorial. The work is concerned with the inability of memory to entirely capture the full complexity of experience, and is constructed in the form of a personal archive. Archives are repositories of past events; but they are only records of incidents or processes, which lack the personal or communal narratives that gave them meaning in the past. Boltanski's very personal archive consists of records belonging to the artist, and relics of his activity in that particular phase of his life.

Commenting on *Vie Impossible Whitechapel,* Boltanski explains:
Everyone owns boxes of papers which are precious to them in life. However the people who discover them after the owner is dead cannot see the significance of one piece of paper over another … If I died tomorrow in this box there will be papers and letters documenting what happened, but no viewer can really understand what it all meant …

Through the appropriation of amateur photographs, and the methodologies of inventory keeping and museum display, Boltanski's seemingly 'objective' archives of real life are an attempt to reconstitute history and collective memory. His art combines humour and irony with a compelling melancholy, whilst exposing its manipulative character and seductive intelligence.

Christian Boltanski lives and works in Paris, where, since 1986, he has taught at the Ecole Nationale Supérieure des Beaux-arts. His artistic career began in the late 1960s, and since then he has had numerous major exhibitions in museums and galleries around the world, including Tate, the Centre Pompidou and the Contemporary Arts Museum in Houston. He has also participated in documenta, 1972, 1986, and the Venice Biennale, 1986, 1993. For the inaugural Folkestone Biennial in 2008, Boltanski created a sound piece, *Whispers,* comprising letters written by and to servicemen in the First World War. He has been the recipient of the Laureate of the Praemium Imperiale, Japan Art Association, 2006; the Kaiser ring, Mönchehaus Museum, Goslar, 2001 and the Kunstprize, Nord/LB, Braunschweig, 2001.

JANET CARDIFF
b. 1957
& GEORGE BURES MILLER
b. 1960

The Missing Voice:
Case Study B

1999
Audio walk, 50 minutes
Commissioned and produced by Artangel

The artist is by your side, at your shoulder, in your ear. You stand together in the crime section of the library. The artist's voice is insistent and intimate, she wants you to follow her: 'There are some things I need to show you' …

Janet Cardiff's *The Missing Voice (Case Study B)*, a 1999 Artangel commission and Cardiff's first work created in the United Kingdom, is a sonic head-trip that began amidst the hushed readers and rustling pages of the Whitechapel Library. With headphones in place, at the push of a button, Cardiff's *noir*-ish narrative wends its way through the Library building, into the surrounding streets (Brick Lane, Spitalfields, Bishopsgate) and bustling spaces of London City.

A woman says, 'sometimes I just want to disappear'. Selves split. You are being followed, and you follow in turn.

Cardiff's clipped voice collides with snatches of film dialogue, detective reports, the noise of sirens, of a passing parade, and always footsteps, which trace a fractured narrative of flight, pursuit, a mysterious redhead, an unknown threat. Told in multiple voices, encompassing ominous and incomplete stories, *The Missing Voice* maps a 'psychogeography' of impermanence and transformation:

I wonder if the workers ever think about
themselves as the changers of the city
the men that cover up the old stories
making room for new ones

It might strike us as fitting and uncanny that in the relocation of the Whitechapel Library, Cardiff's *Missing Voice*, a work patently concerned with the changing cityscape and with the past within the present has itself been subject to a kind of erasure. The Library is gone, but in a city full of ghosts spectral traces remain. Cardiff describes her work thus:

My relationship with the Whitechapel Library is through the senses. I spent a lot of time there walking around listening and recording. My memories are not describable really as they are about the disconnected aftereffects of experience. They are about how the murmuring of the visitors mixed with the musty air and the smell of books. A library heightens your senses so you hear the turning of pages and the phone ringing, the muted footsteps on the worn carpet. I loved the small spiral staircase that is now absent, the paint peeling off the ceiling of the vaulted stairwell and the light coming into the front upstairs room, the windows there so thin that you could hear the traffic outside. When I walked through the space after the renovations I could still feel the presence of the books and the people unable to lose the visual and aural pictures that are embedded in my mind.

Janet Cardiff works in collaboration with her husband George Bures Miller, in a practice much concerned with immersive installation and audio walks. Referencing diverse musical, literary and cinematic genres – spanning medieval plainsong to pulp fiction – their absorbing sound and filmed works enact journeys both physical and psychological. Since 1999, Cardiff and Bures Miller have expanded their audio walks to include the moving image. Works such as *Ghost Machine*, 2005, at the Hebbel Theatre, Berlin and *Conspiracy Theory / Théorie du Complot*, 2003 at the Musée d'art contemporain, Montreal, are shot on binaural audio and video and then replayed by the viewer on the same site, causing a strange co-mingling of past and present as different realities overlap.

The Missing Voice has been re-installed within the expanded Whitechapel Gallery.

LIAM GILLICK
b. 1964

Adjustment Filter

2002/2009
various materials
In collaboration with Nick and Alison Digence

PROTOTYPE CONFERENCE ROOM WITH JOKE BY MATTHEW MODINE (ARRANGED BY MARKUS WEISBECK)

1999/2009
(joke located in Café/Bar)
various materials by Kvadrat, coloured cloth
Courtesy the artist

A good anecdote is something you can really dine out on and Liam Gillick satiates our appetite for humorous diversion. The artist's joke, transcribed in no-nonsense Helvetica on a wall-mounted mirror within the Gallery café, subtly alters the space and is a spur for contemplation and conversation. The absurd, misspelled, namedropping gag provides a witty and wordy entry point into Gillick's ongoing exploration of utopia — understood in the etymological sense as 'literally no place'. The evocation of Stanley Kubrick highlights the artist's identification with the filmmaker, who is likewise involved in the exploration of utopian and dystopian realms; while the imagined space in which Kubrick is represented references the strategies of displacement at the heart of Gillick's practice. The joke is a conduit to meaning; its allusion to an obscure form of realization providing the stimulus for storytelling, which is so crucial to Gillick's belief in the participatory potential of art.

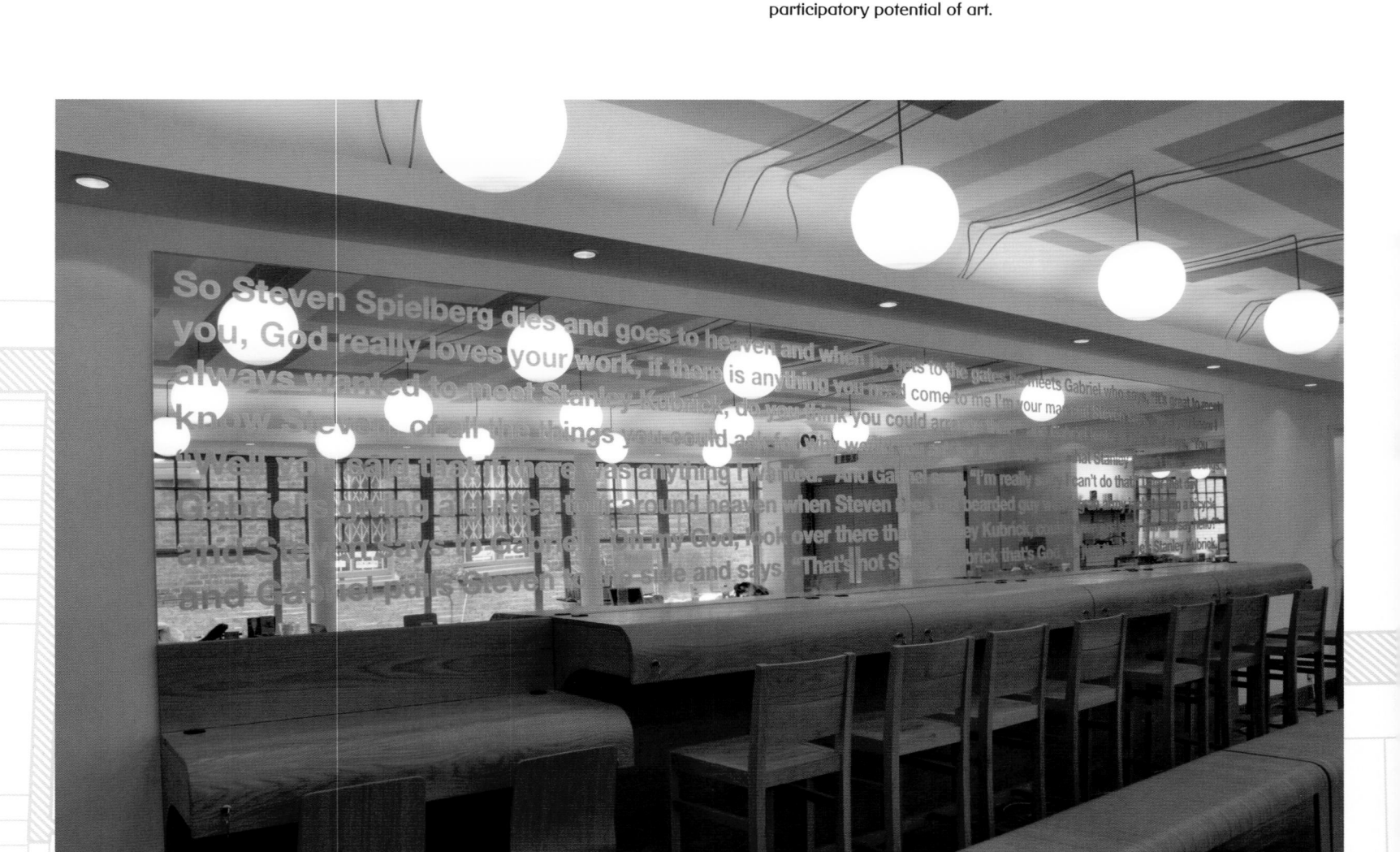

So Steven Spielberg dies and goes to heaven and when he gets to the gates he meets Gabriel who says, "It's great to meet you, God really loves your work, if there is anything you need come to me I'm your man and Steven says, "Well you know I always wanted to meet Stanley Kubrick, do you think you could arrange that?" and Gabriel looks at him and says, "You know Steven, of all the things you could ask for why would you ask for that? You know that Stanley doesn't take meetings. "Well you said that if there was anything I wanted." And Gabriel says, "I'm really sorry I can't do that." Later that day Gabriel's giving a guided tour around heaven when Steven sees this bearded guy wearing an army jacket riding a bicycle and Steven says to Gabriel, "Oh my God, look over there that's Stanley Kubrick, couldn't we just stop him and say hello?" and Gabriel pulls Steven to the side and says, "That's not Stanley Kubrick that's God, he just thinks he's Stanley Kubrick."

Adjustment Filter, Whitechapel Gallery Café/Bar

Describing his practice, Gillick says:

The contemporary art centre is a place where the visitor is occupying a specific type of negotiable location, which is very different from the classic late-modern idea that the visitor completes an exhibition. The contemporary space is still activated by people in the sense that the work does not necessarily function best as objects for consideration alone, it is sometimes good as a backdrop or as a décor rather than a pure content provider. My work is rooted in a negotiation of the way ideologies leak through into the built world. I am not interested in architecture alone, but in the revised practices of the most dynamic people involved in changing the way our urban environment looks and feels. The problem with many people involved in contemporary art in relation to architecture is that they ignore the most dynamic set-ups that are possible in the discourse around contemporary urbanism. They focus on the products not the production methodology.

Gillick's intervention continues downstairs, where his brightly-hued seating plan, *PROTOTYPE CONFERENCE ROOM*, 2002/2009, brings light and life to the Whitechapel Auditorium. Reversing the typical order of prominence within the viewing space, the artist draws visitors' immediate attention away from the stage and screen and toward the chairs, which have been upholstered in myriad colours with Kvadrat fabrics.

Liam Gillick is a British artist who lives and works in London and New York. In 2009, his work will be presented in the German Pavilion at the 53rd Venice Biennale. Significant recent exhibitions include the retrospective *Three Perspectives and a Short Scenario. Work 1988–2008*, a series of four independently curated exhibitions presented at Museum Witte de With, Rotterdam; Kunsthalle Zurich; Kunstverein München, and the Museum of Contemporary Art, Chicago. Gillick's 2002 exhibition at Whitechapel Gallery, *The Wood Way*, was nominated for the Turner Prize.

PROTOTYPE CONFERENCE ROOM, Zilkha Auditorium

RODNEY GRAHAM
b. 1949

Weathervane

2oo7
Copper, steel
c. 147.3 cm high
Edition no. 2 /3 plus 1 Artist's Proof
Courtesy Whitechapel Gallery, London

Rodney Graham's multilayered oeuvre encompasses photography, sculpture, installation, film, music, performance and writing. His practice examines social and philosophical methodologies, with particular emphasis on systems of thought derived from the transition of Enlightenment into Modernism.

Weathervane, 2oo7, is a portrait of the artist in the guise of Dutch Humanist Erasmus, reading a book, seated backwards on a horse. Posed in costume, as depicted by Hans Holbein the Younger in 1523, Graham deploys strategies of appropriation and transformation to insert himself into art history. In this guise he is destined for untold revolutions. Weathervane is essentially circular in structure, its endless rotation and reverse rider necessitate their own operating logic – one based on disorientation, humour and the absurd. Always intended for display in a public space, the literary and art-historical references inherent in the sculpture find their echo in the merged Library and Gallery buildings, for which Graham's sculptural self-representation serves as crown and focal point.

Canadian artist Rodney Graham lives and works in Vancouver. Since the mid-197os he has produced a rigorous and complex body of work that has been exhibited internationally, including at Centro de Art Contemporaneo De Malaga, Spain, 2oo8; Sprengel Museum, Hanover, for which he won the Kurt Schwitters Prize, 2oo6; the Museum of Contemporary Art, Los Angeles, and the Art Gallery of Ontario, 2oo4; Whitechapel Gallery, London, K21, Dusseldorf, Musée d'Art Contemporain, Marseille, 2oo2; and the Wexner Centre for the Arts, Columbus, 1998. In 1997, he represented Canada at the 47th Venice Biennale and in 2oo6 his work was included in the Whitney Biennial. In 2oo2 Graham produced a domestic-scale weathervane for Parkett Editions based on a drawing of the artist riding a bicycle backwards. Weathervane is the inaugural public work commissioned for the expanded Whitechapel Gallery.

'Rodney Graham's work implicates itself in a complex of philosophical, aesthetic, historical and social issues, and does so in novel and unexpected ways.'

Jeff Wall, excerpt from 'Into the Forest', *Rodney Graham: Works from 1976–1994*, 1994

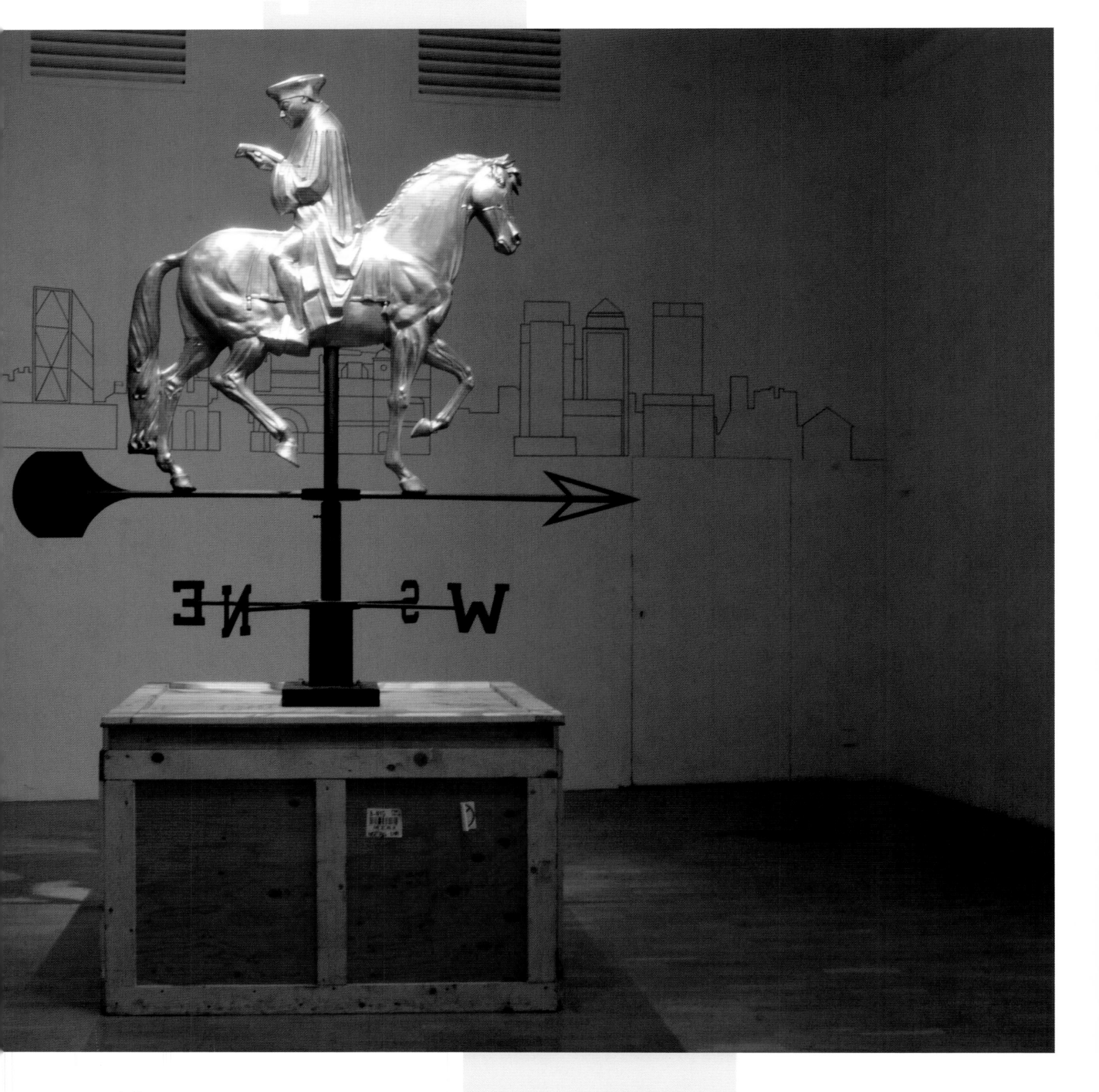

MARY HEILMANN

b. 1940

Clubchair 62
Clubchair 63

2009
Stained wood with polypropylene webbing
84.5 × 63.5 × 67.3 cm
Collection of the Artist, Courtesy Hauser & Wirth, Zurich, London
and 303 Gallery, New York

American artist Mary Heilmann is a pioneering painter, whose work
is informed by elements of abstraction, popular culture and craft.
Heilmann spent her childhood on the West Coast of the United States
— an experience that reveals itself in her vivid, colourful palette, radiant
with optimism and a sense of illimitable possibility. In 1969 Heilmann
moved to New York, where she became acquainted with the great
exponents of Pop Art, Minimalism and Colour Field painting. The glossy
surfaces and chromatic grids favoured by these movements also echo
through her work, cherry-picked and absorbed into the pluralist art of a
postmodern scavenger. Though best known for her paintings, Heilmann's
anti-hierarchical practice extends beyond the wall, to reach ceramics,
textiles and furniture. Representing this latter aspect of her practice,
two *Clubchairs* have been loaned to the Whitechapel Gallery.
Made from stained wood and polypropylene webbing, this is
resting elevated to aesthetic experience, in which the viewer, now
re-inscribed as a 'sitter', is invited to take a seat and to engage with the
sculptural form. The *Clubchairs* are upholstered in a mesh of geometric
stripes and coloured with the vibrant hues for which Heilmann's paintings
are renowned.

*Each time I do a show, or am in a group show, I think of it as
one installation piece. I think of the people who come to see
the work as part of a picture, part of a story. My paintings
and sculptures can be seen as representations of thoughts
and ideas. I like to scan my eyes around the room and read
the show like a storyboard. And I hope my visitors do that too.
That is why I started to include chairs in my shows. I want
people to stay longer. To think, to hang out, and to talk with
each other. I have designed the chairs to fit in sculpturally
and pictorially with the look and feel of the rest of my work.
Sometimes I even make a painting and a chair to work well
together. I get the irony of this, the painting over the couch
idea, and I am happy with it. Donald Judd, Franz West, and
Martin Kippenberger have inspired me to go ahead and make
furniture a part of my practice. And of course, I like what
Matisse once said, that a great painting should be as nice as a
soft chair, or something like that.*

Mary Heilmann was honoured with a retrospective at the New Museum,
New York, 2008–09, preceded by a survey show at Orange County
Museum of Art, Newport Beach, 2007. Her work has also been shown
in solo exhibitions at Secession, Vienna, 2003, Camden Arts Centre,
London, 2001, and Kunstmuseum, St. Gallen, 2000. She has participated
in major exhibitions such as *Der zerbrochene Spiegel* at Vienna Kunsthalle,
1993–94, and *nuevas abstracciones* at Centro de Arte Reina Sofia,
Madrid, 1996.

Clubchair 62

Clubchair 63 in Foyle Reading Room

HENRY VIII'S WIVES
artist collective founded 1997

Tatlin's Tower and the World
(reception area sofa and foot stool)

2008
Dimensions:
Sofa 70 × 210 × 91o cm
Foot stool 38 × 6o × 1oo cm
Fabric printed by Mayer, Italy
Sofa upholstered by Sharon Hennessy at Suite Comfort, London

Artist collective Henry VIII's Wives work with histories — political and imagined, public and personal — to construct architectural, visual and conceptual interventions. Turning to one of the world's most famous un-built monuments — Vladimir Tatlin's *Monument to the Third International*, more popularly known as *Tatlin's Tower*, the Wives explore cultural contexts and political thought through the prism of the impossible tower. In Tatlin's lifetime, the *Monument to the Third International*, to be erected in Petrograd (now St. Petersburg) after the 1917 Bolshevik Revolution, was only ever realized in sketches and models. Designed to stand 4oom tall and span the width of the Neva River, the Tower has come to symbolize the impossible juncture between politics, art and utopian ideals.

As part of their ongoing project *Tatlin's Tower and the World*, the Wives embarked on a mission to construct the tower in 2oo5, both to its original scale and fabricated in its intended materials of girders and steel guy wires. The Wives construction of the monument does not exist in any single space but is dispersed throughout the world as individual components. The choice and manner of the subsequent elements of the Tower are dictated by the unique political and geographic sites on which they are built.

Commissioned by the Whitechapel Gallery for *The Street* — a year-long series of artist projects — Henry VIII's Wives reconfigured the Gallery's off-site space as the imagined foyer to *Tatlin's Tower*. Taking inspiration from locally available products, namely the African fabrics sold on and around Petticoat Lane, the Wives commissioned textile makers Vlisco to create a specially designed wax print fabric for use on a sofa and foot stool in their fantastical foyer. The sofa has been donated to the Study Studio to celebrate the launch of the expanded Whitechapel Gallery.

> *We use art to try to do things out of the ordinary, to make things that are not ordinarily there. And (hopefully without being too tacky) you could also say that we look for the humanity within institutions, for how much leeway they can give to do other things.*
> — Henry VIII's Wives, in conversation with Lars Bang Larsen, 2oo5

Henry VIII's Wives are a collective of artists founded in 1997, and include Rachel Dagnall, Bob Grieve, Sirko Knupfer, Simon Polli, Per Sander and Lucy Skaer. They are based variously in Berlin, Copenhagen, London and Oslo, and are all graduates of the Environmental Art Department at Glasgow School of Art.

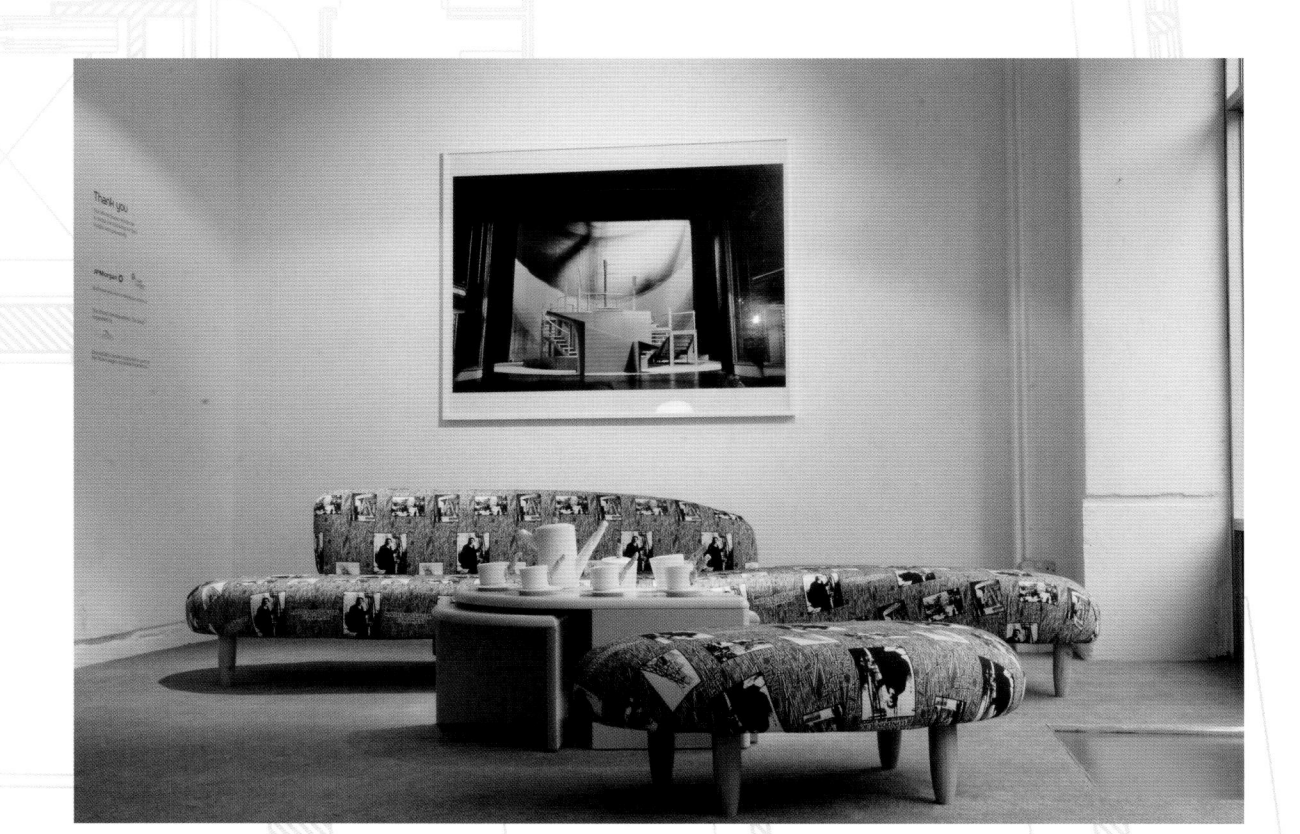

ANNIE RATTI
b. 1956

Following the Flow
(drinking fountain)

2oo9
Mixed media
24o × 11o × 11o cm

Tête à Tête (You and Me)

1999
Mixed media
14o × 81 × 124 cm

Self-confessed 'waterphile', Annie Ratti has created a drinking fountain that champions the science of filtration for the foyer of the Clore Creative Studio. Citing the influence of the Austrian forester and inventor Victor Schauberger, who developed a theory of fluidic vortices for the cleaning and refinement of drinking water, Ratti's fountain uses a spiral-shaped pipe to filter liquid as it flows. In *Following the Flow*, tap water is channelled through an ecologically-sound purification system to attain the quality of spring water. Situated in an area of the gallery frequently used by children, the fountain harks back to a time before the ubiquity of bottled water and brings into question the privatization and distribution of this most basic and essential of elements.

> *The idea of giving something and the desire to make children aware of the great value of water and the need to treat it with respect and pay it the attention it deserves are at the root of this work in which water is purified as it passes through a set of environmentally friendly filters and, coming into contact with romantic images of seas and oceans and with words of love and gratitude , is given a positive charge before it is offered.*

Ratti has also drawn upon her reading of Masaru Emoto, a Japanese writer who believes that water memorizes and carries information, to create a poetic and ameliorative context for the fountain. Text, images and sound, likewise 'filtered' through the surrounding area, create more 'positive' water for the public to drink.

Interactivity and the transformation of private experience into a public, participatory event are also a feature of Ratti's *Tête à Tête (You and Me)*, a curvilinear seat situated opposite the café, on the mezzanine level of the Gallery. Created from plywood, the bench is fashioned into a half-open oval, which provides just enough space for two people to sit inside. Simultaneously isolating yet intimate, *Tête à Tête* separates its sitters from the surrounding space whilst dictating their physical proximity. Whether seating friends or strangers, *Tête à Tête* necessitates interaction between its participants, encouraging and producing new social relationships.

The Italian artist, who lives and works in London and New York, has exhibited in numerous international museums, galleries, and biennales in a career spanning decades and a host of collaborative projects. A focus on communicative methodology and interactivity is evident in an annual series of workshops conceived by Ratti, in collaboration with Anna Daneri, Giacinto Di Pietrantonio, Cesare Pietroiusti, Roberto Pinto and Angela Vettese. Here artists, among them Joseph Kosuth, Allan Kaprow, Ilya Kabakov, Marina Abramovic, Alfredo Jarr and Marjetica Potrc, are invited as 'visiting professors' to interact with young artists, and to collectively brainstorm about such heady and absorbing subjects as the meaning of art, being an artist, and questions of production and representation.

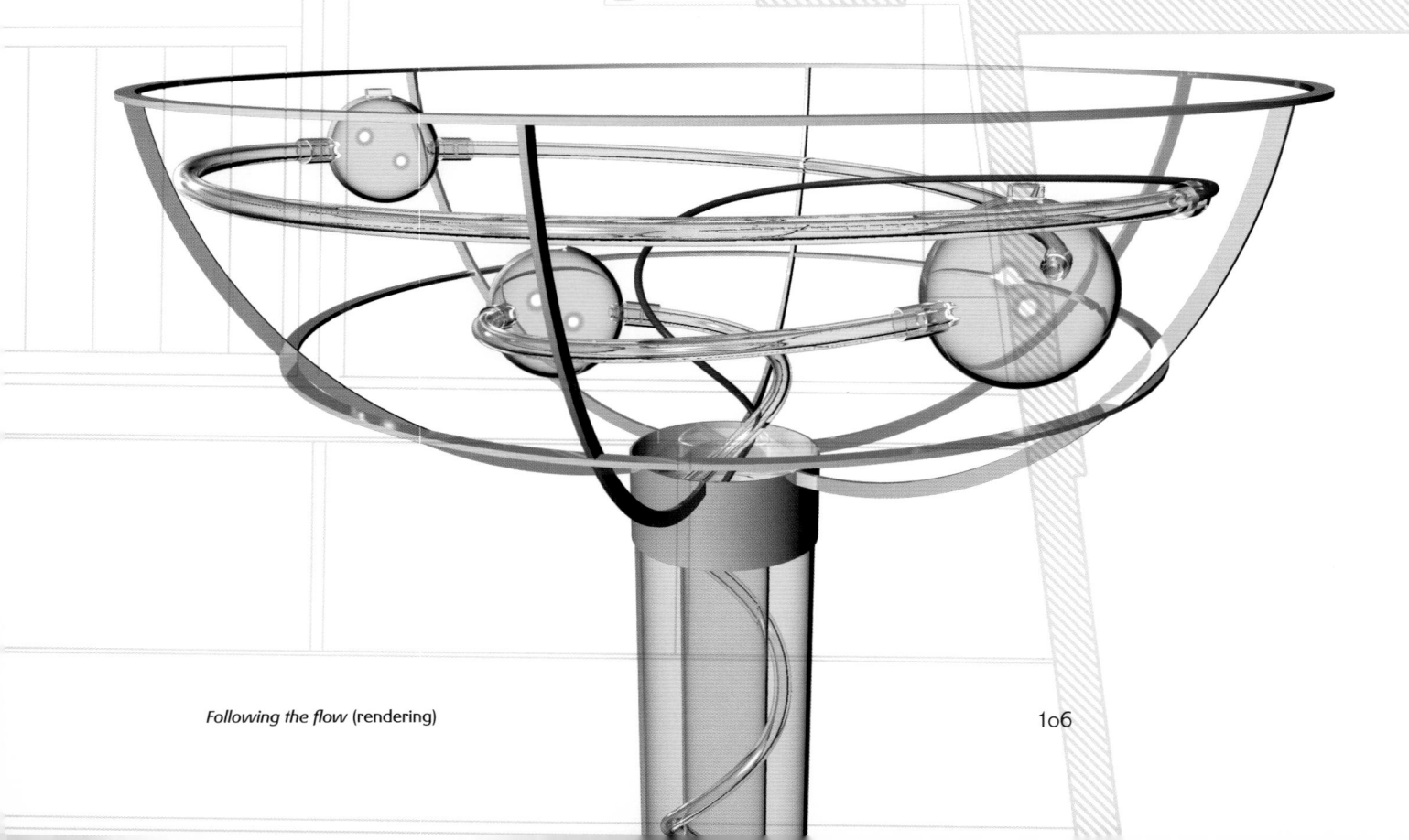

Following the flow (rendering)

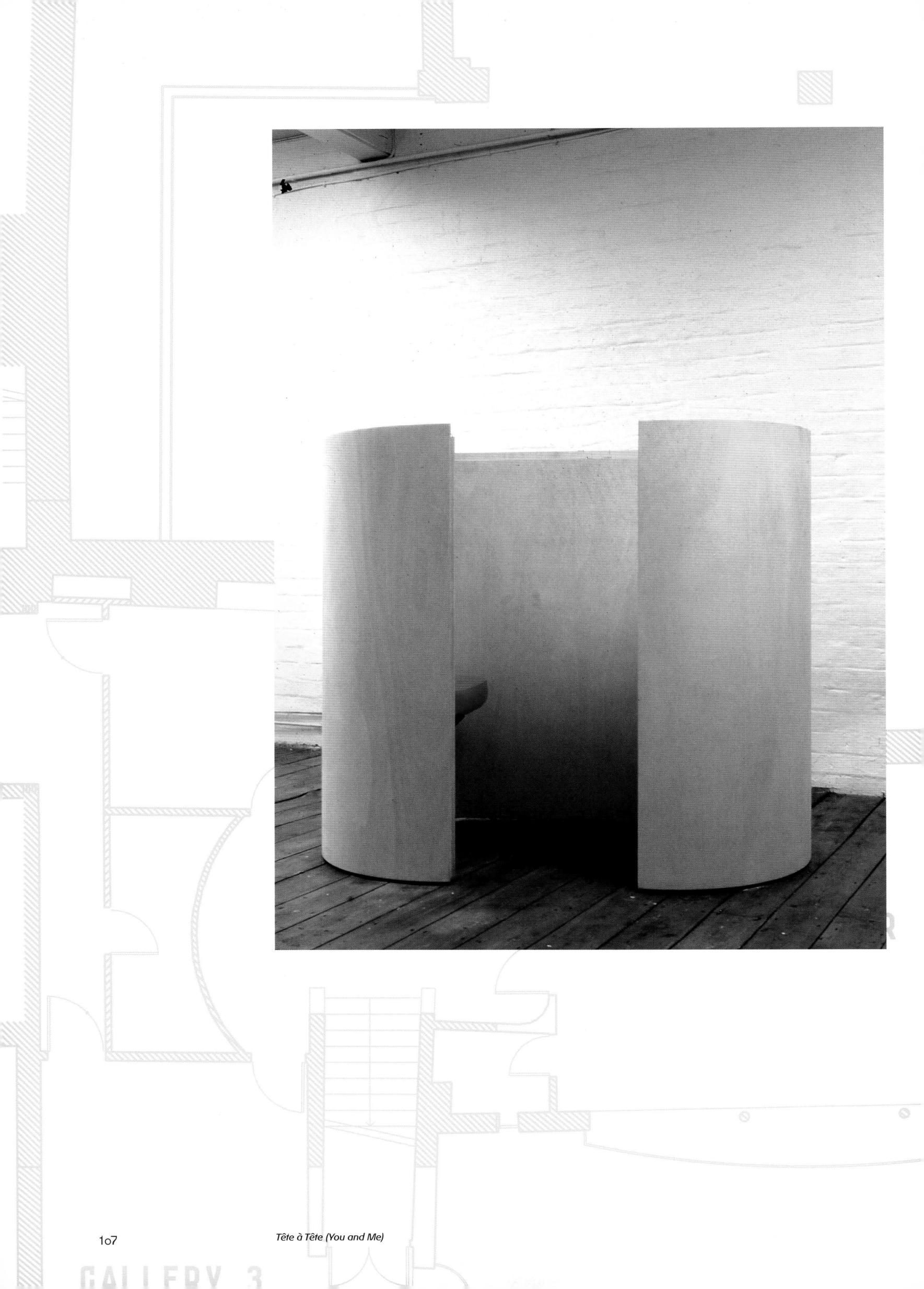

Tête à Tête (You and Me)

TOBIAS REHBERGER
b. 1966

Adaptation 13

2008
Acrylic, electrical appliances
Variable dimensions
Courtesy Ghislaine Hussenot, Paris

Frankfurt-based artist Tobias Rehberger creates environments, sculptures, furniture and ceiling installations inspired by modernist art history and design classics from the 1960s and 1970s. Playful and interactive, Rehberger's installations and objects are often dependent upon the active participation of his audience – an inclusive approach that challenges and unsettles assumptions about the rarefied status of the artwork. In this artist's world, form and function are aligned; utilitarian objects become visually seductive, demanding a reconsideration of the familiar and the domestic. Placing elements of fine art, design and architecture on equal ground, Rehberger creates work that thrives on chance connections and unexpected encounters.

Rehberger's illuminating contribution to the Whitechapel Gallery stairwell is a series of lamps, *Adaptation 4*, 2008, which reverse the standard process of works being built from model forms. While it is customary for a small-scale model to function as a study and guide for a considerably larger, realized project, Rehberger has instead taken a large-scale prototype as the basis for his small-scale lamps. The model for *Adaptation 4* is the cafeteria at Süddeutsche Zeitung Verlag, Munich, for which Rehberger designed a special hardwood floor, a felt-covered ceiling and a large centrally-located block, made of different coloured acrylic panels and illuminated from behind. The brightness of the acrylic wall changes according to the information stream that runs through the building's Electronic Data Processing system, and it is this design feature which the artist has distilled for his lamp series.

Light and lamps have played a prominent role in Rehberger's practice. His 2004 exhibition, *Night Shift*, at the Palais de Tokyo, Paris, was only open at dusk, lit solely by the light emanating from his work.

Born in Esslingen, Germany, Rehberger has received international acclaim for his varied artistic output, with exhibitions at Stedilijk Museum, Amsterdam, 2008; Museo Nacional centro de Arte Reina Sofia, Madrid, 2007; Whitechapel Gallery, London, 2004; Fundacío La Caixa, Barcelona, 2002; Museum of Contemporary Art, Chicago, 2000; Moderna Museet, Stockholm, 1998; Solomon R. Guggenheim Museum, New York, 1997; and Portikus, Frankfurt, 1996. His work has been included in the Venice Biennale, 2003 and the Münster Sculpture Project, 2001.

The use of light in my work is not about 'branding', it's simply a material that I use, like you use a piece of wood to make a chair, to repair a ceiling or as fuel to cook with. For me it's just a material like wood or metal. It's not the content of the work. But it is an extremely interesting material to work with because it can be used in so many different ways. And it is also the essential material of communication. It's the first thing a baby sees, it's crucial for the visual arts, and it conveys a large amount of knowledge. I can use it in different ways as a strategy to change perspectives: literally and metaphorically.

Tobias Rehberger in conversation with Leontine Coelewij, 'Tobias Rehberger: The chicken-and-egg-no-problem wall-painting', Stedelijk Museum, Amsterdam, 2008

CAFÉ/BAR

RICHARD WENTWORTH
b. 1947

A Cabinet of Curiosities:
A Confiscation of String

2oo9
Mixed media
Dimensions as per the length of string

Situated in the heart of the gallery's Education and Research Tower, the Study Studio is an environment for thinking and talking about art. The studio is the context for a yearly curatorial cabinet-based commission, for which the inaugural artist-curator is sculptor, photographer and collector Richard Wentworth. In the spirit of the original *Wunderkammers*, the cabinet's contents might include found objects from nature, science, culture and technology. Wentworth curates the cabinet's contents for one year.

The title for Wentworth's year-long project is *A Confiscation of String*. The phrase encapsulates the word 'fiscal', denoting an interest in currency and exchange, whilst also referring to 'a treasury', a collection of valuable artefacts. The cabinet will contain a collection of string, both natural and man-made, brought to the space by the artist. Some items have been gathered by Wentworth on his personal trips and journeys, and the contents of his father's own string drawer sits within the collection. The artist will also invite additions to the Cabinet, including yarn samples from string manufacturing companies around the world. Wentworth is interested in the aesthetic properties of string in its different manifestations, whether it takes the form of a knot, or a plait or a ball, and the emotional resonances that these objects trigger.

The artist comments:
There are countless things of great modesty which help us to survive. The way we save a paperclip, a safety pin or thumb tack for future use is something which joins us to each other. My first reaction to the Whitechapel invitation was to privilege the elastic band, but then I thought, its formal characteristics and the limit of its size were not enough to give it a starring role.

A Confiscation of String will gather together string and cord during the year ahead into a single display case in the Study Studio. Donations and exchanges will be invited and there will be special presentation events as well as an Etymology Evening and a Knots Night. The curatorial anxiety associated with presenting the material will be the main provocation for adopting varied formal arrangements as the year progresses.

Richard Wentworth is a chronicler of daily life. Since the 197os he has played a leading role in British sculpture, isolating both the formal and sculptural qualities of everyday objects. His enormous archive of photographs, 'Making Do and Getting By' (1974 onwards), captures the provisional ways in which people modify the world they inhabit. By excavating history and looking closely at the material 'now', Wentworth collates and assembles a vivacious archaeology of the world we live in. He reveals that which is curious, ironic, poetic and slight amidst the clutter of daily living.

In 2oo2 Wentworth worked with Artangel at King's Cross, London, to make *An Area of Outstanding Unnatural Beauty*. In 2oo5, Tate Liverpool presented a comprehensive exhibition including works such as *False Ceiling*, 1995 and *Mirror Mirror*, 2oo3. His botanical guide, using enamel signs, at the 2oo8 Folkestone Triennial was a major contribution to the project. His *Clouds Are Events, Shadows Are History* was exhibited in Beijing as part of the Chinese government festival of exhibitions associated with the Olympics. He is Director of the Ruskin School of Drawing and Fine Art at Oxford University and is represented by the Lisson Gallery, London.

FRANZ WEST
b. 1947

Diwan

2oo7
Steel, foam, linen
1oo × 23o × 85 cm
Courtesy Gagosian Gallery

Austrian sculptor Franz West began his career in mid-196o's Vienna, amidst the transgressive, wilfully destructive, milieu of the Viennese Aktionists, whose visceral performances challenged art world passivity and complacency. Emerging from this short-lived and audacious scene, West created an art of involvement, producing sculptures that encourage (an embodied form of) viewer participation. He is perhaps best known for his 'Adaptives' (*aßtücke*) – awkward plaster objects that only attain completion as artworks when the observer picks them up, carries them around or, in some instances, wears them as a quasi-garment. West's installations continue to explore means of stimulating social interaction: 'it doesn't matter what the art looks like but how it's used', he has remarked.

Accessible and often witty, West's practice also extends to furniture, where his talent finds form in comfortable and colourfully-upholstered couches and chairs. The couch, rich in signification, is a recurrent element in West's work. For documenta IX, 1992, he installed rows of metal-framed sofas in a public square behind the Kunsthalle Fridericianum. Covered in cloth, the seating evoked a mass of art-historical associations, positioning Manet's *Olympia* on the couch with Sigmund Freud. To celebrate the reopening of the Whitechapel Gallery, Franz West has provided a diwan for the main foyer space. West's sociable sculptures introduce an element of the domestic to the public spaces they inhabit, providing a welcome respite for those wishing to view the art or simply to watch the passing parade.

Franz West has exhibited twice at documenta, 1992, 1997, and has taken part in many major festivals including the Münster Sculpture Project, 1997, and the Venice Biennale, 1988, 1993, 1997, and 2oo3. His work was presented in a solo exhibition at the Museum of Modern Art, New York, 1997. Further exhibitions include the Museo Nacional de Arte Reina Sofía, 2oo1, Whitechapel Gallery, London, 2oo3; Kunsthalle Wien, Vienna, 2oo3; Gagosian Gallery, New York, 2oo3; and the Galerie Eva Presenhuber, Zurich, 2oo6.

Early on I realized that the purely visual experience of an artwork was somehow insufficient. I wanted to go beyond the purely optical and include tactile qualities as well. My works aren't things one just looks at, but things that the viewer is invited to handle.

Franz West, excerpt from 'Pensées', *Franzwestite*, Whitechapel Gallery, 2oo3

Original Whitechapel Art Gallery logo, 1900

EXHIBITIONS
1901—2009

1901
Modern Pictures by Living Artists
Pre-Raphaelites and Older English
Masters — Burne-Jones, Constable,
Hogarth, Raeburn, Rubens
Chinese Life and Art
Scottish Artists — Bone, Landseer,
Mactaggart, Muirhead, Whistler

1902
Cornish School — Forbes, Stokes
Japanese Exhibition
Children's Work: Tower Hamlets
Schools

1903
Artists in the British Isles at
the Beginning of the Century
— Fry, Legros, Tonks, Watts
Poster Exhibition: British, European,
Chinese and Japanese
Shipping

1904
Scholars' Work from Board
Schools in Bethnal Green, Stepney
and Poplar
Dutch Art — Hals, de Koninck,
Metsu, Rembrandt, van Ruisael,
Amateurs and Arts Students
Indian Empire

1905
LCC Children's Work from Board
Schools in Bethnal Green, Stepney,
Poplar Districts
British Art 50 Years Ago — Holman
Hunt, Millais, Rossetti, Ruskin, Turner
Photography — Chesterton, Pike,
Reid, Selfe, Wastell

1906
Georgian England
Country in Town
Jewish Art and Antiquities
— 1,690 objects

1907
Old Masters: XVII and XVIII
Century French and
Contemporary British
Painting and Sculpture
— Boucher, Le Brun, Chardin,
Claude, David, Grenze, Poussin
Country in Town
Animals in Art

1908
Contemporary British Artists:
Collection of Copies of
Masterpieces — Gainsborough,
Holroyd, Latour, Stevens, Teniers
Country in Town
Muhammaden Art and Life
(in Turkey, Persia, Egypt, Morocco
and India)

1909
Stepney Children's Pageant
Tuberculosis
Flower Paintings
and Old Rare Herbals
Historical and Pageant

1910
Society of Essex Artists
Students Attending London
Technical, Art and Evening
Schools
20 Years of British Art, 1890–1910
— Bone, Burns, Fry, Sargent, Thomas
Country in Town
Shakespeare and Theatrical
Memorial

1911
Society of Essex Artists
Señor Garrido
Toynbee Art Club
Trade Schools
House and Home — Chippendale,
A Stepney Room for Local Workers
Old London

1912
Engineering
Scottish Art and History Exhibition
— Affleck, Hogarth, Jamesone,
Landseer, Wilkie
Toynbee Art Club
Sports and Pastimes

1913
LCC Handwork
Irish Art — Barry, Yeats, Cuala
Industrial Needlework
Toynbee Art Club
Chinese Art1914
LCC Schools Needlework
Twentieth Century Art: A Review
of Modern Movements
— Bomberg, Gertler, Grant, Lewis,
Rosenberg, Sickert

1915
Nature Study and Art
Toynbee Art Club
Design and Workmanship
in Printing

1916
Mothercraft
Toys
War Cartoons and Photographs
(British, Dutch, French, German,
Italian, Japanese, Russian,
Serbian, Spanish)

1917
Allied War Photographs
Lieutenant Samuel H Teed
War Drawings and Lithographs

1918
Munitions of War and Allied
Industries
Women's War Work

1919
Housing and Town Planning

1920
Hugh Blaker Collection
British Art 1830–1850
— Constable, Wilkie
Toynbee Art Club
Household Things

1921
Russian Arts and Crafts
— Goncharova
Modern Dutch Art
— Dijsselhof, Mondrian, Toorop
Women's International Art Club
Polish Art
Knox Guild of Design and Craft
Toynbee Art Club

1922
Modern British Art
— Lavery, Nicholson, Spencer
Chinese Art

1923
Modern British Art
— Clausen, Sickert, Tonks
Dr Edward Wilson: Drawings of
the Antarctic
C. Goosens
Knox Guild of Design and Craft
Toynbee Art Club
Jewish Art
— Epstein, Kramer, Pissarro

1924
Book Illustrations of the 1860's
lent by Harold Hartley
Modern British Art
— Bone, Fry, Nash, Rothenstein
Shipping (prints selected from
the Macpherson Collection)
Toynbee Art Club
International Posters

1925
International Posters
British Art 1875–1925 — Dodd,
Everett, Fry, Lewis, Priestman
Frank Brangwyn
Knox Guild of Design and Craft
Canadian Art

1926
Children's Art Work
Swedish Art
— Grunewald, Larsson, Linnquist,
Nilsson, Sjöstrand, Svensson, Zorn
British Decorative Art
Toynbee Art Club

1927
Belgian Bronzes — Meunier
16th Century Flemish Art
— van Bolswert, Cock, Genoels,
Pontius, van Sompel
Students' Work (Westminster,
Slade, Royal Academy,
Royal College, Central)
Jewish Art and Antiquities
British Handicrafts
Hollar Society of Czech
Graphic Art

1928
Health
International Theatrical Art
International Art (Engravings
and prints under the auspices of
the League of Nations and works
by the Optimists' Group of
Swedish artists)
Toynbee Art Club
Contemporary British Art
— Kelly, Scott
Christabel Dennison Memorial
East London Art Club

1929
Maritime Pictures and Models
Kibbo Kift Educational
Czechoslovak Industrial Art
International Photographs
Contemporary British Art
(including the collection of
Edward Marsh) — Gaudier-
Brzeska, Gertler, Spencer
East London Art Club
No Jury Art Club

1930
Children's Art Work
Thames Bridges
Tempera Painting
(Modern English)
Modern Belgian Art — Delville,
Fabry, Gailliard, Paulus, Paulus

1931
Travel Posters
British Decorative Art
(Creative Art and Decoration
by the Arts Group of Farnham)
Contemporary Art Society's
Paintings and Drawings
Yugoslav Painting
and Sculpture Association
of Civil Service Art Clubs
Association of Students'
Sketch Clubs

1932
Old Masters
— A Thousand Colour Prints
19th Century French Art —
Degas, Géricault, Millet, Vlaminck
Herbert Gurschner
Archibald Ziegler
East End Academy

1933
Students' Sketch Clubs
Contemporary Chinese Art
— Dzun, King, Shi, Yen, Yin
East End Academy
Toynbee Art Club
Association of Civil Service Art
Clubs

1934
Students' Sketch Club
Graham Robertson Collection
— Blake, Robertson
Professor Chytil's Collection of
Modern Chinese Art
East End Academy
Society Of Essex Artists
Toynbee Art Club
Students' Sketch Clubs

1935
Cricket and Sporting Pictures
Mural Decorative Pictures
Spinning, Weaving and Dyeing
East End Academy
Society Of Essex Artists
Toynbee Art Club

1936
Students' Sketch Clubs
Charing Cross Bridge,
design and models
Punch Cartoons
Harvey Collection of Old Masters
Powell Collection of early
engravings, watercolours
and drawings
Byra Art Club
East End Academy
Society Of Essex Artists
Toynbee Art Club

1937
Students' Sketch Clubs
Photographs of National Trust
Properties and of buildings
in all parts of the world
Contemporary Art Society's
Paintings and Drawings
— Bell, Meninsky, Nash, Roberts
Isaac Rosenberg
Rovinsky: Pictures of Spain
Hackney Art School Students'
Work
East End Academy
Society of Essex Artists
Toynbee Art Club

1938
Local School Children's Work
Contemporary British Art
Byra Art Club
East End Academy
Society of Essex Artists
Toynbee Art Club

1939
Spanish Art — Picasso's *Guernica*
Artists International Association
— Gill, John, Moore, Nash
Wyndam T Vint's Collection of
Oil Paintings
Angela Antrim
Contemporary French Painting
Herbert E West Collection of
English Watercolours
East End Academy

1940
Gregory Brown (Travel Posters)
British Watercolour Collection
John Outram Collection of
Paintings
Photographs: 'Might of Britain'

1941
Dr WM Crofton: Collection of
British Masters — Constable,
Gainsborough, Turner

1942
British Painting Today
— Hitchens, Jones, Medley,
Moynihan, Nicholson, Williams
Graphic Art: Czech, French,
Spanish
East End Academy

1943
Wings of Victory
Artists Aid Jewry
— Mrs Churchill's Fund
Marine Pictures
Czechoslovak Art
Poster Designs
for Wartime Britain
Stepney Reconstruction Plans
Hogarth and Early English
Caricature

1944
Salute the Soldier
East End Academy
Russian Photographic Display of
3 Heroic Cities: Leningrad,
Stalingrad and Sebastopol
Modern French Pictures from
Algiers and North Africa
— Dufy, Marquet, Puy
East End Academy

1945
Aspects of Jewish Life
and Struggle
Engineers' Art Society
Modern Brazilian Painting
— do Amaral, Lazar, Segall
This Extraordinary Year (Artists'
International Association)
American Art
Toynbee Art Club

1946
Stepney Borough Council: Road
Safety
Soviet Graphic Art — presented
by the Embassy of the USSR
East End Academy

1947
Czechoslovak Modern Art
— Beneš, Fulla, Kaplický,
Špála, Vaníček
Pictures for Schools
Stepney in War and Peace: Rose
Henriques
East End Academy

1948
Five Centuries of European
Painting: Cook, Bearsted
and other collections
— El Greco, Hogarth, Memling,
Rembrandt, Titian
Pre-Raphaelites
— Brown, Burne-Jones, Rossetti
East End Academy
Prints and Sculpture (Europe from
the Middle Ages to the present)
— Dalou, Duccio, Dürer, Goya,
Moore, Rembrandt, Whistler
London School Paintings

1949
Design Fair
Arts and Crafts by Members of
Bnei Akiva
Manchester Group — Lowry
East End Story: History and Life
of East London from Roman
Times to 1920
Mark Gertler: Memorial
Exhibition
Pictures for Schools — Hilton,
Lowry, Tunnard, Uhlman, Weight
East End Academy

1950
English Sporting Pictures
— Alken, Morland, Satorius, Stubbs
Painters' Progress: Lives and
Work of Some Living British
Painters — Armstrong, Clough,
Grant, Hitchens, Lowry
East End Academy
Pictures for Schools
— Berger, Moody, Napper,
Nicholson, Soukop

1951
East End Academy
Eighteenth Century Venice
— Canaletto, Guardi, Tiepolo
East End 1951 (Festival of Britain)
Black Eyes and Lemonade
(Festival of Britain-related
exhibition of popular
and traditional art)
William Powell Frith

1952
The Arts of India and China
Setting Up Home for Bill and
Betty: A Shopping Guide with
Oxford House
— furniture, wallpaper
Looking Forward: British Realist
Pictures — Clough, George,
Minton, Moynihan, Rogers
East End Academy

1953
James Goldsmith
JMW Turner
Twentieth Century Art Form
— Braque, Colquhoun, Gropius,
Heron, Kandinsky, Lasdun, Picasso,
De Staël
James Gillray
Thomas Rowlandson
John Martin
East End Academy

1954
Pictures for Schools
— Feddon, Lowry, Rie, Weight
Barbara Hepworth Retrospective
British Painting and Sculpture —
Frost, Paolozzi, Turnbull, Vaughan
East End Academy

1955
Pictures for Schools
Bearstead Collection
— Bosch, Breughel, Cuyp,
El Greco, Gainsborough
American Primitive Art 1670–
1950 — Bard, Levin, Moses,
Prior, Santo
Piet Mondriaan
Michael Ayrton
London Group
East End Academy

1956
Pictures for Schools
— Bratby, Coper, Hughes,
Williams
Josef Herman
Nicolas De Staël
Charles Howard
This is Tomorrow
— Adams, Alloway, Carter,
Catleugh, Crosby, Ernest, Facetti,
Goldfinger, Hamilton, Heath,
Henderson, Hill, Holroyd, Hull,
Jackson, Jackson, Martin, Martin,
Matthews, McHale, Newby,
Paolozzi, Pasmore, Phillips, Pine,
del Renzio, Scanavino, Smithson,
Stirling, Thornton, Turnbull,
Voelcker, Williams, Weeks,
Wilson, Wright
Merlyn Evans
Jewish Artists in England 1656–
1956 — Adler, Cohen, Cohen,
Freedman, Kestelman, Wolfe
East End Academy

1957
George Stubbs
Bernardo Bellotto
Sidney Nolan
Women's International Art Club
— Ayres, Blackadder, Redpath
SW Hayter
East End Academy

1958
Guggenheim Painting Award
Recent Paintings by
7 British Artists
Pictures for Schools
Robert Colquhoun
Alan Davie
Women's International Art Club
— Carstensen, Drew, Leeman,
Richbell, Youngman
Jackson Pollock

1959
Pictures for Schools
East End Academy
The Graven Image: Recent
British Prints and Drawings
— Ayrton, Hermes, Piper, Richards
Jack Smith
Kenneth Armitage
Kasimir Malevich
Cecil Collins

1960
Ceri Richards
Women's International Art Club
Pictures for Schools
East End Academy
Ida Kar
Roy de Maistre
Prunella Clough
Henry Moore
1961
Contemporary Art Society
Pictures for Schools
Vanishing Stepney: Paintings
by Rose Henriques
Edmond Kapp
Recent Australian Painting
— Hughes, Underhill, Tucker
Mark Rothko
Derek Hill
1962
East End Academy
Barbara Hepworth Sculpture
1952-1962
Pictures for Schools
Mark Tobey
Keith Vaughan
Arthur Boyd
Hallmark Collection
— Clavé, Hartung, Greaves, Wyeth
Thelma Hulbert
1963
Marzotto Prize
Philip Guston
Serge Poliakoff
British Painting in the Sixties
— Auerbach, Bacon, Freud,
Frost, Nicholson
Anthony Caro
Robert Medley
1964
Young Commonwealth Artists
Robert Rauschenberg: The Dante
Drawings and Paintings
The New Generation — Boshier,
Caulfield, Hoyland, Jones, Riley
Franz Kline
Painting and Environment:
Nigeria, Uganda
Mary Potter
Jasper Johns
1965
Marzotto Prize
The New Generation — Annesley,
King, Piché, Scott, Tucker
Harold Cohen
Morris Louis
Lee Krasner
Peter Stuyvesant Foundation
— Bacon, Caulfield, Hamilton,
Mynter, Riley, Smith
1966
Robert Motherwell
Bryan Kneale
Plastics: Exploration in Design
Richard Smith
The New Generation — Cina,
Knowles, Lancaster, Newsome
Women's International Art Club
Printmaking: Exeter College of Art

1967
East London Open
John Craxton
John Hoyland
Tim Scott
The Face of London
Gertrude Hermes
British Sculpture and Painting
from the Collection of
Leicestershire Education Authority
— Burgin, Epstein, Hepworth, Lewis,
Moore
1968
Contemporary Art Society: Recent
Acquisitions
New British Painting
and Sculpture — Caro, Huxley,
King, Riley, Vaughan
Olwen Tarrant and Grace
Lowe-March
The New Generation — Carter,
Jones, Newsome
Ghika
Phillip King
Betty Parsons
1969
Shalom of Safed
Hélio Oiticica
Helen Frankenthaler
Robert Downing
Yves Gaucher
Three Israeli Artists: Agam, Lifshitz,
Zaritsky
1970
David Hockney
Robert Graham
Modern Chairs 1918–1970
Donald Judd
New Multiple Art
— Apple, Arman, Beuys, Christo,
Finlay, N.E. Thing Company,
Pistoletto, Wall, Yuan-Chia
1971
Jack Smith
East London Open
Michael Upton
Douglas Binder
Mary and Kenneth Martin
Dali: Art in Jewels
Alexander Hollweg
Gilbert and George
Richard Long
1972
East London Open
Leon Kossoff
Strike for Kids under 12
Joseph Beuys
Systems — Allen, Hughes,
Lowe, Saunders, Spencer
David James
John Peek
Pre-Raphaelites — Collinson,
Dyce, Hunt, Millais, Rossetti
John Davies
Patrick Heron
This is Whitechapel (Ian Berry)
Bill Woodrow
Alan Charlton
Peter Logan
Decade 40s
— Roberts, Medley, Lanyon
Evelyn Williams
Spike Milligan
Michael Perton
Prints and how they are made
Llewellyn Xavier

1973
James Coleman
Neville Boden
Patrick Hayman
Sweets
Crackers at the Popular Palace
East London Open
John F Holland
Norman Adams
Derrick Greaves
The Ashington Group 1932–1972
— Floyd, Kilbourn, Laidler,
Robinson, Wilson
Banner Bright: Trade Union
Banners
Claude Rogers
Brian Shaffer
Tess Jaray
Ed Meneeley
Inside Whitechapel — Ian Berry
Dan Jones
Derek Boshier
Four Painters: Stephen Amor,
Christopher Davies, Keith Dean
and David Kay
Trevor Bell
Gareth Jones
Elise Few
The London Group — Bell,
Buchanan, Coxon, Fielding, Hoskin
1974
G F Watts
Earth Images: Ceramic Sculpture
East London Open
Albion Island Vortex
Tim Head
Euan Uglow
Ray Atkins
Henri Chopin
David Hepher
ILEA Art Collages
Frank Collins
Present Printing Pastimes
Printed in Watford: Watford
School of Art
Floris van den Broeke
Seiichi Niikuni
Karl Weschke

1975
La Belle Epoque: Belgian Posters,
Watercolours and Drawings
1892–1914 — Gandy, Mignot,
Rysselberghe, Vanloo
Alan Cox
Ray Exworth
Michael McInnerery
Barrie Cooke
Bruce Lacey
Norman Mommens
Pedro Uhart
Peter Cunliffe
East London Open
Fifty Drawings by the Blind
— Hearn, Smethurst, Wheeler
Women and Love
Magdalena Abakanowicz
Luis Fernando Benedit
City Poems and City Music
— Betjeman, Henri, McGough
Francis Hewlett: 'Big Hand'
John Lifton: 'Green Music'
Dianne Setch
Peter Dent
Sculptures from London Art
Schools
Brian Nissen
Deanna Petherbridge
Peter Schmidt
Franciszka Themerson
Colin Lanceley
Anthony Austin: 'The Toymaker'
John Davies
Pury Sharifi: Knitted Costumes
and Wall Hangings
Yolanda Sonnabend
NH Werkman
1976
Flower Show of Tower Hamlets
Liz Harrison
Andrew Logan
Participation Projects including
ILEA Cockpit Arts Workshop
Word–Images by Pupils of Cayley
Primary School
Michael Druks
Leopoldo Maler
Tom Norton
Norman Toynton
Derek Goldsmith
Beryl Cook
East London Open
Madelon Hooykaas
Elsa Stansfield
Tapestries from the Royal
College of Art
Les Lelanne: François Xavier
and Claude Lelanne
Saskia de Boer
Chris Orr
Charlie Meecham
Inner London Education
Authority Arts Schools
Embroidery and Fashion:
Goldsmith's College and
St. Martin's School of Art
Tadeusz Kantor
Michael Chilton
Tower Hamlets Arts Project

1977
Stanley Brouwn
Richard Long
Pearly Kings and Queens
Nicholas Hawksmoor
Kilims: Plain-weave tapestries
from Persia, Turkey and the
Caucasus
Keith Arnatt
Walter Pichler
Robert Smithson
Morton Feldman and the
Creative Associates
Graphic Design Works: ILEA Art
Schools
Whitechapel Open
— Irvin, Klassnik, Logan, Morris
Robert Ryman
Working Party: Böhmler,
Brehmer, Helms, Mitzka, Oehms,
Polke, Rückriem, Rühm, Walther
The Fairground
1978
Carel Visser
Mother Goose comes to Cable
Street
Carl Andre
Artists' Placement Group
Art for Society — Atkinson,
Boyle, Breakwell, de Francia,
Furlong, Jones, Kelly, Parr
Liberty, Equality and Sisterhood
Whitechapel Open — Allen,
Fisher, Newman, Rowlett, Wilson
Bob Law
Live Arts Summer School
Boyd Webb
Working Lives
13° E: Eleven Artists Working in
Berlin — Brus, Hacker,
Koberling, Vostell
Christchurch Gardens Mural
1979
Stephen Willats
Up The Broadway
Joan Jonas
Bow Mission Mural
Circles and Spirals from Straight
Lines
Hamish Fulton
Gerhard Richter
Eva Hesse
Edward Barber: 'People Portraits'
Brick Lane 1978
Riduan Tomkins
Uses of Drawing: ILEA Schools,
Colleges and Adult Education
Institutes
Live Arts Workshops
Whitechapel Open
Blackwall Adventurers' Club:
drawings
Gough Grove Community Group:
weaving and puppet making
David Bomberg
Markus Lüpertz
Jude Lockie: woodcuts
World's End Press
Arts of Bengal
Shafique Uddin: Memories of
Village Life in Bangladesh
Contemporary Artists from
Bangladesh
Lloyds: Proposed Redevelopment

1980
Mario Merz
Joel Shapiro
William Larkins
Pictures for an Exhibition
Gunter Brüs
Arnulf Rainer
Police Mug-Shots of the
Nineteenth Century
Four Jewish Artists of London's
East End Whitechapel Open
Holborn Underground
Competition
Fotografia Polska
— Groer, Jorczak, Krieger,
Kzaca, Szpakowski
Growing Up With Art: The
Leicestershire Collection for
Schools and Colleges
Harry Blacker: The East End
in the Thirties
Max Beckmann
Georg Baselitz
Cyril Arapoff: An East End
Slum Tenement
To Build A Jerusalem
1981
Eva Lockey
30 ex-ILEA: work by former
students
Joseph Cornell
Tony Cragg
Rodin at Bethnal Green
Antony Gormley
Brice Marden
Ashbee and the Guild of
Handicraft in East London
Gilbert and George
Breaking Through: Television
from East London
British Sculpture in the Twentieth
Century — Barker, Caro,
Hepworth, Moore, Paolozzi,
Turnball, and others
1982
Whitechapel Open
Islington Schools Environment
Project
Frida Kahlo
Tina Moddotti
Anselm Kiefer
Madge Gill
Jannis Kounellis
Old Billingsgate Market
Christopher Wren
Philip Guston
Bethnal Green Museum of
Childhood
1983
Francesco Clemente
Barry Flanagan
Auschwitz Exhibition
Whitechapel Open
— Allington, Panchal,
Wentworth, Wilding, Uddin
A Child's View of Docklands
in 1961
Terry Atkinson
Bruce McLean
A Visit to Bangladesh
Purbo London
Malcolm Morley
The New Whitechapel
Georg Baselitz: 1960-1983
Work from a Salvation Army
Hostel
Richard Hollis
1984
Whitechapel Open

1985
Whitechapel Open
Howard Hodgkin
Jacqueline Poncelet
Susanna Heron
Per Kirkby
Wolfgang Laib
1986
Ray Walker
Whitechapel Open
In Tandem: The Painter–Sculptor
in the Twentieth Century —
Artschwager, Degas, Giacometti,
Johns, Matisse, Twombly
East End Festival
Terry O'Farrell
Jeffrey Dennis
Victor Willing
Tower Hamlets Women's Arts
Festival
From Two Worlds: Sixteen Artists
of Non–European Background —
Araeen, Bhimji, Camp, Piper, Ryan
Family Books
Julian Schnabel
Boston–London Art Exchange
David Smith
1987
Fernand Lanceley
Bruce Nauman
Three Artists in East London
Schools
Whitechapel Open
East Ham Graphics
Boyd Webb
Jacob Epstein
Cy Twombly
Fernand Léger
John Murphy
Homerton Hospital Painting
Commission
1988
Island Seen
Jamdani Weavers
Rob Kesseler
Woven Air: The Muslin and
Kantha Tradition of Bangladesh
Sonia Boyce
Michael Sandle
Lucio Fontana
Joanna Kirk
Matthew Hale
Whitechapel Open
Richard Deacon
Kate Whiteford
1989
Artists in East London Schools
Kate Davis
Naomi Hines
Joan Miró
Sean Scully
Tunga
Marie Jo Lafontaine
Euan Uglow
Whitechapel Open
Michael Craig–Martin
1990
Arshile Gorky
Christian Boltanski
Julio Gonzalez
Harald Klingelhöller
Seven Obsessions
— Bulloch, Burden, Calle,
Counsell, Head, Thompson, Viner
Ian McKeever
Emil Nolde
Whitechapel Open

1991
Michael Andrews
Albert Pinkham Ryder
Markéta Luskačová
Jack B Yeats
Martin Disler
Without Walls
Cindy Sherman
Peter Doig
Matthew Tickle
Richard Diebenkorn
Cabinet of Signs: Contemporary
Art From Post Modern Japan
— Miyajima, Morimura,
Nomura, Sugimoto
1992
Alfredo Jaar
Living Wood: Sculptural
Traditions of Southern India
Whitechapel Open
Juan Gris
Tim Head
1993
Susana Solano
Tony Bevan
Piotr Nathan
Summer Residencies: Clare
Charnley and Monica Ross
Rave Machine
Lucian Freud
Latin American Experimental
Photography: related to
American Ya! Festival
Nunhead Adult Education
Institute, Southwark
Jordan Baseman and Edwina
Fitzpatrick: residency at Surrey
Docks Day Centre
Design a Bookmark Competition
Stepney 'A' Team: drawing and
textiles for a Moghul tent
Woodcraft Folk
Bill Viola
Thomas Buxton Infants School:
relating to Susana Solano
exhibition
1994
St Botolph's Day Centre
Art Group
Medardo Rosso
Mundanzos: Six Spanish Artists
— Civera, Gómez, Pelaez, Rom,
Ulsé, Valldosera
Art and ESOL
Art begins at Eighty: elderly
Jewish artists in North London
Edwina Fitzpatrick: residency
at Daneford School
Ramadan Exhibition
Mulberry and Bishop Challoner
Schools: murals
Avenues Unlimited: mural
in Quaker Street
Whitechapel Open
Franz Kline
Breda Beban and Hrvoje
Horvatic
Miguel Barcelo
Worlds in a Box: Cornell, Fluxus,
Herms, LeWitt, Samaras
1995
Kiki Smith
New Art from Cuba — Bruguera,
Kcho, Los Carpinteros, Rodriguez
Guillermo Kuitca
Drawing the Line
— Duchamp, Egyptian c. 1400 BC,
Michelangelo, Modersohn-Becker
John Virtue
Seven Stories about Modern Art
in Africa — Abdalla, Emokpae,
Kentridge, Koloane, Samb
Emil Nolde

1996
Jeff Wall
Renato Guttuso
The Open/Open Studios
Inside the Visible — Clark, Gego,
Hiller, Kusama, Mendieta, Salomon,
Woodman, and others
1997
Tony Cragg: Sculpture and
Drawing
Antechamber — Alÿs, Austin,
Heath, Pippen, Štrba
Krishna, the Divine Lover
Cathy de Monchaux
David Siqueiros: Portrait
of a Decade
Lines from Brazil — Grindberg
1998
Thomas Schütte
Whitechapel Open/Open Studios
Peter Doig
Aubrey Williams
Speed: Visions of an Accelerated
Age — Flavin, Graham, Gursky,
Hamilton, Hapaska
Rosemarie Trockel
1999
Terry Winters
Henri Michaux
Examining Pictures: Exhibition
Paintings — Bacon, Beecroft,
Guston, Halley, Raedecker
ooozerozerozero — Biswas,
Fernandes, Islam, Sawhney, Tegala
Alighero e Boetti: The Maverick
Spirit of Arte Povera
Gary Hume
2000
Live in your Head — Brisley,
Breakwell, Clark, Hilliard, Latham
Francisco Toledo
Carl Andre
Protest & Survive — Creed,
Fahlström, Gonzalez-Torres, Spence
A Different Kind of Show
2001
Temporary Accommodation
— Alvi, Faithfull, Gibbs,
the Szupev Gallery
Whitechapel Centenary
Raymond Pettibon
Toba Khedoori
Mark Wallinger: No Man's Land
2002
Nan Goldin: Devil's Playground
A Short History of Performance:
Part I — Bensteins, Brisley,
Kounellis, Nitsch, Schneemann
Benita–Immanuel Grosser:
Participating, at the Same Time
Liam Gillick: The Wood Way
Helio Oiticica: Quasi Cinema
Early One Morning — Afrassiabi,
Barclay, Lambie, Rothschild, Webb
Rodney Graham
2003
Mies van der Rohe: 1905–1938
Cristina Iglesias
Philip–Lorca diCorcia:
A Storybook Life
Janet Cardiff & George Bures
Miller: Recent Works
Franzwestite: Franz West Works
1973-2003
A Short History of Performance:
Part II — the Atlas Group,
Beuys, Dion, Fraser, Inventory,
Morris, Young

2004
Gerhard Richter: Atlas
Edge of the Real
— Artlab, Cullinan + Richards,
Carpenter, Cooke, Hume, Grassie,
Innes, James, Monroe, Morton,
Parsons, Raedecker, Rayson,
Shaw, Skaer, Thorpe
Raoul De Keyser
East End Academy
— Avora, Bishop, Brierly,
Carne, Corby, Course, Clark,
Davies & Sherwood, Griffiths,
Guillen, Haegele, Harrison, Hughes,
Lee, Jandrell, MacCarthy, O'Brien,
Paganelli, Peri, Plender, Saiz,
Stewart, Taylor, Zatorski & Zatorski
Paul Noble
Tobias Rehberger: Private Matters
2005
Faces in the Crowd: Picturing
Modern Life from Manet to Today
— Acconci, Ackerman, Alÿs, Arnold,
Atget, Bacon, Balkenhol, Beckmann,
Bellows, Beuys, Boccioni, Boltanski,
Bomberg, Brassäi, Broodthaers,
Buckingham, Burri, Cahun, Capa,
Calle, Carrà, Cardiff & Bures-Miller,
Cartier-Bresson, Deacon & Fraser,
Deller, DiCorcia, Dittborn, Doherty,
Dong, Dubuffet, Duchamp, Durant,
Ensor, Export, Evans, Fast,
Giacomelli, Gilbert & George,
Goldblatt, Goldin, Gordon, Grosz,
Gupta, Gursky, Guston, Guzman,
Hamilton, Heartfield, Hopper,
Huyghe, Jonas, Katz, Keita,
Kentridge, Kirchner, Klucis, Kollwitz,
Leckey, Léger, Levitt, Magritte,
Manet, Man Ray, McCarthy,
McQueen, Modotti, Munch, Muñoz,
Nauman, Ofili, Paolozzi, Pfeiffer,
Picasso, Piper, Pistoletto, Prince,
Richter, Rodchenko, Sala, Sander,
Schad, Schütte, Sherman,
Schneemann, Segal, Sickert, Sidibé,
Singh, Strand & Sheeler, Toulouse-
Lautrec, Vertov, Wall, Warhol,
Wearing, Weegee, Wilkström,
Winogrand, Yeats
Cummings and Lewandowska:
Enthusiasm
Robert Crumb: A Chronicle of
Modern Times
Back to Black: Art, Cinema
and the Racial Imaginary
— Bafaloukos, Barnes, Bjorkman,
Bearden, Bey, Brown, Burke,
Burrows, Camus, Catlett, Cohen,
Crain, Davis, DePalma, Deren,
Gerima, Gonzales, Hamilton,
Hammons, Hendricks, Henzell, Hill,
Jantjes, Kapo, Kayiga, Lichfield,
Locke, Love, Manley, Marks, Moses,
Ové, Overstreet, Parks, Piper,
Poitier, Ringgold, Romero, Saar,
Shear, Simon, Van Peebles, Watson,
White, Williams, Xavier
A Short History of Performance:
Part III — Allan Kaprow
Paul McCarthy: LaLa Land Parody
Paradise

2006
Paul McCarthy: Caribbean Pirates
David Adjaye: Making Public
Buildings
Ugo Rondinone: zero built a nest
in my navel
A Short History of Performance:
Part IV — Ahtila, Barry, Byrne,
Coleman, Horn, Jankowsi, Julien,
Kruger, Mik, Anna Sanders Films,
Sullivan, Vezzoli, Wearing,
Zmijewski
The Whitechapel Files
Inner Worlds Outside
— Agar, Alcock, Angelus, Balnaves,
Baron, Bartmann, Baselitz, Basquiat,
Beehle, Bellmer, Blagdan, Blank,
Blankenhorn, Blayney, Bourgeois,
Braz, Breakwell, Von
Bruenchenhein, Buhler, Burland,
Burra, Carlo, Castle, Micahel the
Cartographer, Cochran, Darger,
Delauney, Dellschau, Domsic,
D'Souza, Dubuffet, Duhem, Ensor,
Ernst, Farrer, Fautrier, Gelli, Van
Genk, Gill, Gillespie, Goesch,
Gordon, Grebing, Greuter,
Grünenwaldt, Guston, Hauser,
Heyligen, Hipkiss, Horacek,
Kandinsky, Kernbeis, Klee, Klett,
Klojer, Kubin, Kusmic, Kurelek,
Lange, Lesage, Lonné, Lortet,
Louden, Mackintosh, Maier, Man
Ray, Marshall, Masson, Matta,
McDonagh, Mckesson, Mebes,
Mesens, Meyer, Michaux, Miró,
Molloy, Monsiel, Murray, Natterer,
Nedjer, Nie, Nijinsky, Nolde, Van
Nuffel, Nutt, Howard O, Von
Oertzen, Paolozzi, Penfold, Penrose,
Peploe, Von Perfall, Perifimou,
Phillippe, Picabia, Potter, Price,
Pujolle, Ramírez, Rops, Do Rosário,
Rousseau, Samaras, Schiele,
Schneller, Schöpke, Schröder-
Sonnenstern, Soutter, Schudel,
Sekulic, Smith, Sonntag, Soutter, Von
Stropp, Suckfüll, Tàpies, Theo, Tobey,
Traylor, Trevelyan, Tschirtner, Uddin,
Verbena, Walla, Watts, Von Wieser,
Wilde, Williams, Wilson,
Wladyslawa, Wölfli,
Wojciechowsky, Yoakum,
Zemánková
Albert Oehlen: I Will Always
Champion Good Painting
The Whitechapel Auction:
Defining the Contemporary
Hans Bellmer
Pierre Klossowski
The Vicious Circle
— Balthus, Cahun, Duchamp,
Maccheroni, Molinier, Zurn
Closure of main galleries

2007
Margaret Salmon
Whitechapel Laboratory: Jennifer
Allora & Guillermo Calzadilla
Art in the Auditorium:
David Malkovich
The Street: Pablo Pijnappel;
Marcus Coates; Amar Kanwar;
Sarah Morris; Langlands & Bell
2008
Nick Waplington
Cornelia Parker
Whitechapel Laboratory:
Daniel Pflumm
Art in the Auditorium: Nathalie
Djurberg / Diego Perrone; Wang
Jianwei / Ali Kazma; Lene Berg /
Leandro Erlich; Shahryar Nashat /
Ryan Trecartin
The Street: Nedko Solakov; Bernd
Krauss; Shimabuku; Jens Haaning;
Henry VIII's Wives
Creative Connections:
Let Me Tell You
2009
Reopening of Gallery
Isa Genzken: Open, Sesame!
Goshka Macuga: The Bloomberg
Commission
British Council Collection:
Great Early Buys
Whitechapel Boys
John Kobal New Work Award:
Andrew Grassie, Rosalind
Nashashibi, Nick Relph & Oliver
Payne, Juergen Teller
Archive Adventures
Minerva Cuevas: S.COOP
Elizabeth Peyton: Live Forever
East End Academy:
The Painting Edition
Art in the Auditorium:
Ursula Mayer
The Street: Melanie Manchot

WHITECHAPEL PROJECT
CREDITS

The Whitechapel Gallery thanks its supporters, whose generosity enables the Gallery to realize its pioneering programme

INTERNAL PROJECT TEAM

Whitechapel Gallery
Iwona Blazwick OBE DIRECTOR
Tom Wilcox GENERAL MANAGER
Jo Dunnett PROJECT CO-ORDINATOR
Loveday Shewell PROJECT CONSULTANT
Sandy Weiland PROJECT CONSULTANT
Stephen Escritt HEAD OF STRATEGIC DEVELOPMENT
Sue Evans CAPITAL PROJECT AND FUNDING MANAGER
Amy Stephens PROJECT ASSISTANT

DESIGN TEAM

LEAD ARCHITECTS
Robbrecht & Daem Architecten
Paul Robbrecht
Kristoffel Boghaert
Gert Jansstume

EXECUTIVE ARCHITECTS
Witherford Watson Mann Architects
William Mann
Chris Watson
Stephen Witherford
Joerg Maier

CONSERVATION ARCHITECTS
Richard Griffiths Architects
Richard Griffiths

PROJECT MANAGERS
Steve Collins
Mott MacDonald

SERVICE ENGINEERS
Max Fordham LLP
Colin Darlington
Christine Wiech

STRUCTURAL ENGINEERS
Price and Myers
David Derby

QUANTITY SURVEYORS
Davis Langdon LLP
Richard Baldwin
Laurence Brett
Alan Lovesey

CONTRACTOR
Kier Group PLC — Wallis

BUILDING COMMITTEE

Alice Rawsthorn DESIGN CRITIC, INTERNATIONAL HERALD TRIBUNE
Duncan Ackery CHIEF EXECUTIVE, SEARCY'S
Andrew Bramidge CHIEF EXECUTIVE, HARLOW RENAISSANCE
Christophe Egret DIRECTOR, STUDIO EGRET WEST
Keir McGuinness LAWYER
James Pellatt SENIOR DIRECTOR, TISHMAN SPEYER

SPECIALIST CONSULTANTS

ARCHITECTS
DunnettCraven Ltd
Charles Dunnett
James Craven

ACCESS CONSULTANTS
David Bonnetts Associates
Davis Bonnett

ARCHIVE CONSULTANTS
Jon Newman Associates
Jon Newman

INSURANCE CONSULTANTS
Blackwall Green
Robert Hepburn-Scott

LEGAL CONSULTANTS
Cameron McKenna LLP
Martin Pennell
Christopher Fletcher
Caroline DeLaney
Danielle Drummond-Brassington

LEGAL CONTRACTS
Linklaters LLP
Ann Minogue
Sarah Holman
Carolyn Lee
Jill Moore

LIGHTING CONSULTANTS
Jason Bruges Studio Ltd
Jason Bruges
Jon Hodges

LIGHTING CONSULTANTS
Lightwaves
John Johnson

PLANNING SUPERVISORS
Tetra Consulting Ltd
Michael Storey

PUBLIC ART COMMISSION
Donald Young Gallery
Donald Young

SIGNAGE CONSULTANTS
Holmes Wood
Alexandra Wood
Lucy Holmes

VAT CONSULTANTS
SOC VAT Consultants
Socrates Socratous

FRANCHISES

Koenig Books BOOKSHOP
Walther König
Franz König
Charlotte Kettle

James Soane PROJECT ORANGE
Christopher Ash
Rachel Coll
Michael Boyes

51% Studio Architects
Peter Thomas

Woodcraft Joinery Limited
Steve Peters

Vacherin Limited
Phil Roker
Mark Philpott
Clive Hetherington
Chris Giannangelo

PLANNING CONTACTS

Transport for London
Ian Carter
Frank Gosling
Steve Decker
Steve Watts

LUL
Malcolm Payne
Tim Hill

Robin Simons Associates

English Heritage
Nick Collins
Cindy Molenaar

Government Office for London
Mr. J. Rowett

 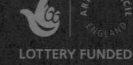

colophon

RISES IN THE EAST A GALLERY IN WHITECHAPEL

First published 2oo9
© 2oo9 Whitechapel Gallery Ventures Limited

Unless otherwise acknowledged,
all images © Whitechapel Gallery
Construction and gallery photographs © Patrick Lears and
Richard Bryant
Building plans and elevations © Robbrecht en Daem Architecten
& Witherford Watson Mann Architects

With thanks
Horniman Museum
RIBA British Architectural Library
Tower Hamlets Archive and Library
V&A Images, Victoria and Albert Museum

ISBN 978-0-85488-171-0

A catalogue record for this book is available
from the British Library

Edited by Katrina Schwarz and Hannah Vaughan
Designed by Niall&Nigel at Pony, London, www.ponybox.co.uk
Printed by 1455 Fine Art Printers, Belgium
Binding by Boekbinderij Van Waarden, The Netherlands

Whitechapel Gallery Ventures Limited
77–82 Whitechapel High Street
London E1 7QX
www.whitechapelgallery.org
To order (UK and Europe) call: +44 (o)2o 7522 7888
or email MailOrder@whitechapelgallery.org
Distributed to the book trade (UK and Europe only)
by Central Books
www.centralbooks.com

Produced upon the occasion of the opening of
the expanded Whitechapel Gallery, April 2oo9

COVER AND PAGES 14, 15
 architectural line drawing © Robbrecht en Daem Architecten
 and Witherford Watson Mann Architects Limited
ENDPAPERS
 Charles Harrison Townsend, wallpaper design (detail),
 The Studio, 1898. Courtesy RIBA Library Photographs Collection